The Amphoto Photography Workshop Series

IMAGE

Designing effective pictures

W9-AQJ-295

The Amphoto Photography Workshop Series

IMAGE
Designing effective pictures

Michael Freeman

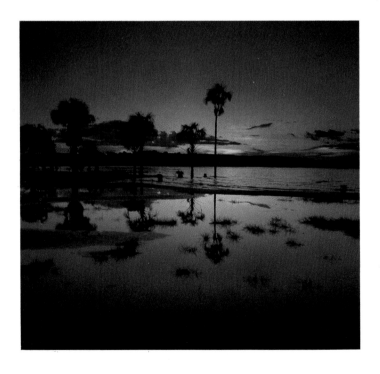

AMPHOTO
An imprint of Watson-Guptill Publications
New York

First published in 1988 in the United States by
Amphoto, an imprint of Watson-Guptill
Publications, a division of Billboard Publications,
Inc., 1515 Broadway, New York, New York
10036

Copyright © 1988 William Collins Sons & Co
Ltd
Photographs copyright © 1988 Michael
Freeman

All rights reserved. No part of this publication
may be reproduced or used in any form or by any
means, electronic, or mechanical, including
photocopying, recording, taping, or information
storage and retrieval systems without the prior
written permission of the copyright owners.

**Library of Congress Cataloging-in-
Publication Data**

Freeman, Michael, 1945-
 The Amphoto photography workshop series.
 Image.

 Includes index.
 1. Photograph. I. Title.
TR145.F658 1987 770 87–1130
ISBN 0–8174–4013–5 (pbk.)

Editor	Sydney Francis
Designer	Christine Wood
Illustrations	Rick Blakely
	David Powell

Phototypeset by Tradespools Ltd, Frome
Printed and originated in Italy by Sagdos, Milan

All the photographs in this book were taken by
Michael Freeman, with the exception of the
following: 131 (top) Neyla Freeman; 183 Viesia
Clavell.

The author and publishers also gratefully
acknowledge the assistance of Kodak (UK) Ltd.

Michael Freeman, an established photographer
for nearly twenty years, has emerged as one of
the most important authors of books on
photography in recent years. He specializes in
studio, reportage and wildlife photography. His
work has appeared on posters and record
sleeves and in numerous books and magazines.
Michael Freeman's other publications include
*The Photographer's Studio Manual, The 35mm
Handbook, Collins Concise Guide to Photography*
and *Wildlife and Nature Photography*.

CONTENTS

INTRODUCTION

Sophisticated equipment is used more and more to make a photographic image. As a result, it seems to many people that the best way of improving the results is to rely on technology. Favoured solutions are on the lines of longer focal lengths, faster film, techniques for focusing, and so on. To an extent, of course, technical answers do help, but they encourage a one-sided view of photography. There is much more to the making of a good photograph than being able to wield the equipment proficiently.

The important decisions in photography are those concerned with the image itself: the reasons for taking it, and the way it looks. Camera and film technology remains vital, but the best it can do is to help realize the photographer's ideas and perception. Moreover, there are many different ways of seeing anything, and consequently a great variety of possible images. Using more equipment may not always be the best way of improving a photograph; simple changes of framing or viewpoint may be more economical solutions.

The process of organizing the image is design, which is the subject of this book. Most people assess what they see intuitively, liking or disliking without stopping to think exactly why. Most photographers compose their pictures in the same way; those who do it well are natural photographers.

The reason why the intuitive approach to the image is so common lies in the way photographic images are made. Whatever level of thought goes into a photograph, the image is created in an instant, when the shutter release is pressed. This means that a picture can always be taken casually and without thought, and because it can, it often is. Bad habits apart, intuitive design is, however, necessary in any active photographic situation, such as in street photography. If there is really no time to consider the image, the only thing to do is to rely on experience and training.

Intuitive photography, therefore, can be based either on natural ability (or lack of it) or on a good knowledge of the principles of design. In other graphic arts, design is taught as a matter of course; only in photography has it received less attention than it deserves.

Objective principles of design

The principles of photographic design are to an extent different from those in paintings and illustrations. For the most part there is no particular value here in making these comparisons, but it is important to understand that there are objective principles of design; that is, they exist independently of individual taste. They explain why certain photographs create the impressions they do, and why particular ways of organizing the image have predictable effects.

The fundamental principles of design are contrast and balance. Contrast stresses the differences between graphic elements in a picture, whether it is contrast of tone, colour, form or whatever. Two contrasting elements reinforce each other. Balance is intimately related to contrast; it is the active relationship between opposed elements. If the balance (between blocks of colour, for example) is resolved, there is a sense of equilibrium in the image. If unresolved, the image seems out of balance, and a visual tension remains.

Both extremes, and all varieties of balance in between, have their uses in photography. The eye seeks harmony, although this does not make it a rule of design. Denying the eye perfect balance can make a more interesting image, and help to manipulate a response the photographer wants. Good design is not committed to producing gentle images in familiar proportions. It is usually visually satisfying, but ultimately good design is functional. It begins with the photographer having a clear idea of the potential for a picture, and of what the effect of the image should be.

Finally, design has to work within limits: what its audience already knows about photographs. This audience may know nothing of design techniques, but it has an understanding of the conventions, based on familiarity from seeing countless images. Sharp focus, for instance, is understood to mark the points of interest and attention. Certain ways of composing an image are considered normal, so that there are assumed standards; the photograph can meet these or challenge them, as the design suggests. Photographic design is essentially vernacular. It assumes that its audience has certain preconceptions.

This neon restaurant sign is well balanced in the frame, giving a sense of equilibrium and harmony to the picture.

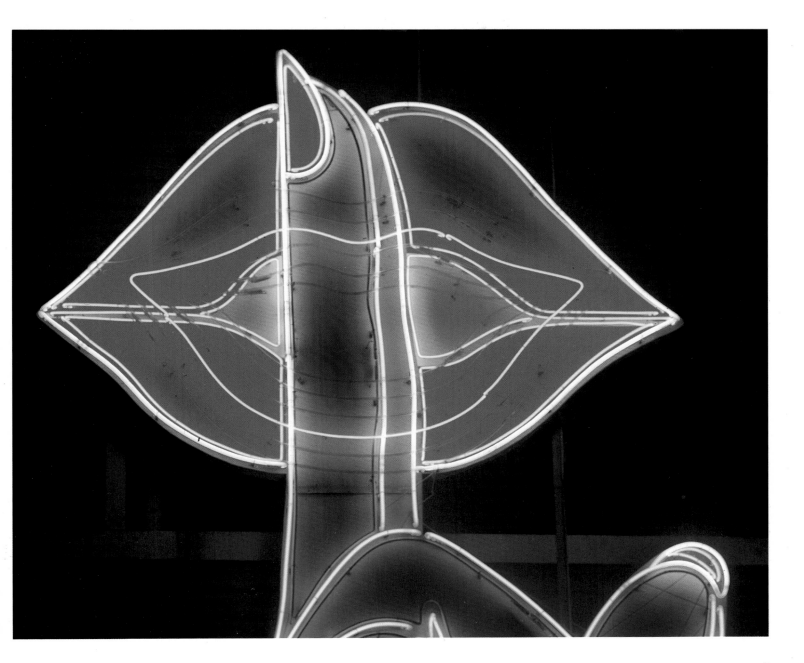

Design by contrast

The most fundamental overhaul of design theory this century took place in Germany in the 1920s and its focus was the Bauhaus. Founded in 1919 in Dessau, this school of art, design and architecture was a major influence because of its experimental, questioning approach to the principles of design.

The Basic Course at the Bauhaus, run by Johannes Itten, became famous as the foundation for modern mass media design. Itten's theory of composition was rooted in one simple concept: contrasts. Contrast between light and dark (chiaroscuro), between shapes, colours and even sensations, was the basis for designing an image.

One of the first exercises that Itten set the Bauhaus students was to discover and illustrate the different possibilities of contrast. These included, among many others, large/small, long/short, smooth/rough, transparent/opaque, and so on. These were intended as art exercises, but they translate very comfortably into photography.

Itten's intention was, as he said, "to awaken a vital feeling for the subject through a personal observation", and as a vehicle for plunging in and getting a feeling for the subject. For these reasons, the following is a valuable initial project.

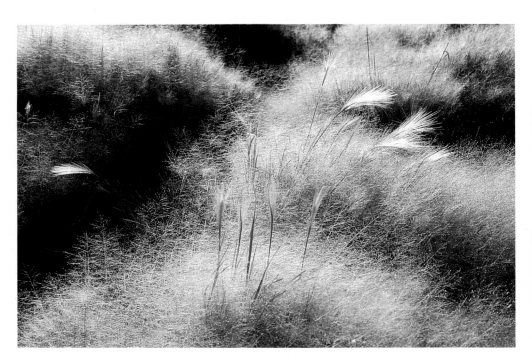

Soft
The very fine texture of this marsh grass near Mono Lake, California, is made to appear even more delicate by choosing a viewpoint against the sun.

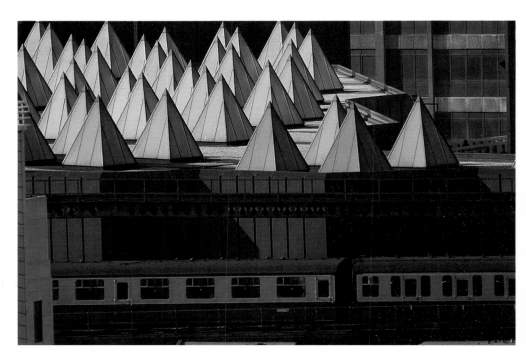

Hard
The dull lighting, drab urban setting and foreshortening effect of a telephoto lens all contribute to the spiky, aggressive quality of these architectural roof pyramids.

Project: Contrast

Ideally, do this project now, at the start, with an unprejudiced eye. As we go through this Workshop, you may find it interesting to look back at these contrast exercises. The project is in two parts. The first is rather easier – producing pairs of photographs that contrast with each other. The easiest way of doing this is to look back though your files and select those that best show a certain contrast. Do this by all means, but then go out and look for images to fit a contrast that you have already planned. This is more difficult, but very valuable, as you will have to plan and execute shots to order. This is exactly what a professional photographer has to do most of the time: to bring back a picture the design of which has been decided in advance. The second part of the project is to combine the two poles of the contrast in one photograph, an exercise that calls for quite a bit more imagination.

You decide on the contrast; there are no restrictions. You can choose, for example, very basic picture elements, such as lines or points. Or you could develop the contrast idea to take in a concept, such as continuous/intermittent, or something non-visual, like loud/quiet. As an aid, the list below is from the Bauhaus exercise:

Point/line	Area/line
Plane/volume	Area/body
Large/small	Line/body
High/low	Smooth/rough
Long/short	Hard/soft
Broad/narrow	Still/moving
Thick/thin	Light/heavy
Light/dark	Transparent/opaque
Black/white	Continuous/ intermittent
Much/little	
Straight/curved	Liquid/solid
Pointed/blunt	Sweet/sour
Horizontal/vertical	Strong/weak
Diagonal/circular	Loud/soft

Itten wanted his students to approach these contrasts from three directions; "they had to experience them with their senses, objectivize them intellectually and realize them synthetically". That is, each student had first to try to get a feeling for each contrast without immediately thinking of it as an image, then list the ways of putting this sensation across, and finally make a picture. For example, for "much/little", your first impression might be of a large group of things with one of them standing out because it is in some way different. On the other hand, you might feel it as a group of things with an identical object standing a little apart, and so isolated. These are just two approaches out of several alternatives.

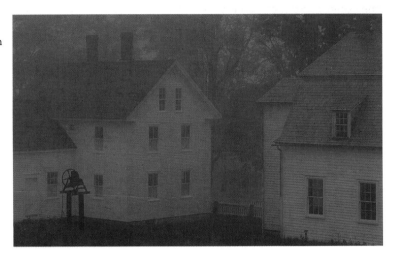

Flat
The low contrast in this view of a Shaker village in Maine is due entirely to the quality of lighting: early morning fog.

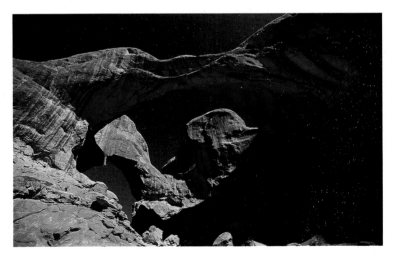

Contrast
The highest contrast of lighting effects is from a high sun in clear weather and unpolluted air. The strong relief of these rock arches creates deep, unrelieved shadows.

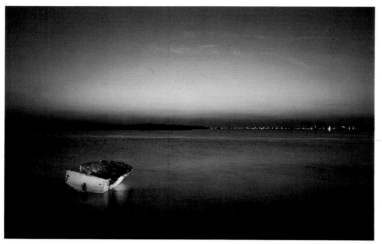

►Many
To maximize the impression of quantity, this shot of drying fish was composed right to the edges of the rack, but not beyond, so that the fish appear to extend beyond the frame edges.

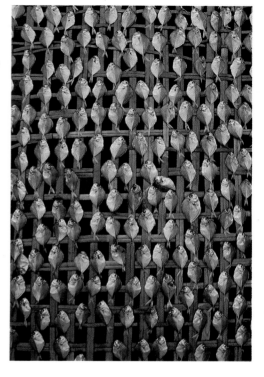

▲One
To emphasize the isolation of this abandoned boat, a wide-angle lens increases the perspective, separating it from the distant shore. The composition helps by eliminating from the view other extraneous points of attention.

▼Solid
Hard lighting and rough, dry texture give the impression of rocky solidity. A telephoto lens compresses the view of these canyons into a wall-like structure, filling the frame.

▼Liquid
Water and other liquids have no intrinsic shape, so a usual method of representing them would be in droplets or falling streams against a non-liquid background. Here, however, as a way of photographing nothing but water, the wave patterns of sunlight convey the effect in a swimming pool.

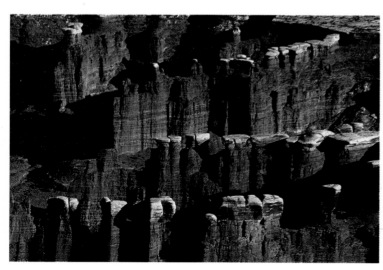

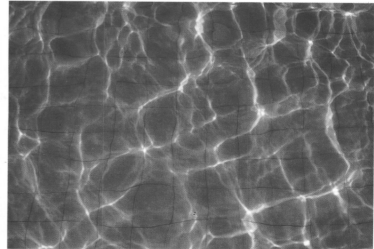

The second approach – identical things with one set apart – is easy to realize; the answer is a box full of map pins, made a little more interesting visually by being photographed in polarized light through a polarizing filter, to give them irridescent colours. The alternative version – one slightly different among many – was saved until a good opportunity came up during the course of other shooting. The result was the aerial picture of yachts anchored in a marina at the moment when the sails of one were being unfurled, on page 75.

This is something else you might consider when doing this project (and the others): go one step further than you really need to. Always try to add something a little special to your photographs.

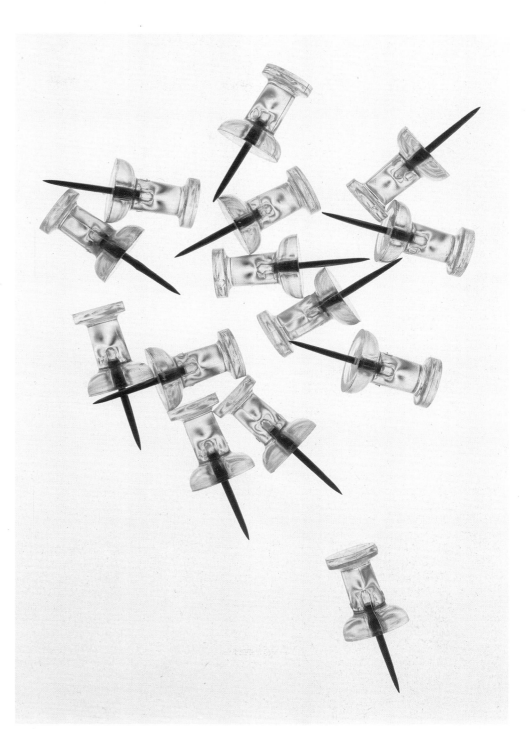

Combining contrast in one picture
All of the contrast pairs suggested here can be handled in single images. This usually requires more care and effort than producing separate photographs of each half of a pair, as shown *opposite*; it does, however, sharpen the appreciation of contrasting qualities. Many of the previous exercises can probably be assembled from your existing stock of photographs, but single images showing contrast will normally need to be shot intentionally. This photograph of map pins is a very simple solution to the "one/many" contrast.

THE PICTURE FRAME

The frame *opposite* is the starting point for the making of every image of this book. There are other shapes, of course, and other cameras. But all except a handful of pictures were taken with one model. The make is unimportant; what matters is that everything discussed here is about the changes that can be made within this frame – and not camera technique.

This frame is of much greater importance to a photograph than a canvas or paper is to a painting or illustration. The reason is the principal difference between photography and every other graphic art: the elements of a photograph are already in front of the camera. A painting or illustration is built up from nothing, out of perception and imagination. The process of photography, by contrast, is one of selection from real scenes and events. Potential photographs exist in their entirety inside the frame every

time the photographer raises the camera and looks through the viewfinder. Indeed, in many types of highly active photography, such as street photography, the process of making the image involves using the viewfinder, and so the frame, to watch the progress of the image as it evolves. The actual creation of the image – its commitment to film – is normally instantaneous.

Being instantaneous, however, calls into question the relative importance of the moment of shooting. If everything – more detail than the eye can possibly appreciate at the time – is converted into the finished photograph in a fraction of a second, then the essential part of the process must be in the period leading up to this. If the subject is static, like a landscape, it is easy to see that enough time can be spent studying and evaluating the frame. With active subjects, however, there is not this period of grace.

Design decisions, whatever they are, must often be taken in less time than it takes for them to be recognized as such. In other words, they must be intuitive.

This takes us back even further if we were considering the important part of making a photograph. The only realistic way of improving the way you design pictures is to learn the principles of design, then put them on one side, and allow what you have absorbed to come up naturally in the moment you need it.

Facility at using this frame depends on two things; knowing the principles of design, and the experience that comes from taking photographs regularly. The two combine to form a photographer's way of seeing things, a kind of frame vision that evaluates scenes from real life as potential images. What contributes to this frame vision is the subject of the first section of this volume.

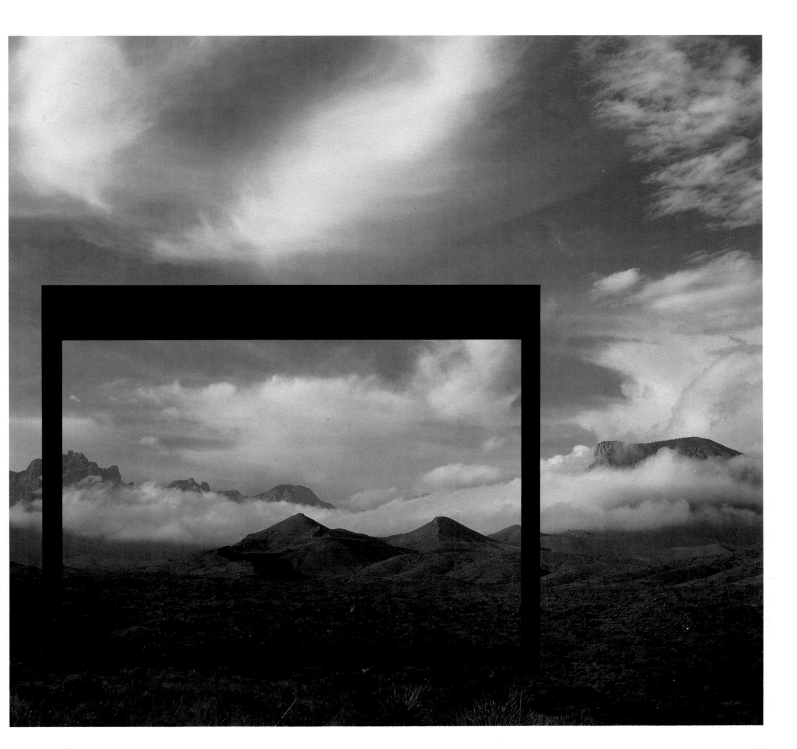

Dynamics of the Frame

The setting for the image is the picture frame. In photography, the format of this frame is fixed at the time of shooting, although it is always possible later to adjust the shape of the frame to the picture you have taken. Nevertheless, whatever opportunities exist for later changes (see pages 58–61), do not underestimate the influence of the viewfinder on composition. With most cameras, your view of the world is a bright rectangle surrounded by blackness, and the presence of the frame is usually strongly felt. Even though experience may help you to ignore the dimensions of the viewfinder frame in order to shoot to a different format, intuition will work against this, encouraging you to make a design that feels satisfying at the time of shooting.

The most common picture area is the one shown here: that of a horizontal 35mm frame. This is the most widely used format of camera, and holding it horizontally is the easiest method. As an empty frame it has certain dynamic influences, as the diagram on this page shows, although these tend to be felt only in very minimal and delicately toned images. More often, the dynamics of lines, shapes and colours in the photograph take over completely.

Depending on the subject and on the treatment the photographer chooses, the edges of the frame can have a strong or weak influence on the image. The examples shown here are all ones in which the horizontal and vertical borders, and the corners, contribute strongly to the design of the photographs. They have been used as references for diagonal lines within the pictures, and the angles that have been created are important features.

What these photographs demonstrate is that the frame can be made to interact strongly with the lines of the image, but that this depends on the photographer's intention. If you choose to shoot more loosely, in a casual snapshot fashion, the frame will not seem so important. Compare the structural images on these two pages with the loosely designed picture on page 40.

The empty frame
Just the existence of a plain rectangular frame induces some reaction in the eye. These are vague, however, and the vectors shown in this diagram should not be read as precise. The tendency – and it is no more than that – is to start at the upper left and drift down and right, coming back several times to cover the area. Be warned that the overplay of graphic elements in the photograph is usually so strong as to overwhelm this natural drift of attention.

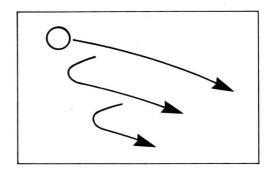

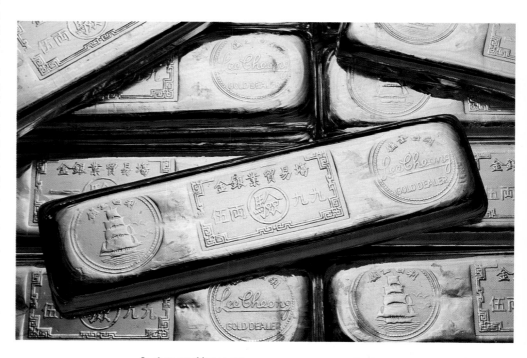

In photographing an array of gold bars, a regular, ordered stack, as shown in the first diagram, would have been dull. Angling three of the bars introduces a dyamic into the picture; this works entirely as a result of the angles that are created with the edges of the frame. The sharp angles at the top and bottom enliven the image.

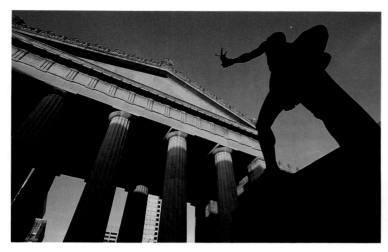

Diagonal tension
The dynamic movement in this wide-angle photograph comes from the interplay of diagonals with the rectangular frame. Although the diagonal lines have an independent movement and direction, it is the reference standard of the frame edges that allows them to create tension in this picture.

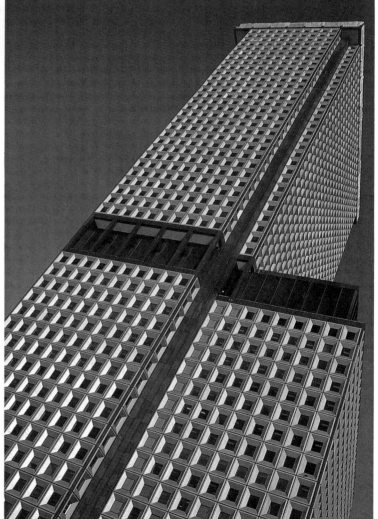

Alignment
One simple device for originating an image that has prominent lines is to align one or two of them with the frame. In the case of this office block, the alignment of two edges avoids the untidiness of two corner areas of sky. Alignment like this emphasizes the geometry of an image.

Frame and Subject

In order to be able to talk about the different graphic elements in design, and to look at the way they interact, the first thing we must do is to isolate them, choosing the most basic situations for composing pictures. A little caution is needed here, because in practice you will normally be faced with a multitude of possibilities and design choices. If some of our earlier examples in this book seem a little obvious, it is because we need them as clear, uncluttered examples.

The most basic of all photographic situations is one single, obvious subject in front of the camera. We have an immediate choice; to close right in so that it fills up the picture frame, or to pull back so that we can see something of its surroundings.

What would influence the choice? One consideration is the information content of the picture. Obviously, the larger the subject is in the photograph, the more detail of it can be shown. If it is something unusual and interesting, this may be paramount; if very familiar, perhaps not. For example, if a wildlife photographer has tracked down a rare animal, we would reasonably expect to see as much of it as possible.

Another consideration is the relationship between the subject and its setting. Are the surroundings important, either to the content of the shot or to its design? In the studio, you can place an object on a plain roll of background paper so that it is on neutral territory; then the setting has nothing to tell the viewer, and its only value is for compos-

ition. Outside the studio, however, settings nearly always have some relevance. They can show scale (a climber on a rock-face) or something about the activity of the subject.

A third factor is the subjective relationship that you might want to create between the viewer and the subject. The most commonly used expression for this is presence. If you want the subject to be imposing, and if you want to take the viewer right up to it, then filling the frame is a reasonable option. There are other things involved, such as the ultimate size of the picture when displayed, (see pages 46–9), the focal length of lens, and the scale of the subject to begin with. Nevertheless, a big subject filling the frame of a big picture usually acquires force and impact.

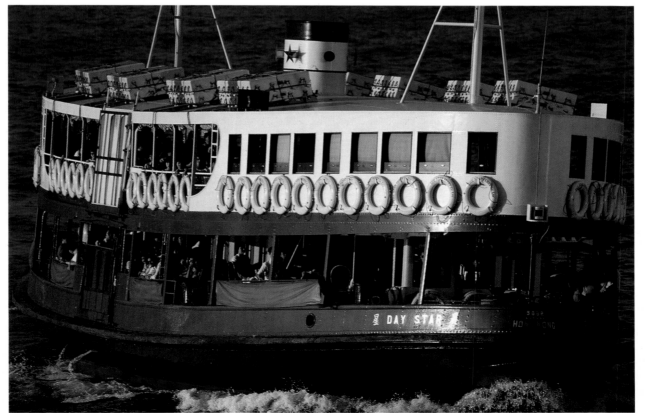

Varying the size in the frame
For this project, take a single subject that is naturally isolated against a relatively plain setting. In this example, the subject is one of Hong Kong's star ferries.

1 The success of this shot depends almost entirely on perfect timing as the ferry approaches the camera. Although it may not be immediately obvious, much of the design appeal of this photograph lies in the almost exact fit of the boat's shape to the 35mm frame. A little earlier, with more water showing around the edges, would have been more ordinary; a fraction later would have looked like a mistake. The ferry in this picture *feels* large; it has presence.

The shape of the subject in relation to the format of the frame clearly has an effect. In the sequence shown here, the main picture shows a very satisfactory fit: the boat from this angle just reaches the edges all round. In the majority of single-subject pictures, however, the focus of attention does not fill the frame. The shape may not coincide with the format of the picture (cropping a print to fit the subject is always possible, but not necessarily elegant). Another design disadvantage with running the edges of the subject right up to the borders of the picture is that the eye tends to feel uncomfortable concentrating on points at the edges of the picture. It often needs a little free area around a subject to be able to move without feeling constricted.

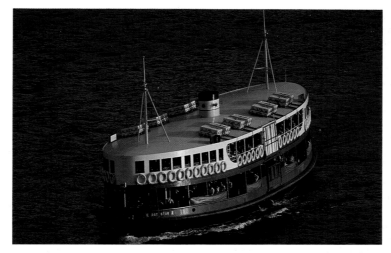

2 Pulling back gives a more typical subject-in-its-setting treatment. Successful because of the crisp lighting but more ordinary than the main photograph, the setting in this case can be taken as read; we know the ferry must be on water, and as there is nothing unusual about it (heavy waves or interesting colour), it adds little to the picture.

3 A different kind of context shot. More informative than attractive in its design, this photograph shows us less about the ferry but more about where it is and what it does.

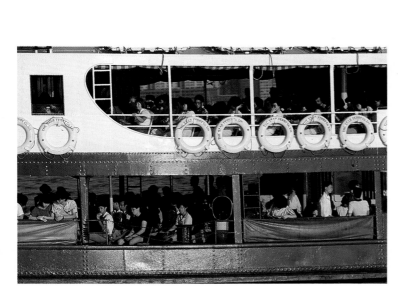

4 Over-filling the frame takes us into the structural details of a subject. Here, the lifebelts inform us that this is a boat, but the definition of the subject has altered: this picture is now concerned as much with the people as with the ferry.

This can be demonstrated by taking a simple, comfortably centered shot and cropping in on it until the edges of the frame and subject just meet. You can see how uncomfortable this can become, particularly with a still-life image which evidently owes every aspect of its composition to the photographer's intention.

As soon as you allow free space around the subject, its position becomes an issue. It has to be placed, consciously, somewhere within the frame. Logically, it might seem that the natural position is right in the middle with equal space around, and indeed, there are many occasions when this holds true. If there are no other elements in the picture, why not?

One compelling reason why not is that it is very predictable – and, if repeated, boring. We are faced with a conflicting choice. On the one hand, there is a desire to do something interesting with the design, and so escape the bull's-eye method of framing a subject. On the other hand, placing the subject anywhere but in a natural position needs a reason. As an extreme example, if you place a subject right in the corner of an otherwise empty frame, you need a justification, or the design becomes simply perverse. Eccentric composition can work extremely well, but as we see later in the book, its success depends on there being some purpose.

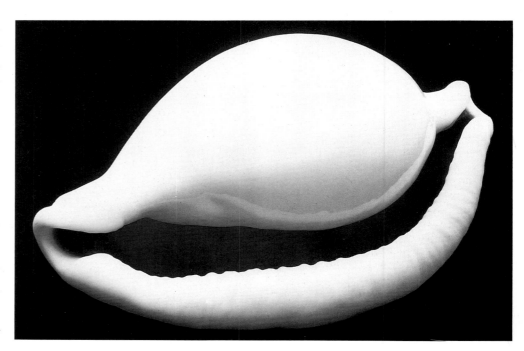

Edge to edge
In the original picture, *top*, the cowrie shell fits the 35 mm frame with equal space all round. Bringing the edges of the shell right to the limits of the frame, as in the 4 × 5 inch picture *right*, makes it uncomfortable to view, because the eye has insufficient space to move around the shell's image. The feeling is constricted, and unnecessarily tight.

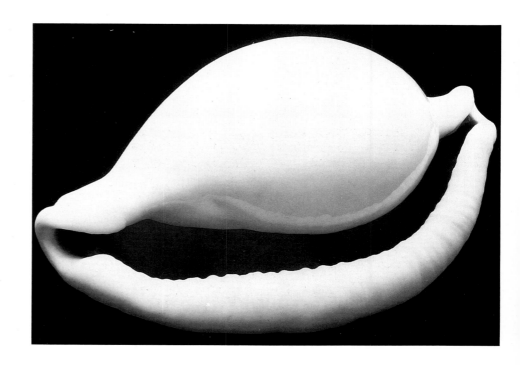

The importance of placement increases as the subject becomes smaller in the frame. In the photograph of the man standing against the Wailing Wall, we are not really conscious that the figure is actually in any position in the frame. It is, in fact, centered but with not so much space around it as to be obvious. With the photograph of the water-bound hamlet on page 21, we are made very aware of its position in the frame because it is so small and isolated. Such a small subject behaves graphically as a point, and we deal with this in detail on pages 70–5. For the time being, however, it is enough to say that some off-centeredness is usually desirable simply in order to set up a relationship between the subject and its background. A position dead center is so stable as to have no dynamic tension at all. If slightly away from the middle, the subject appears to be set against the background.

In practice, other elements do creep into most images, and even a slight secondary point of interest is usually enough to influence the placement of the subject. In the

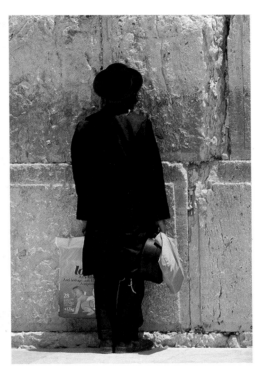

Centering the subject
If the subject – here a man praying at Jerusalem's Wailing Wall – is to occupy most of the frame space, there is often no good reason for placing it anywhere else but in the middle. The setting is more or less featureless, and off-centering the figure would merely raise a question in the viewer's mind as to why, with no good answer. An alternative treatment would have been to show the size of the wall, making the figure smaller. In that case it would probably have been best to place the figure low in the frame to emphasize the wall's great height.

Placing the subject low
A typical condition is where the foreground is uninteresting, distracting, or otherwise of little value to the shot. In this case, a reasonable solution is to raise the camera and place the subject low in the frame. It may also, as here, help the composition by darkening the upper part of the visible sky (with a graduated filter) to give a little counterbalance.

case of the stilted houses, the position of the sun above and to the left of the picture produces a lighter tone in the upper left corner; this makes it natural to off-set the houses slightly in the opposite direction. Another factor that can influence an off-center position is movement. If the subject is obviously in motion, and its direction is plain, then the *natural* tendency is to have it entering the frame rather than leaving it. I emphasize the word natural, however, because there may always be special reasons for doing things differently – and different usually gets more attention.

As a rule of thumb, when the setting is significant – that is, when it can actually contribute to the idea behind the picture – then it is worth considering this kind of composition, in which the subject occupies only a small area. In the case of the houses in the sea, the whole point of the picture is that people live in such unusual circumstances: surrounded by water. Closing in would miss the point. Unfortunately, moving further back would only reduce the size of the houses so much that they would be indecipherable, although it would show still more ocean.

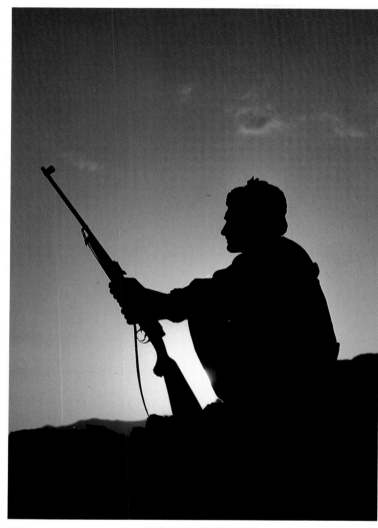

Balancing tones
Tonal considerations made it natural to position the silhouetted figure of a Pathan tribesman relatively low in the frame. Had it been more central (see diagram *right*) the black mass below would have unbalanced the picture, and detracted from the outlines of the man. As the second diagram shows, the chosen composition allows for the relative weights of the black and the gold.

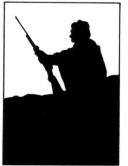

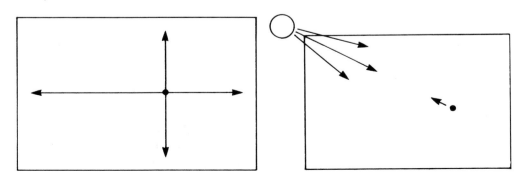

The purpose of this aerial view of stilted houses built in the middle of the Sulu Sea in the Philippines is to draw attention to their unusual and isolated location. Off-centering the subject brings some life to the design, and encourages the eye to move from the houses towards the upper left corner of the frame.

Balance

At the heart of design lies the concept of balance. Balance is the resolution of tension, opposing forces that are matched to give equilibrium and a sense of harmony. It is a fundamental principle of visual perception that the eye seeks to balance one force with another. Balance is harmony and symmetry: forces that are equally opposed.

In this context, balance can refer to any of the graphic elements in a picture. On pages 68 to 141 we review each of these in turn, from points and lines to the relationships between colours. Balance and harmony occur in each case.

If we consider two strong points in a picture, for example, the center of the frame becomes a reference against which we see their position. If one diagonal line in another image creates a strong sense of movement in one direction, the eye is aware of the need for an opposite sense of movement. In colour relationships, successive and simultaneous contrasts demon-

strate that the eye will seek to provide its own complementary hues.

When talking about the balance of forces in a picture, the usual analogies tend to be ones drawn from the physical world: gravity, levers, weights and fulcrums. These are quite reasonable to continue with, because the eye and mind have a real, objective response to balance that works in a very similar way to the laws of mechanics.

We can develop the physical analogies more literally by thinking of an image as a surface balanced at one point, rather like a weighing scale. If we add anything to one side of the image – that is, off-center – it becomes unbalanced, and we feel the need to correct this. It does not matter whether we are talking about masses of tone, colour, an arrangement of points, or whatever.

Considered like this, there are two distinct kinds of balance. One is symmetrical or static; the other is dynamic. In symmetrical balance, the arrangement of forces

is centered – everything falls equally away from the middle of the picture. We can create this by placing the subject of a photograph right in the middle of the frame. In our weighing scale analogy, it sits right over the fulcrum, the point of balance. Another way of achieving the same static balance is to place two equal weights on either side of the center, at equal distances. Adding a dimension to this, several graphic elements equally arranged around the center have the same effect.

The second kind of visual balance opposes weights and forces that are unequal, and in doing so enlivens the image. On the weighing scale, a large object can be balanced by a small one, as long as the latter is placed far enough away from the fulcrum. Similarly, a small graphic element can successfully oppose a dominant one, as long as it is placed out towards the edge of the frame. Mutual opposition is the mechanism by which most balance is achieved. It is, of

Using the analogy of a weighing scale, think of a picture as balanced at its center. A blank frame is in equilibrium.

Imbalance
If one visual element or force is positioned away from the center, the balance is upset.

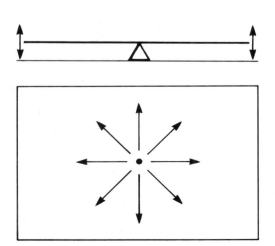

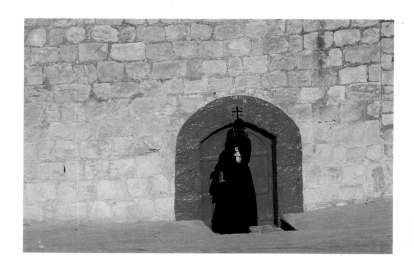

course, a type of contrast (see Design by contrast on pages 8–11).

These are the ground rules of visual balance, but they need to be treated with some caution. All we have done so far is to describe the way the balance works in simple circumstances. In many pictures, a variety of elements interact, and the question of balance can only be resolved intuitively, according to what feels right. The weighing scale analogy is fine as far as it goes – to explain the fundamentals – but I would certainly not recommend actually using it as an aid to composition.

Apart from this, a more crucial consideration is whether or not balance is even desirable. Certainly, the eye and brain need equilibrium, but providing it is not the undisputed job of art or photography. Georges Seurat, the neo-impressionist painter, claimed that "Art is harmony", but as Itten pointed out, he was mistaking a means of art for its end.

Static balance 1
The maximum symmetry occurs when a group of objects or lines are arranged radially around the center of the frame. A square format contributes even more to this formal symmetry.

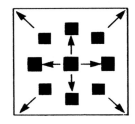

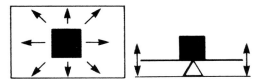

Static balance 2
If a single subject is centrally placed, the balance is maintained. The forces are symmetrical.

Static balance 3
Two equal elements equally positioned around the center of the frame are also in symmetrical, static balance.

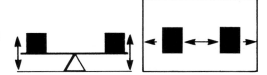

If we accepted a definition of good photography as images that produced a calm, satisfying sensation, the results would be very dull indeed. An expressive picture is by no means always harmonious, as you can see time and again throughout this book. We will keep returning to this issue, and it underlines a lot of design decisions, not just in an obvious way – where to place the center of interest, for example – but in the sense of how much tension or harmony to create. Ultimately, the choice is a personal one, and not determined by the view or the subject.

In composing the image, the poles are symmetry and eccentricity. Symmetry is a special, perfect case of balance, not necessarily satisfying, and very rigid. In the natural run of views that a photographer is likely to come across, it is not particularly common. You would have to specialize in a group of things that embody symmetrical principles, such as architecture or seashells, to make much use of it. For this reason, it can be appealing if used occasionally, but to succeed it must be absolutely precise. Few images look sloppier than a nearly-symmetrical view that did not quite make it. Precise composition is by no means easy without some visual aid, and grid lines etched on the focusing screen are almost a necessity.

Dynamic balance
Dynamic equilibrium opposes two unequal subjects or areas. Just as a small weight can balance a larger mass by being placed further from the fulcrum, large and small elements in an image can be balanced by placing them carefully in the frame.

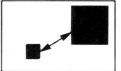

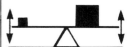

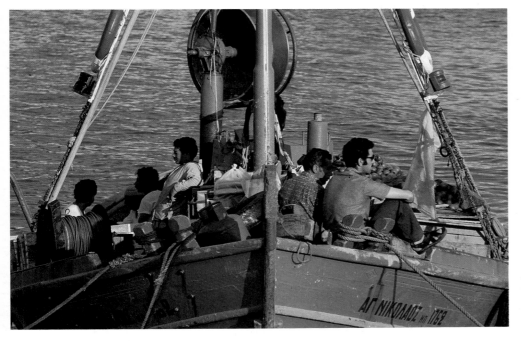

The need for precision
The line between
symmetrical and
asymmetrical is very
fine. If you attempt
a symmetrical
composition, then it must
be exact to succeed. If
not, the smallest
misalignment will stand
out immediately, and the
picture will look as if you
tried to be precise but
failed; which is, of
course, exactly what
would have happened.
A grid-etched focusing
screen is an invaluable
positioning guide for
pictures like these.

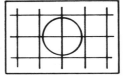

Bilateral symmetry
Certain classes of subject
are naturally symmetrical
around one axis.
Architecture often falls in
this class, and it applies
also to most living things
(consider head-on views
of people or practically
any animal).

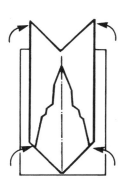

We ought now to consider how tension actually works in an unbalanced composition. The mechanics are considerably more subtle than the balancing scale analogy can show. While the eye and brain search for balance, it would be wrong to assume that it is satisfying to have it handed on a plate. Interest in any image is in direct proportion to the amount of work the viewer has to do, and too perfect a balance leaves less for the eye to work at. Hence, dynamic balance tends to be more interesting than static balance. Not only this, but in the absence of equilibrium, the eye tries to produce it independently. In colour theory, this is the process involved in successive and simultaneous contrast (see pages 124–41).

This can be seen in action in any eccentrically composed picture. To make the point as obviously as possible, the examples here are of extreme displacement – the photographs of the worker in the rice field and of the woman with an umbrella. The rice field picture is graphically the simpler of the two. According to the weighing scale analogy, the equilibrium is completely upset, yet if you study the picture it is not, in fact, all that uncomfortable in appearance.

What happens is that the eye and brain want to find something closer to the center to balance the figure in the top right corner, and so keep coming back to the lower left center of the frame. Of course, the only thing there is the mass of rice, so that the

setting in fact gains extra attention. The green stalks of rice would be less dominant if the figure were centrally placed. As it is, you would be hard put to say whether the photograph is of a worker in a rice field or of a rice field with, incidentally, a figure working in it.

This process of trying to compensate for an obvious asymmetry in an image is what creates visual tension, and it can be very useful indeed in making a picture more dynamic. It can help draw attention to an area of a scene that would normally be too bland to be noticed. In the case of the second picture, of a woman with an umbrella, the photographer wanted tension because of the subject: a Manila slum built

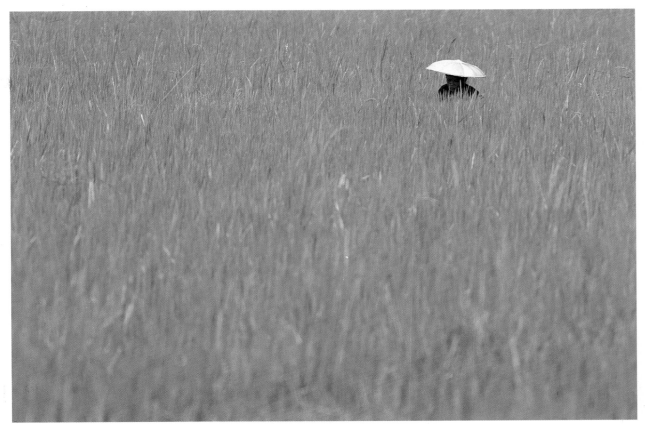

Natural compensation
An unbalanced composition encourages the eye to produce its own equilibrium by paying more attention to the "empty" area of the frame. In both these examples, this was a deliberate attempt to upgrade the visual importance of the surroundings.

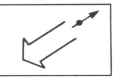

on a gigantic rubbish heap. The asymmetry forces the eye left into the background.

A second factor involved in eccentrically composed images is that of logic. The more extreme the asymmetry, the more the viewer expects a reason for it. Theoretically, at least, someone looking at such an image will be that bit more prepared to examine it carefully for the justification. Be warned, however, that eccentric composition can as easily be seen as artificial.

Finally, all considerations of balance must take into account the sheer graphic complexity of many images. In order to study the design of photographs, we are doing our best in this book to isolate each of the graphic elements we look at. Many of the examples, such as the rice field picture, are deliberately uncomplicated. In reality, most photographs contain several layers of graphic effect.

As an example of this, consider a picture of a car, very small in the frame, entering from the left, and placed close to the left edge of the picture. Although on one level a point, it also has implied movement, and its perceived position in the frame is actually closer to the middle because we see it as having potential movement into the frame. Were it in exactly the same position but facing in the opposite direction, the balance of the shot would seem quite different. This is the case with the photograph of a yacht on page 73.

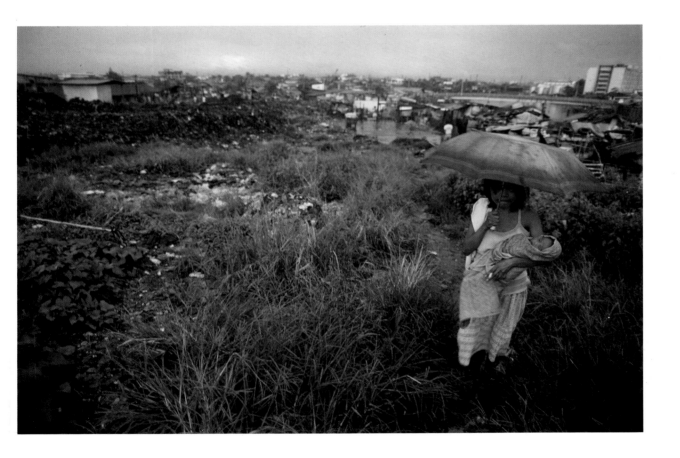

Dividing the Frame

Any image, of any kind, automatically creates a division of the picture frame. Something like a prominent horizon line does this very obviously, but even a small object against a bland background (a point, in other words) makes an implied division. Look at any of the pictures in this book which comprise a single small subject; shifting the position of the subject changes the areas into which the frame is divided.

There are, naturally, an infinite number of possible divisions, but the most interesting ones are those that bear a definable relationship to each other. Division is essentially a matter of proportion, and has preoccupied artists in different periods of history. During the Renaissance in particular, considerable attention was given to dividing the picture frame by geometry.

This is an interesting point in photography, for while a painter must exercise some deliberate control over the structure of a picture, a photographer usually has little such opportunity, so much less of a reason to think about exact proportions. Nevertheless, different proportions evoke certain responses in the viewer, whether they were calculated exactly or not.

Before you even take a photograph, consider that the frame contains its own proportions – 2:3 in the case of the most commonly used 35mm cameras. This is a proportion based on two simple numbers, and the frame can also be sub-divided according to this ratio. There are many other simple ratios that can be used to divide a frame, such as 1:1, 2:1, 4:5, 5:8.

What Renaissance artists decided was that these proportions produced an essentially static division. By contrast, a dynamic division could be made by constructing more interesting ratios. The Golden Section, which was known to the Greeks, is the best known "harmonious" division.

The Golden Section is based on pure geometry, and as a photographer you will never need to construct it. The importance of the division lies in the fact that all the areas are integrally related; the ratio of the small section to the large one is the same as that of the large section to the complete frame. They are tied together, hence the idea that they give a sense of harmony. The logic of this may not seem completely obvious at first, but it underlies more than just the sub-division of a picture frame. The argument is that there are objective physical principles that underlie harmony. In this case, they are geometric, and while we may not be aware of them in operation, they still produce a predictable effect.

The sub-division of a standard 35mm frame according to the Golden Section is

Golden Section divisions drawn on a clear piece of film to the size of a 35 mm frame make it easy to check the accuracy of the proportions in the project on page 30.

shown here. The proportions are, in fact, very close to those of the frame itself, 2:3 (and so the ratio of the shorter to the longer, 2:3, is fairly similar to that of the longer to the total, 3:5).

We may be able to ignore the geometry, but we can not ignore the fact that these proportions are fundamentally satisfying. Notice also that, by dividing the frame in both directions, an intersection is produced, and this makes a generally satisfying location for a point, or any other focus of attention. Compare this with the off-center placement of small subjects on pages 22–7.

The Golden Section is not the only way of making a harmonious division. It is not even the only method in which the ratios are integrally related. Another basis is a sequence of numbers in which each is the sum of the previous two, hence . . . 1, 2, 3, 5, 8, 13 . . . In yet another method, the frame is

Golden section proportions
Familiarity with these proportions makes it easy to reproduce them in a composition without calculation. Needless to say, in this photograph no great thought went into the sub-division of the frame; it was done in an instant, by intuition. Nevertheless, the constant practice of dividing images into areas creates familiarity with the classic proportions.

Trace these proportions on clear film. Then, on a light-box, you can judge the accuracy of attempts to divide the frame intuitively.

sub-divided according to the ratio of its own sides. There is, indeed, a massive variety of sub-divisions that obey some internal principle, and they all have the potential to make workable and interesting images.

This is all very well for a painter or illustrator, but how can photography make sensible use of it? Certainly, no-one is going to use a calculator to plan the division of a photograph. Intuitive composition is the only practical approach for the majority of photographs. The most useful approach to dividing a frame into areas is to prime your eye by becoming familiar with the nuances of harmony in different proportions. If you know them well, your intuitive design will naturally become more finely tuned.

Projects: Dividing the frame
Make an effort to familiarize yourself with the principal methods of sub-division, starting with the Golden Section. Where the situation is appropriate and the image calls for a definite sub-division, try to use these formal systems from memory. Check your accuracy by drawing the proportions on a clear piece of film to the scale of the film format you are using, and use this as an overlay on the transparencies or negatives when the film is returned from the laboratory. If you feel the proportions are difficult to remember, and the prism head on your camera is removable, try slipping this piece of film underneath, so that it lies on top of the focusing screen.

Golden Section division
Although there is never any reason to perform this exercise in photography, the method of dividing a line according to the Golden Section demonstrates clearly enough its cohesion. In step **1**, a triangle is drawn with the line that is to be divided (a,b) as a base; b,c is at right angles and is half its length. In step **2**, an arc is drawn from the apex c so that the distance b,c is transferred to the longest side, a,c. In step **3**, another arc is drawn, this time from a, transferring the distance a,d down onto the original line. This point creates a Golden Section division.

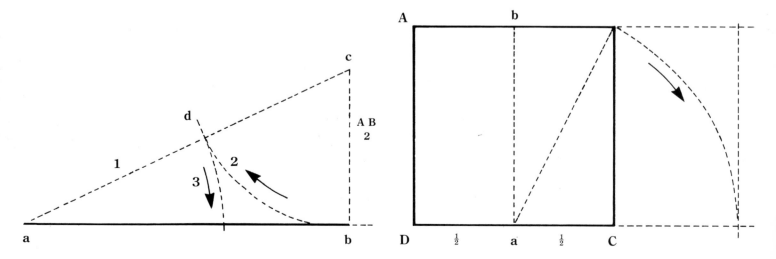

Integrated proportions
In principle, any subdivision of the frame that is integrated internally produces a sense of harmonious balance. The Golden Section is perhaps the most obvious, but there are others. In this, the subdivision is based on a series of numbers – 1,2,3,5... – in which each is obtained by adding together the preceding two. Hence, 1 and 2 produce 3, 2 and 3 produce 5, and so on.

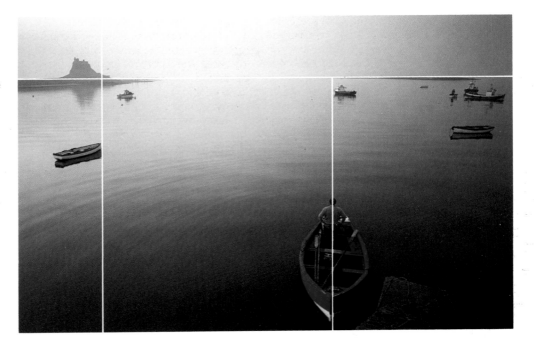

Other integrated divisions
Other coherent methods of sub-dividing the same shape of frame include those using a series of numbers and those based geometrically on the frame's own sides. Most of the useful sub-divisions are rectilinear, but diagonals can also be used to create triangular spaces.

The horizon

Probably the most common of all situations of photography where the frame must be divided cleanly and precisely is the one that includes the horizon line. In landscapes of the type shown on these pages it becomes the dominant graphic element, the more so if there are no outstanding points of interest in the scene.

Plainly, if the line of the horizon is the only significant graphic element, placing it becomes a matter of some importance. There is a natural tendency to place the line lower in the frame than higher. This probably derives from the association of the bottom of the picture frame with a base; a low position for anything gives a greater

sense of stability. This apart, the question of the exact position remains open. One method is to use the linear relationships just described on the preceding pages. Another is to balance the tones or colours (see pages 126–41 for the principles of combining colours according to their relative brightness).

Yet another method is to divide the frame according to what you see as the intrinsic importance of the ground and sky. For instance, the foreground may simply be uninteresting, distracting, or in some other way unwanted. In that case, you might place the horizon low, by default. A more positive reason for the same proportions would be that the sky has some visual interest. You can see an example of this in

the project on pages 152–3; the form of the clouds is definitely worth making part of the image, but the clouds are too delicate in tone simply to use a wider angle of lens and include more of the dark foreground. They can register properly only if the proportion of the ground is severely reduced so that it does not overwhelm the picture.

If, on the other hand, there is some distinct feature of interest in the foreground, this will encourage a higher position for the horizon. Indeed, if the sky has no graphic value and the foreground has plenty of interest, it may make more sense to reverse whatever sub-division you choose, and place the horizon much closer to the top of the frame.

Placement exercise
This wide-angle view of Mono Lake in California provides a graphically clean landscape in which the horizon is dominant.

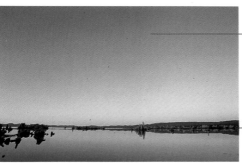

The minimal nature of this landscape makes it possible to treat it as an abstract arrangement. Only slightly lower than the center, the horizon here is in a position which would not normally be chosen for a less unusual landscape.

Small tufa projection needs to be either completely in or out of the picture.

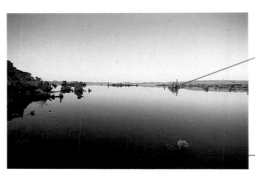

Horizon slightly higher than the center emphasizes the foreground water.

The darker water here causes the picture to be less well tonally balanced.

Now the sky dominates, and gives a more spacious feeling to the image.

Lowering the horizon line to here gives more eccentric and more dynamic proportions.

A different approach is to take a slightly different camera position, and introduce symmetry into the image. Now the position of the horizon becomes slightly less important.

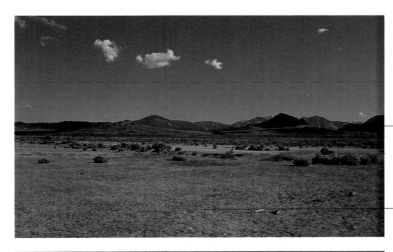

Tonal balance
In this sequence, there is a distinct problem – the uninteresting foreground – which suggests a very low horizon.

The interest in the image lies only in a narrow band.

The foreground is of little interest and is visually untidy.

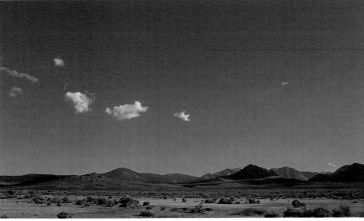

Unfortunately, there are insufficient clouds to justify this large area of sky.

Lowering the horizon to here solves the problem of the foreground.

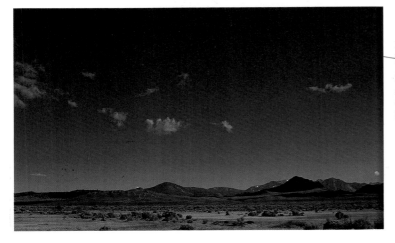

Darkening the upper part of the sky with a graduated filter lowers the attention to the hills on the horizon – the original intention of the picture.

Project: Placing the horizon
The only way of resolving the aesthetic considerations of placing the horizon is to take several landscape settings and run through the alternatives. There is little point in simply starting low and moving progressively higher without considering the influences. The value in doing this project is to look in each case for reasons, to justify why you have selected a particular position, and to decide your preferences. As with all these projects, the decisions need to be made more thoughtfully than they would under normal shooting conditions, and it is not suggested that you continue being so methodical any longer than is necessary. Simply do them until you are satisfied that you have a good familiarity with the proportions.

One of the lessons to be learnt from this project is that different horizon positions have equal validity. It depends on the circumstances of the picture, and also on personal taste. You should be able to find reasons for using a variety of horizon positions in different landscapes. Certainly, to develop just one preference and compose each picture according to that would be static and unimaginative.

Figure/Ground Relationships

We are conditioned to accepting the idea of a background. In other words, from our normal visual experience, we assume that in most scenes there is something that we look at (the subject), and there is a setting against which it stands or lies (the background). One stands forward, the other recedes. One is important, and the reason for taking a photograph, the other is just there because something has to occupy the rest of the frame.

In most picture situations this is essentially true. We select something as the purpose of the image, and it is more often than not a discrete object or group of objects. It may be a person, a still-life, a group of buildings, a part of something. What is behind the focus of interest is the background, and in many well-designed and satisfying images, it complements the subject. Typically, we already know what the subject is before the photography begins. The main point of interest has been decided on: a human figure, perhaps, or a horse or car. If it is possible to control the circumstances of the picture, the next decision may well be to choose the background: that is, to decide which of the locally available settings will show off the subject to its best advantage. This occurs so often, as you can see from a casual glance at most of the pictures in this book, that it scarcely even merits mention.

There are, however, circumstances when the photographer can choose which of two components in a view is to be the figure and which is to be the ground against which the figure is seen. This opportunity occurs when there is some ambiguity in the image, and it helps to have a minimum of realistic detail. In this, photography is at an initial disadvantage to illustration, because it is hard to remove the inherent realism in a photograph. In particular, the viewer knows that the image is of something real, and so the eye searches for clues.

Some of the purest examples of ambiguous figure/ground relationships are in Japanese and Chinese calligraphy, in which the white spaces in between the brush strokes are just as active and coherent as the black characters. When the ambiguity is greatest, an alternation of perception occurs. At one moment the dark tones advance, at another they recede. Two interlinked images fluctuate backwards and forwards.

The preconditions for this are fairly simple. There should be two tones in the image, and they should contrast as much as possible. The two areas should be as nearly equal as possible. Finally, there should be limited clues in the content of the picture as to what is in front of what.

The point of importance here is not how to make illusory photographs – this is, at best, an unusual special case – but how to use or remove ambiguity in the relationship between subject and background. The two examples here, both silhouettes, use the same technique as the calligraphy: the real background is lighter than the real subject, helping it to stand forward; the areas are nearly equal; the shapes are not completely obvious at first glance. The shapes are, however, recognizable, even if only after a moment's study. The figure/ground ambiguity is used, not as an attempt to create an abstract illusion, but to give a bit of optical tension to the images.

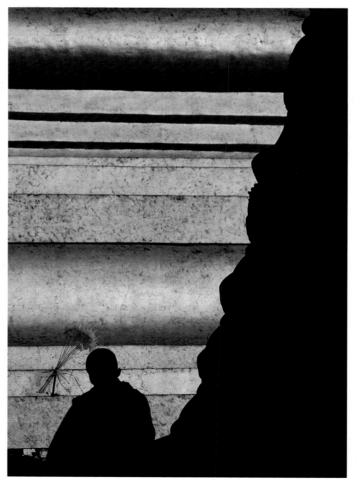

The subject is not immediately obvious – a monk praying at the side of a stupa, silhouetted against the golden wall of a large pagoda – which helps to confuse the eye a little. Both light and dark areas are equal in size, and the background is light. All help to provide a slight alternation, which makes the image more dynamic.

The same graphic conditions apply to this photograph of a stork on the branch of a tree. Cropping in on the left, as in the second version, simplifies the distribution of the areas of tone, and so improves the alternation.

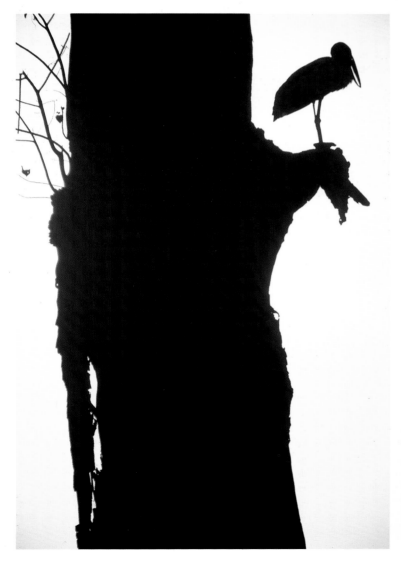

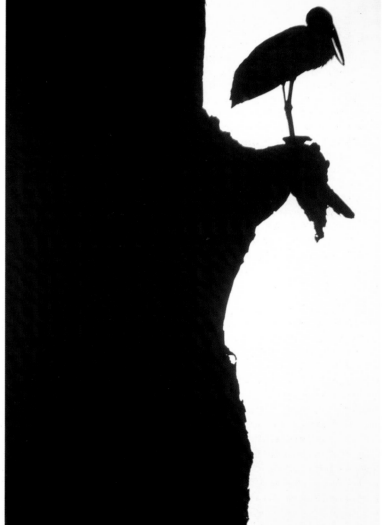

Frames Within Frames

One of the most predictably successful of all photographic design constructions is an internal frame. As with any established design formula, it contains real risks of over-use, and has the makings of a cliché, but these dangers are only evidence of the fact that it does work. It simply needs a little more care and imagination when it is being applied.

The appeal of frames within frames is partly to do with composition, but at a deeper level it relates to perception. A frame of the type shown here and on the next few pages enhances the dimensionality of a photograph by emphasizing that the viewer is looking through from one plane to another. As we will see at other points in this book, one of the recurrent issues in photography is what happens in converting a fully three-dimensional scene to a two-dimensional picture. It is more central to photography than to painting or illustration because of photography's essentially realistic roots. Frames within the picture have the effect of pulling the viewer through; they are a kind of window.

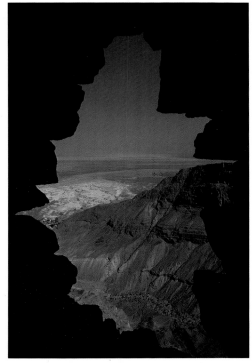

▼ The relationship between the frame of the photograph and an internal frame creates an initial step in which the viewer's attention is drawn inwards (the corners are particularly important in this). Thereafter, there is an implied momentum inwards.

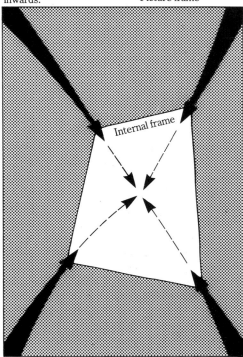

Picture frame

Internal frame

▼ The rhythm and shape of the gap between the two frames is only dynamic when narrow, as in the diagram *below*. A small internal frame (*below right*) simply appears to be embedded in the picture.

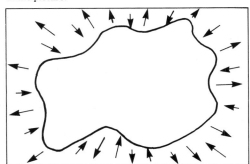

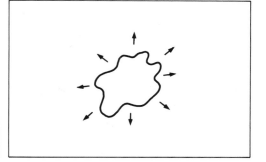

▲ As a landscape, the view over the hills surrounding the Dead Sea as seen from Masada in Jordan is interesting enough, but nothing special, particularly in flat midday lighting. Certainly, a composition like this without the frame of a broken wall would have been unsatisfying. The jagged frame, however, gives a natural cohesion to the view, and as a bonus creates an interesting tension of line and shape with the surrounding rectangle of the picture frame.

Another part of the appeal is that, by drawing a boundary around the principal image, an internal frame is evidence of organization. A measure of control has been imposed on the scene. Limits have been set, and the image held back from flowing over the edges of the pictures. Some feelings of stability and even rigidity enter into this, and this type of photograph lacks the casual, free-wheeling associations that you can see in, for example, classic journalistic or reportage photography.

As a result, frames within frames appeal to a certain aspect of our personalities. It is

a fundamental part of human nature to want to impose control on the environment, and this has an immediate corollary in placing a structure on images. It feels satisfying to see that the elements of a picture have been defined and placed under a kind of control.

On a purely graphic level, frames focus the attention of a viewer because they establish a diminishing direction from the outer picture frame. The internal frame draws the eye in by one step, particularly if it is similar in shape to the picture format. This momentum is then easily continued further into the picture.

Another important design opportunity to note is the shape relationship between the two frames. As has already been shown when looking at the dynamics of the basic frame, the angles and shapes that are set up between the boundary of the picture and lines inside the image can be an important part of the composition. This is especially so with a continuous edge inside the picture. The graphic relationship between the two frames is strongest when the gap between them is narrow. When the internal frame is small and deeply inset, its edges hardly react to the edges of the photograph.

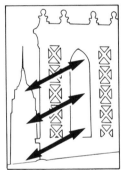
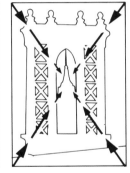

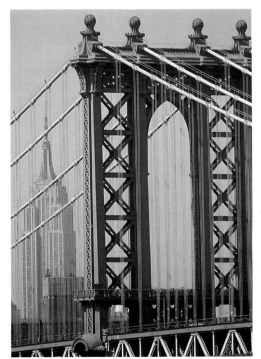

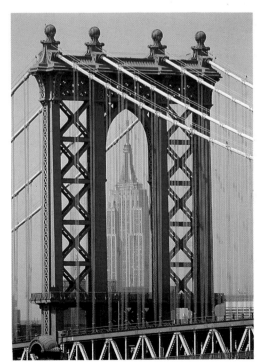

This pair of photographs, taken a short distance apart, of the Empire State Building and the Brooklyn Bridge in New York, shows how the frame-within-frame technique can alter the dynamics of the image. In the first photograph (*left*), the viewpoint was chosen so that the image of the building butts right up to the edge of the bridge's tower. The principal dynamic here is the correspondence of shapes, encouraging the eye to move between the two, as shown in the diagram *above left*. From a viewpoint slightly to the right, the building can be made to fit neatly into the bridge tower's central arch. Now the eye is directed inward towards the building, in three steps, as shown by the arrows in the second diagram (*above*). Once again, the internal frame structures the image more formally.

The simplest frame-within-frame treatment is this "window" shot, looking out from a dark interior. One of the strengths of this picture is that it is highly structured and precise. You can see how easily this is lost by cropping in at the sides, as in the sketch. The view is no longer contained, and the image runs off to the left and right. One effect of cropping like this is that the attention is less concentrated.

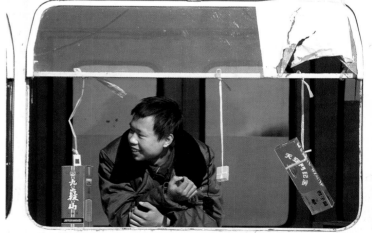

The opposite of the *above* example in both tone and direction, this photograph of a vendor's window in Beijing has less inward pull because the white surround is less forceful. However, its compactness and organization are strengthened by one immediate feature: the window frame fits the uncropped 35mm film frame with unusual precison.

1

2

Here, stepping back with a wide-angle shift lens into an archway neatly solves a minor design problem about how to handle the sky area above this clock tower at Hampton Court palace. Without the frame, the upper corners of the picture would simply be empty sky (see diagram **1**); by no means wrong, but certainly not lifting the photograph out of the ordinary. The frame is relevant to the scene (because the archway is part of the architecture) *and* neatly matches the outline of the tower. In addition, notice how the attention is pulled down into the picture and the perspective greatly enhanced. As diagram **2** shows, the shape of the black area between the picture frame and the arch pulls the eye down in a first step; then, the distant archway establishes the perspective and directs the attention further down.

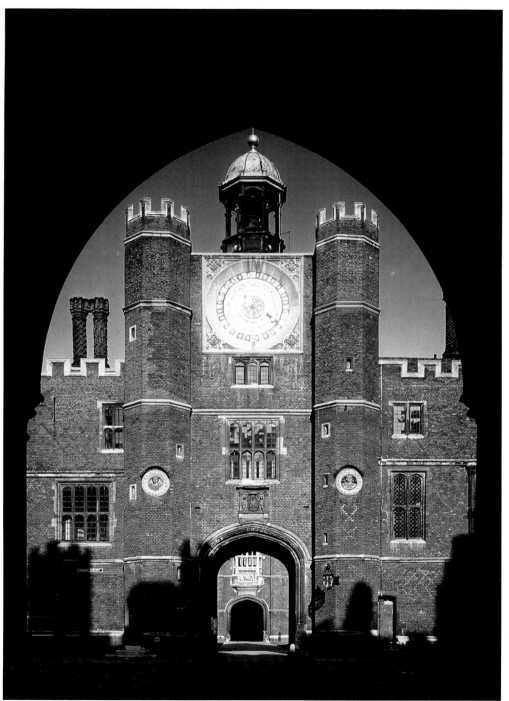

Framing the View

The frame is used quite differently in photography from any other graphic medium. It is used to select directly from potential images in the real world – and the choices are virtually infinite. In a very active picture situation, for example, a 35mm camera is typically used as a viewing instrument, a way of checking out potential pictures. Moving the camera around and changing position brings different parts of the scene into view, and acts as a kind of on-site editing process.

In a great deal of candid and reportage photography, there is almost no time to consider the framing of the shot, and any decisions must often be made as the camera is being raised. In this photograph of a street scene in Calcutta, it helped that the photographer was familiar with the 20mm lens being used, and could visualize how the frame would be filled before looking through the viewfinder. As it was, one person in the scene was already alerted to the presence of the camera by the time the shutter was released.

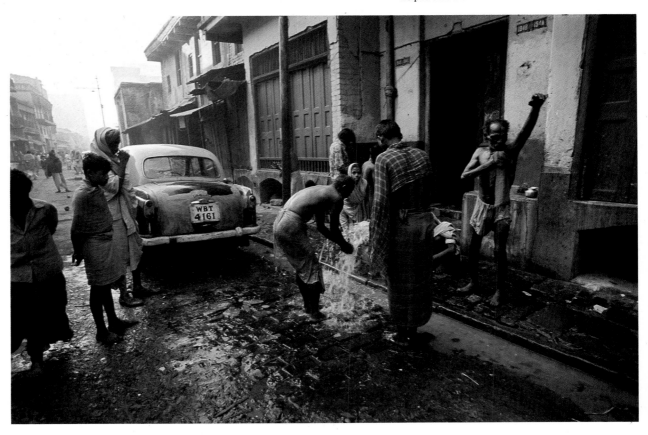

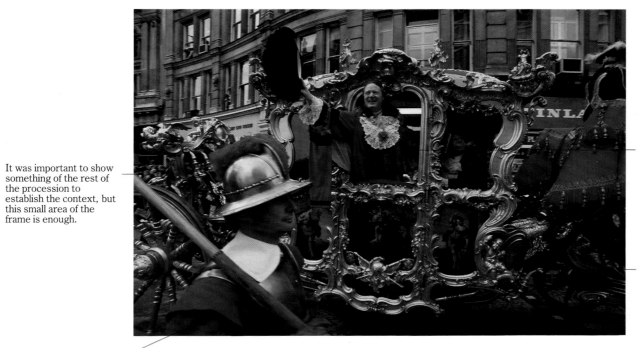

It was important to show something of the rest of the procession to establish the context, but this small area of the frame is enough.

The main subject of the shot is the newly-elected Lord Mayor. He is kept fairly close to the center of the frame.

The coach must be recognizable, so the photographer stays close enough to fill the frame from top to bottom. To have included the horses as well would have made the figure of the Lord Mayor too small.

The image of a foot soldier fills a corner of the frame that would otherwise have been empty. As these shots were taken while walking, precise composition was not possible.

The basic structure of this picture is a balance between the coach behind and the soldier in the foreground. Essentially, the soldier is included to help the design of the image and to enhance the sensation of depth, giving the viewer more of a feeling of being present.

Project: Analysis

An aid towards helping the way you edit the image in the viewfinder is to analyze your natural technique. I say natural technique because most of us compose with a large measure of intuition, not stopping to think about the reasons for our decisions. There is, of course, nothing the least bit wrong with this; if you had to consider on the spot the reasons behind every move you make with the camera, you would probably lose many of your best shots. Improving intuitive composition does demand some analysis, however, so that it is worth looking in detail at editing technique.

If you can be sufficiently objective with your own pictures, do a similar analysis to the ones shown here. You will also need a fairly good memory to be able to remember what lay outside the picture frame. If you are able to remove the prism head on the camera, you might try cutting out a black paper frame slightly smaller than the one visible in the viewfinder. Slip it under the prism, and shoot to this cropped-down format. What you will have when the processed film is returned is a set of images surrounded by a "border" that lay outside your chosen composition. Using the same paper frame that was under the prism head, check to see whether your compositions still seem as good.

Including the figure of a footman provides a counter-point to the robed aldermen waiting to begin the procession.

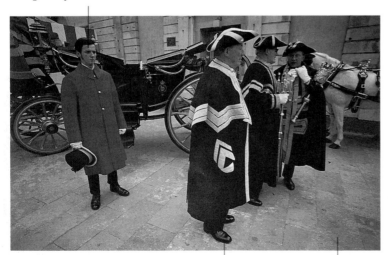

The viewpoint was chosen to give a triangular composition, the apex being the feet nearest the camera.

From this picture, the next possible shot was anticipated, facing the three aldermen from here.

The photographer stepped back slightly in order to include the roof of the building behind.

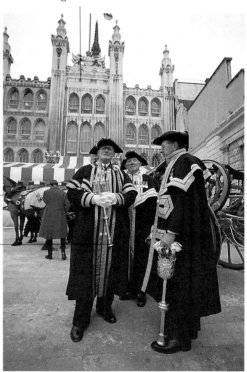

From this viewpoint, the group of figures makes a vertical shape. A vertical camera format is natural.

From this second picture, the photographer sees the ornamental maces as a potential image in themselves.

As used in the German magazine *Geo*, the final shot is graphically simple enough to make the title spread for a feature on the City of London.

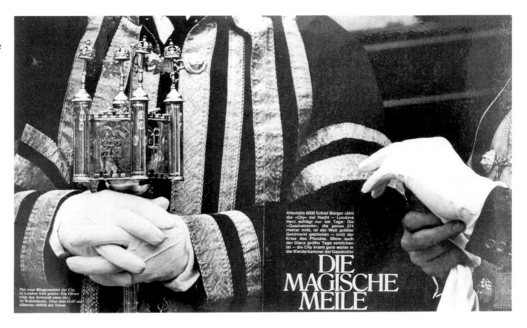

Affenfalls 6000 Schlaf-Bürger zählt die »City« bei Nacht — Londons Herz schlägt nur am Tage: Die »Quadratmeile«, die genau 274 Hektar mißt, ist der Welt größter Geldmarkt geblieben — trotz der Krise des Pfundes. Wenn auch der Glanz großer Tage verblichen ist — die City kramt gern weiter in der Kleiderkammer der Geschichte

DIE MAGISCHE MEILE

Der neue Bürgermeister der City of London wird gekürt: Ein Diener trägt den Amtsstab eines der 26 Wahlmänner. Über dem Griff ein silbernes Abbild des Tower

A slight change of viewpoint to the right, and the movement of another pair of gloved hands gives a better balance.

The black and gold robes make a homogenous background, and the photographer deliberately excludes any other tones and colours.

Changing lenses from wide-angle to standard, the photographer now crops in closely on the maces and the gloved hands. This shot is nearly right, but marred slightly by the lack of a balancing element at the left of the frame.

Project: Sequence

As you can appreciate from thinking about your own technique, a single shot is often the end product of several potential images; views that were tried out in the viewfinder but were not quite right. Normally, a photographer would pass these over, but for this stage of the book, make a conscious effort to shoot small sequences as you work out an image. The still-life sequence on these pages is a studio example of this, but you can apply it to any situation that contains the seeds of a worthwhile image. As with most of the other projects here, having a developing set of pictures is one of the most useful learning devices.

A slightly different kind of sequence, which involves making continuous editing decisions in the viewfinder, illustrates this. A single situation will offer a variety of images, from different viewpoints and at different scales. Often, such a sequence is a progressive closing-in from an overall view to a detailed one, as each image gives a clue to a further possible picture within it. In such a situation, make a point of shooting all the worthwhile stages and then study the progression when the film has been processed. In the quieter conditions of home, decide whether you took the best possible decisions about framing, or whether you could have improved on them.

Use the following checklist when assessing each picture:

● From exactly the same position, would it have worked better to have moved the camera right, lower or to one side?

● Would it have been better to pull back either by moving or by changing focal length?

● Would closing in have helped, either by moving or changing to a telephoto lens?

● Would a slightly different viewpoint (right, lower or to one side) have usefully altered the relationships between objects?

● Would a change of format have helped?

Step 1
In the initial arrangement, the basic elements of the still-life – books of pressed flowers and their cabinet – are laid on an old wooden floor.

This is an obvious problem – a large white space that dominates the image because of its brightness, yet is empty. As all the left-hand pages of the books are blank, this will have to be solved by re-arrangement. Something will have to cover up or shade this page.

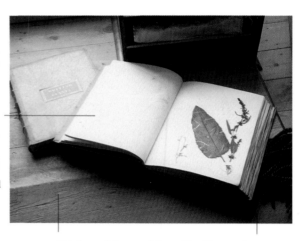

This lower left area of the picture is distractingly empty.

Too big a gap between the corner of the book and the bottom of the frame. Unnecessary.

Step 2
Two re-arrangements have now been made. The closed book has been laid over the blank page, and the open book has been laid at a stronger angle, and slightly closer to the camera.

While there is nothing wrong with the cabinet being aligned with the floorboards, the angle of both is a little too similar to the top edge of the frame. Possibly the camera should be moved.

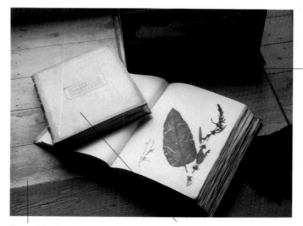

Repositioning the open book has reduced the empty space in the lower left corner, but not enough. Both of these corners are too well lit to be so featureless.

Unfortunately, the shiny cover of the closed book now appears almost as bright as did the blank page. This is a problem of reflection.

Step 3
To make the lines of the floorboards more diagonal, the camera has been moved to the left. The structure of the picture is more interesting, and the new camera angle has reduced the reflection from the book cover.

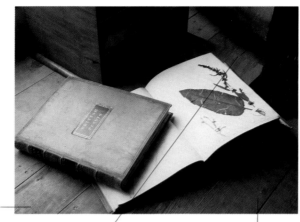

The tone is still too light.

The setting works well enough, but seems a little stiff and characterless. It might help to introduce some casually placed object to help loosen the composition.

Introducing part of another object would probably improve this corner.

Step 4
A black card has been positioned just out of frame close to the top left corner, reducing the reflections on the book cover to an acceptable level. Two new objects have been introduced to help fill up the previously bare composition.

This scrap of paper adds a casual touch. The picture could possibly do with a little more of this.

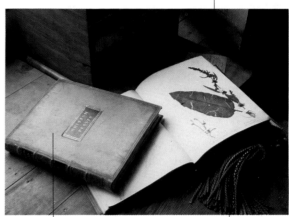

The reflection is acceptably darker, but a longer look at the image suggests that a heavy darkening of the entire left side of the picture might give a stronger atmosphere.

Tassle fills the corner and provides a "frame" for the book.

Step 5
Much stronger shading has been added at the left, giving a richer atmosphere and pushing attention more towards the pressed plant. A third, cloth-wrapped volume has been pulled partly out of the cabinet; this loosens the composition even more, and adds some interesting texture.

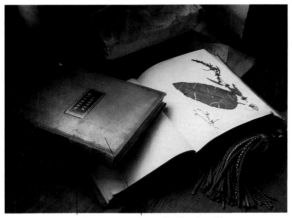

Raising the book tilts it away from the camera to make it seem less shiny.

The reflection is still a little too strong.

Step 6
The final small touches are an adjustment to the shading of the window to help the reflections on the book cover (this has been a technical problem from the beginning), and a slight alteration to the framing.

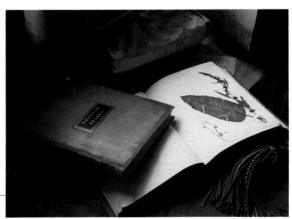

A slight raising of the camera tidies up the gap in the previous photograph.

Display

One advantage that professional photographers have over amateurs, and which often helps the ultimate success of a picture, is that they are accustomed to thinking about how a photograph is likely to be used. This goes with the job, as their photographs are always destined for some purpose. The effect of a picture depends very much on the way it is displayed, and you can and should take this into account when shooting. A professional's photographs are likely to end up published somewhere, but prints are subject to the same influences.

It is tempting to think that bigger is better. If you make a small, postcard-sized print from a photograph and then raise the enlarger to produce an 8 × 10 inch (203 × 254mm) print you will almost certainly be impressed by the latter. If you then go up to 16 × 20 inches (406 × 508mm), that will seem more powerful still. This is true for each individual image, but consider how it will be for a succession of images. When everything is the same size, the effects of enlargement are, to an extent, dissipated.

A more interesting approach is to display images at different scales, according to the particular needs of each, and according to how different photographs relate to each other when seen side by side. Notice how, in a book like this, or in most magazines, the layout and sizes of the pictures are varied, to keep up the visual interest.

If you have to choose between scales of reproduction, certain photographs need to be presented large, while others can survive being quite small. The two images on these pages demonstrate the difference. The format of this book imposes some limitations, being too small to show the equivalent of a large print, but the comparisons are relative. Even better than this, make your own project in displaying pictures by choosing two images that have similar qualities and printing them as large as possible, and also small.

First, the portrait of the young Chinese boy. There are no problems, of course,

with reproducing this picture large, but if we shrink it to just 1¼ inches (30mm) across it still reads well. The essential elements in the picture remain easy to see; both the information (principally the expression on the child's face) and the design (the blocks of tone and colour, and their arrangement) are decipherable. This picture survives a reduction in size for two reasons: the design is simple, and its content is familiar. The diagrams show the essentials; the photograph is composed of simple, flat blocks, unmodulated by shadows because of the frontal lighting, and the principal subject is a face. Now, faces are one visual subject with which everyone is extremely familiar,

and we can read an expression at a surprising distance. Hence, this photograph can do its work even when it appears very small.

The second photograph, on the opposite page, is quite different – a mass of pelicans in the African Rift Valley. Seen large, this is an impressive picture, but small it is meaningless. Reproduced very large it is an extremely powerful image. There are really two factors at work here; why the picture *needs* to be big and why it *deserves* to be big. The first is easy to see. The pelicans are packed so closely together, they are a jumble of form and colour. Only by being close can we distinguish one from another. We are not used to seeing this many

Design
The shapes are uncomplicated and made up of virtually solid blocks of tone and colour. The diagram **1** is a first-stage simplification. **2** reduces the graphic elements to their essentials: two circles and part of another to the left.

Information
Our natural interest in and familiarity with other people's faces makes them easy to read when small. They are even easy to make recognizable with a few lines in a diagram.

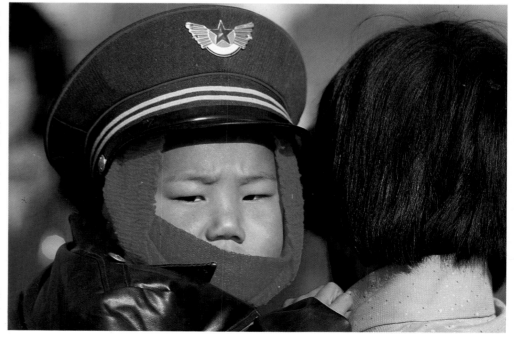

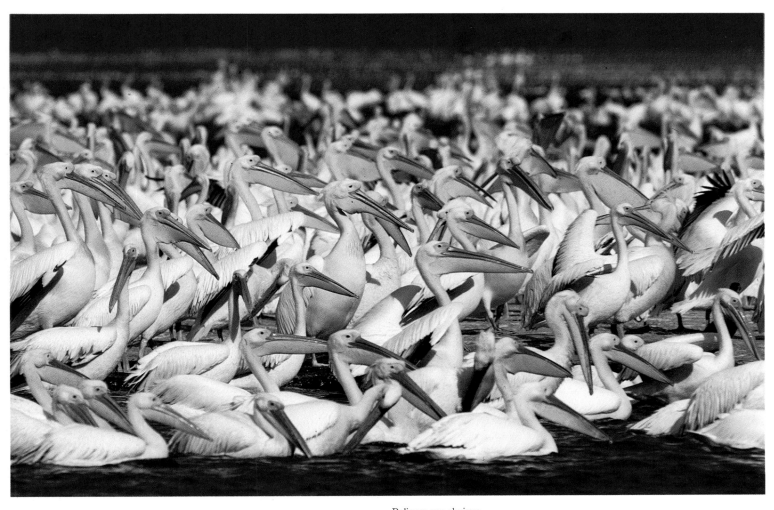

Pelicans are obvious enough as subjects, but their appearance is unusual for most viewers, especially when massed in such a concentration that there is an initial confusion in looking at it. When small, they become unrecognizable.

animals at once, and so need some help to appreciate the spectacle; in this case the help of a big picture.

It is also a waste to be mean with the proportions of this shot, because the essential appeal is the staggering number of birds. To make the most of it, we should project the viewer right into the scene to get the full impact of mass. The only way to do this is for the picture to be as big as possible, and for the viewer to stand close to it, so that the image fills the frame of view.

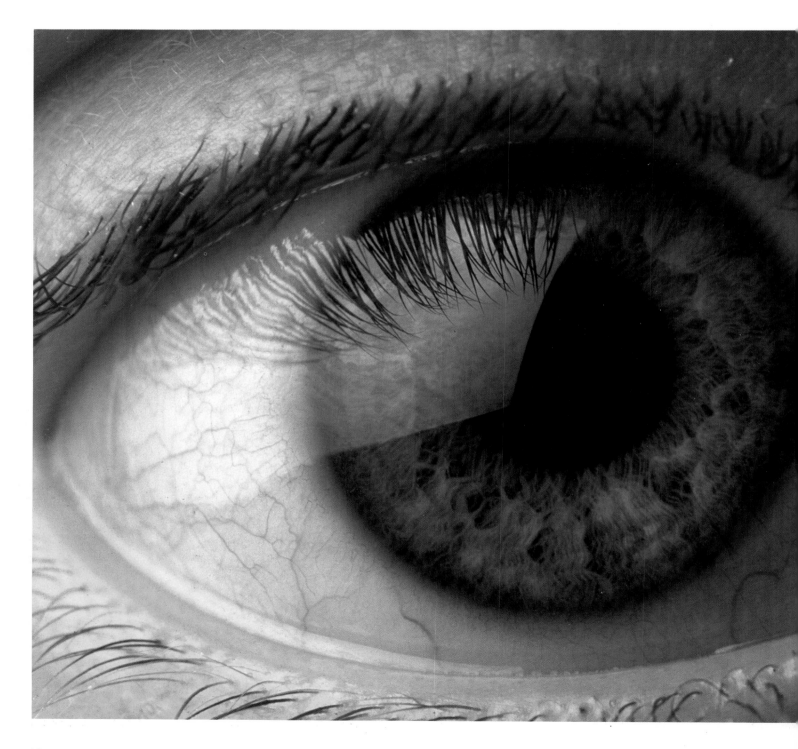

Both the boy and the pelicans are fairly straightforward examples. The solutions are logical and most designers would come up with them. However, there are sometimes opportunities for treating certain photographs in an unexpected way. Not a great deal can be done by reducing size – we then run into the problem of illegibility – but startling effects are possible by enlarging a picture well beyond what is reasonable. Again, the page size here limits the effect we can show, but the picture of the eye gives some idea. Not only is it much larger, even here, than it needs to be; it is actually uncomfortable to look at. This is not just because the eye is magnified and we can see details of the iris that most of us are probably unfamiliar with. It is because we are looking at somebody from intimately close. Many pictures that contain intimacy, or aggression, have a startling appearance when over-enlarged. This can be a useful technique for gaining impact.

Size and focal length

A separate consideration is the effect that the scale of reproduction has on the pers-pective effects of different focal lengths. We are accustomed to compressed views from telephotos and stretched views from wide-angle lenses, but these effects are mainly due to the fact that the photographs are taken at one angle of view and seen at another. Imagine that you stand in front of a series of prints at a distance that gives you about a 40° view of each (40° is approximately what you would get by holding something about 18 inches – 450mm – long at arm's length in front of you). As that is roughly the view you get with a standard lens, any photograph taken with one will look perfectly normal at that distance.

A view taken with a 400mm telephoto, however, has an angle of only 5° across the longer side; your view of the print is too close for a normal perspective effect. Equally, a 20mm photograph taken at an angle of 84° no longer wraps around your vision. If you stand right back from the telephoto photograph or much closer to the wide-angle view, they will lose their distortion. Practically, of course, the alteration of the perspective effect is exactly what many people enjoy in using different focal lengths.

◄The graphic value of magnification is that it gives us unaccustomed views. By the same token, it can take us too close for comfort, as in this confrontation with an eye.

The apparent distortion which is the hallmark of wide-angle views is largely due to the fact that we see the photographs relatively small. Were this image large enough and close enough to you that it filled your field of view, it would not seem distorted at the edges. If you stand back from the page, this edge distortion becomes more pronounced.

Format

We have seen on pages 14–21 how the frame of a photograph can interact with the image. The shape of the picture clearly has a strong influence too, and for the next few pages we will look at the different dynamics of the main camera formats.

In theory, there are no restrictions to the picture format; it can always be cropped. In practice, however, two things work against this. One is that most photographers stick to taking pictures and leave the production of the final prints to someone else, usually a photo-finishing laboratory. And if, like most professional photographers, you shoot colour reversal film, the end product is exactly the format that you saw through the viewfinder: a transparency. The second reason why shooting unusual formats is not so easy is that, unless you place a specially cut frame mask in the viewfinder, the pressure to compose intuitively right up to the edges of the viewfinder frame is strong. This is why many photographers do not care much for square-format rollfilm cameras. The manufacturer's argument has always been that a square format allows the photographer to compose freely vertically or horizontally. However, it takes long experience to ignore the parts of the image

that are not being used, and some people never get used to this.

Most photography, then, is composed to a few rigidly-defined formats, unlike other graphic arts. By far the most common format is the horizontal 2:3 frame – that of the standard 35mm camera. The reason for these proportions is a matter of historical accident; there are no compelling aesthetic reasons why it should be so and more natural proportions would probably be less elongated. Most printing papers are, after all, in 4:5 proportions, and most rollfilm formats 6:7. Nevertheless, the popularity of the standard 35mm format simply demonstrates how easily our sense of intuitive composition adapts. This format has now become the norm in photography.

Horizontal format
There are two reasons why this format is mainly used horizontally. The first is pure ergonomics. It is difficult to design a camera that is to be used at eye-level so that it is just as easy to photograph vertically as horizontally. Indeed, few manufacturers have even bothered. Normal 35mm SLRs and rangefinder cameras are made to be used for horizontal pictures. Turning them

on their side is just not as comfortable, and most photographers tend to avoid it.

The second reason is more fundamental. Our binocular vision means that we see horizontally. There is no frame as such, as human vision involves paying attention to local detail and scanning a scene rapidly, rather than taking in a sharp overall view all at once. Our natural view of the world is in the form of a vaguely-edged, horizontal oval, and a normal horizontal film frame is a reasonable approximation.

The net result is that a horizontal frame is natural and unremarkable. It influences the composition of an image, but not in an insistent, outstanding way. It conforms to the horizon, and so to most overall landscapes and general views. The horizontal component to the frame encourages a horizontal arrangement of elements, naturally enough. It is marginally more natural to place an image lower in the frame than higher – this tends to enhance the sensation of stability – but in any particular photograph there are likely to be many other influences. Placing a subject or horizon high in the frame produces a slight downward-looking, head-lowered sensation, which can have mildly negative associations.

Human vision
Our natural view of the world is binocular and horizontal, so a horizontal picture format seems entirely normal. The edges of vision appear vague because our eyes focus sharply at only a small angle, and the surrounding image is progressively blurred.

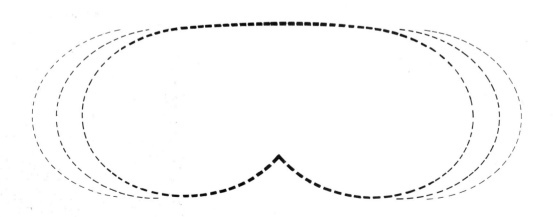

▼Standard photograph frames
Approximately in proportion to their popularity of use, these are the most common formats in photography. The ascendancy of the 35mm SLR has made 2:3 the standard.

3:4
4.5 × 6cm rollfilm cameras

6:7
Most common rollfilm proportions

4:5, 8:10
Normal printing paper and sheet film proportions

2:3
Standard 35mm frame

▶The correspondence of the horizon line and the format makes a horizontal frame natural for most long scenic views.

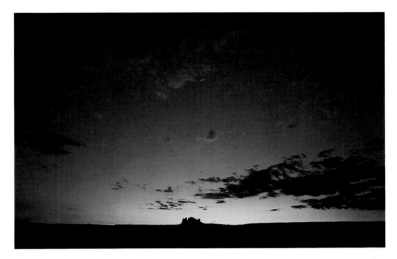

▼Vertical subjects
Although this format is not very well suited to a vertical subject like standing figures and tall buildings, inertia often encourages photo-graphers to make it work as well as possible. One technique is to off-center the subject like this, so as to persuade the eye to move horizontally, across the frame.

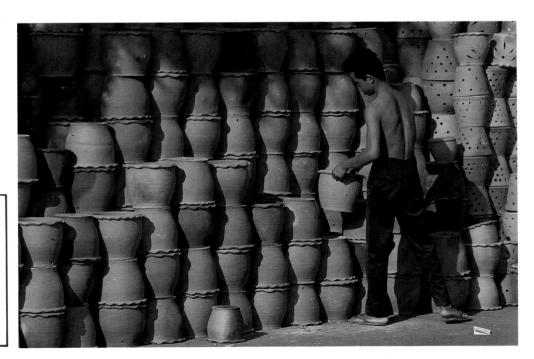

Vertical

As explained, there is a slight natural resistance to photographing vertically, and if you make a rough count of how many of your shots are indeed vertical, you may be surprised at how few there are; certainly if you use a 35mm camera. Professional photographers usually make an effort to shoot vertically as well as horizontally because of the demands of their clients; most printed pages are vertical.

For naturally vertical subjects, this is the normal choice of format, and the human figure, standing, is the most commonly found vertical subject. The elongation of the normal 35mm frame is ideal; a fortunate coincidence, as in most other respects the 2:3 proportions are rarely completely satisfactory. You can demonstrate this for yourself with a simple exercise.

Take any isolated subject (one that is fairly compact in shape) against a relatively featureless background. Shoot it to a vertical format without pausing to think about the composition. Most people place such a subject *below* the center of the frame, and the more elongated the format cover, the lower, proportionately, the object goes. Better still, shoot the same subject from the same viewpoint both horizontally and vertically. Again, shoot quickly and intuitively. The usual tendency with a dominant single subject is to push the focus of attention sideways in the horizontal picture and downwards in the vertical image. This shows an inclination to avoid the upper part of a vertical frame. The naturalness of horizontal vision reinforces the eye's desire to scan from side to side, and a corresponding reluctance to scan up and down.

As with horizontal frames, there is a normal assumption that the bottom of the picture is a base; a level surface on which other things can rest. This is why it seems more natural than not to use the lower part of the frame. The 2:3 proportions of a 35mm frame are a little extreme, however, and this often leaves the upper part of the picture under-used.

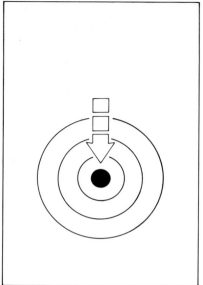

2:3

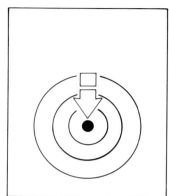

4:5

The eye is naturally reluctant to scan up and down, and the bottom edge of a picture frame represents a base, thus gravity affects vertical composition. Subjects tend to be placed below the center, the more so with tall formats.

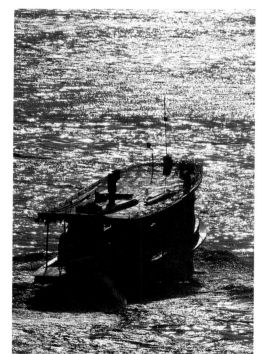

In a 35 mm vertical shot of a river boat, the natural placement is below center, as the diagrams *above* explain.

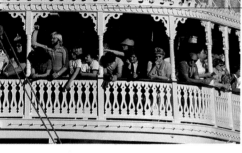

◄The mass of people on a paddle steamer in Disneyland is the main focus of attention. As the principal subject, the people are placed below center.

Visual center of gravity

The standing human figure is one of several classes of subject which suits a vertical format. Others include tall buildings, trees, many plants, bottles and drinking glasses, doorways and archways.

▲In these photographs of a man sleeping on the Khyber railway, the natural balance occurs when his head is placed slightly low in the vertical shot, and to one side in the horizontal.

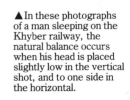

Square

While all other photographic frames are rectangular, with varying proportions, one is fixed: the square. A few major current cameras have this unusual format, including the Hasselblad and Bronica, but a number of old twin lens reflex models and the Polaroid SX–70 and SLR 680 instant film cameras also feature it. It is unusual in that very few images lend themselves well to square composition. In general, it is the most difficult format to work with, and most design strategies for a square frame are concerned with escaping the tyranny of its perfect equilibrium.

We ought to look a little more closely at why most subjects are ill-suited to a square arrangement. In part, this has to do with the axis of the subject. Few shapes are so compact that they have no alignment. Most things are longer in one direction than in another, and it is natural to align the main axis of an image with the longer sides of a rectangular picture frame. Hence, most broad landscape views are generally handled as horizontal pictures, and most standing figures as verticals.

The square, however, has absolutely no bias. Its sides are in perfect 1:1 proportions, and its influence is a very precise and stable division of space. Here lies the second reason for the unsympathetic nature of square proportions; they impose a formal rigidity on the image. It is hard to escape the feeling of geometry when working with a square frame, and the symmetry of the sides and corners keeps reminding the eye of the center.

Occasionally a precise symmetrical image is interesting; it makes a change from the normally imprecise design of most photographs. However, a few such images quickly become a surfeit. It is fairly normal for photographers who work consistently with a square format camera to imagine a vertical or horizontal direction to the picture, and to crop the resulting image later. Practically, this means composing fairly loosely in the viewfinder, to allow a certain amount of free space either at the sides or at the top and bottom. In either case, it is not particularly satisfactory, and only the relatively large film size in a medium format camera like the Hasselblad makes it practical.

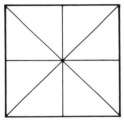

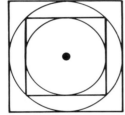

◀The equal dimensions of a square frame make it susceptible to symmetrical division, as these examples show. Vertical and horizontal lines enhance the square's stability; diagonals are more dynamic.

With its strongly implied center and equal sides, a square format takes very easily to a radial composition.

There is a precise relationship between the square and circle. Fitting one concentrically in the other emphasizes the sensation of focus and concentration on the center.

A natural subdivision is by vertical and horizontal lines, although the effect is extremely static.

A more dynamic, but still centered, subdivision is by means of diagonals and diamonds.

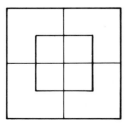

▼Patterns and other formless arrangements fit well into a square format because the frame has no directional emphasis. Under these circumstances, it does not intrude on the image.

►Balancing two unequal areas in the picture reduces the significance of the frame. The effect is less static than when the frame's proportions are allowed to control the composition.

▼Radial and other completely symmetrical subjects are particularly well-suited to the perfect equilibrium of the squares. Their precision is complementary, but exact alignment is essential.

▼The majority of subjects are not particularly well-suited to a square format. Even so, with a subject that has a definite axis in one direction – vertical in this case – it is possible to assist the design by composing slightly off-center.

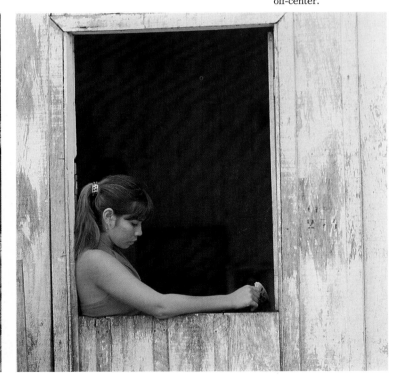

Panoramic

Unusual though it may seem at first glance, a panoramic frame has a special place in photography. Although its proportions sound extreme, it is for many images a more accommodating format than, for instance, a square.

Through usage and familiarity, the 2:3 proportions of a 35mm frame are the reference standard for the rectangular format. These can be squeezed to about 6:7, or stretched to approximately 1:2, and will still appear to be in the same class of format. If elongated so that the horizontal is more than twice the vertical, however, the frame starts to behave differently, and no longer has the dynamics of an ordinary rectangle.

To understand why, we have to look again at the way human vision works. We see by scanning, not by taking in a scene in a single, frozen instant. The eye's focus of attention roams around the view, usually very quickly, and builds up the information in the visual cortex. All of the normal photographic formats – and most painting formats, for that matter – are areas that can be absorbed in one rapid scanning sequence. The normal process of looking at the picture is to take in as much as possible in one prolonged glance, and then to return to details that seem interesting.

We can do this with a 2:3 frame, but 1:3 and 1:4 proportions allow the eye to consider only a part of the image at a time. Now, this is by no means a disadvantage, because it replicates the way we look at any real scene. Apart from adding an element of realism to the picture, this slows down the viewing process and, in theory at least, prolongs the interest of exploring the image. All of this depends, however, on the photograph being reproduced fairly large and viewed from sufficiently close; something we cannot, unfortunately, do here.

This virtue of the panorama – to draw the viewer in and present some of the image only to the peripheral vision – is regularly exploited in the cinema, where an elongated screen is normal. Special projection systems, such as Cinerama and IMAX, are premised on the height and realism of wrapping the image around the viewer. Still panoramic images have a similar effect.

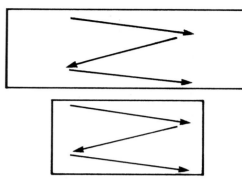

Providing that the image is sufficiently large in front of us, the way we look at a panoramic image is quite similar to the way we view a real-life scene. Although the eye can easily scan a normal rectangular frame from edge to edge, the elongation of a panoramic frame is such that we would normally scan only a section of it at a time. Parts of such an image remain peripheral: a realistic condition that is typical of normal vision.

In this traditional, classic use of a panoramic frame, the sky and much of the foreground are removed from the image, leaving the eye free to follow the rhythm of the horizon line. Treated like this, a large number of natural landscapes fit very comfortably into stretched proportions.

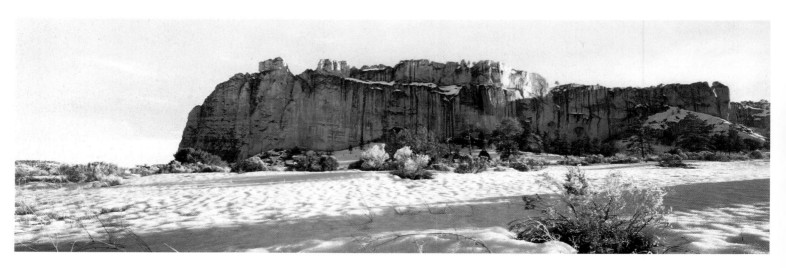

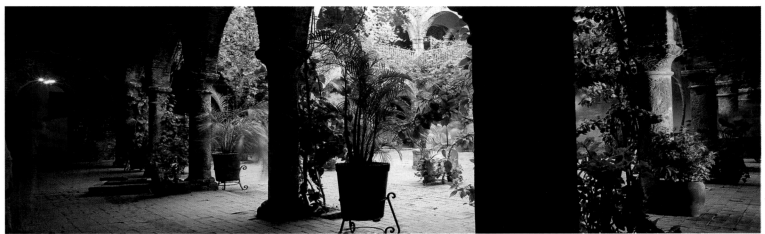

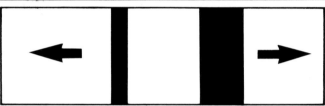

A panoramic frame is an essentially acceptable format in its own right, and can therefore be used for interesting treatments of subjects that are themselves not stretched. In this view of the courtyard and cloisters of a monastery, the vertical interruptions of the columns subdivide the image into three, like triptych panels.

Breaking the normal rules, a panoramic frame is used here to exaggerate an abstract treatment of the back of an adobe church in New Mexico. A normal approach would have been to show the top of this building and the lower buttressing down to the ground. The subject here, however, is not a literal version of the church, but the geometry and textures of the unusual planes. Squeezing the image at the top and bottom removes some of the realism, and compels the eye to consider the structure out of context.

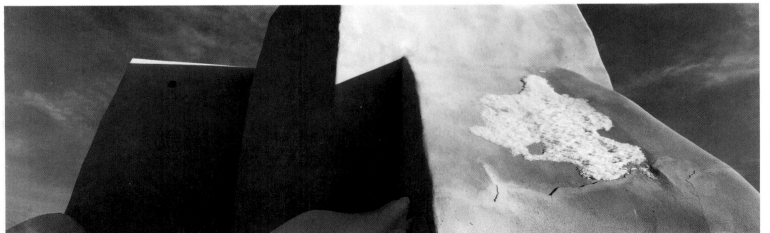

Cropping

One of the principal techniques adopted in this book is to re-examine photographs and subject them to a design analysis. Cropping, which is a process of reworking the image well after it has been shot, fits neatly into this method. Think of it as an option that is open to you at a later stage, a way of deferring design decisions, and even of exploring new ways of organizing an image. Practically, cropping is tied to the enlargement of a print. Small format transparencies do not lend themselves so easily to adjustments of the frame, because of their size.

First, the equipment. Assuming you will produce a print, whether from a black-and-white negative, colour negative or a colour transparency, the final crop will be on the baseboard of the enlarger. You can certainly use the enlarging easel as a cropping guide, but it is usually easier and more relaxing to experiment earlier, with the original film, on a contact print or a rough print. For this, some kind of opaque adjustable mask is needed. There are one or two proprietary designs available, but there are no difficulties in making your own from black paper, card or from more durable plastic sheeting.

Why black? Most images have at least some tone at the borders, so a dark frame provides a stronger contrast. For transparencies viewed on a light box, the surrounding light can be very distracting, and also give a false impression that the image is darker than it really is, hiding shadow detail. When viewing transparencies, cover up as much as possible of the rest of the light box. If you take a significant number of black-background photographs, however, you will find white masks more valuable for prints. One idea is to cut the L-frames or window masks from card that is black on one side and white on the reverse.

It is important not to think of cropping as a design panacea or as an excuse for not being decisive at the time of shooting. The danger just of having the opportunity to alter and manipulate a negative after the exposure is that it can lull you into imagining that you can perform a significant portion of photography in the darkroom. Cropping introduces an interruption in the process of making a photograph, and most images benefit from continuity of vision.

Projects
In the first instance, see what you can make of the two photographs shown on these four pages. It is best to undertake your own versions of cropping before looking at how they have been handled here. In the case of the misty Scottish landscape, simply see how many workable, distinct images you can make, without any limitations on format. Do not, however, crop in to less than half the area of the frame; even though the original was shot on 4×5 inch film and the resolution is good, over-enlargement lowers the picture quality and defeats the object of the exercise.

In the second landscape, of a deserted Thai temple in the middle of a rice field, the object is to limit yourself to one size and format of frame, as shown. In fact, what we have done here is to make 35mm frame size crops on a 4×5 inch transparency (see page 61).

Having undertaken your own cropping of these two pictures, select prints of your own and do similar exercises. In order to give yourself the maximum opportunity for selecting different images out of one basic scene, you may find that a wide-angle landscape view is the easiest type of picture, as in these examples. It is close to being the equivalent of actually confronting the scene in real life, and choosing a shot with a longer focal length.

Let us look at the kind of decisions involved in both of these methods of cropping. In the Scottish landscape, the original framing has clearly been chosen to make something of the rippled clouds at the top of the frame, and the horizon has been placed correspondingly low. This in itself reduces our options a little.

Cropping masks
Three types of mask have specific advantages for different forms of photograph. The black L-frames are the most traditional, and can be cut easily from black paper or card. The pair of window frames give a more isolated cropped image – the ones shown here are cut to a maximum 4×5 inches, and are designed for cropping sheet-film transparencies on a light-box. The large black borders to the windows are deliberate, to cover the immediate surroundings of bright illumination.

Proprietary adjustable mask for transparencies from 35mm up to 6×7cm

L-frames for prints up to 10×12 inches

Window frames for 4×5 inch and medium-format transparencies

► Window frames for transparencies
Although a 35mm image is already small and leaves little space for major cropping and enlargement, there is often room for altering the proportions – that is, cropping either vertically for a more panoramic view, or horizontally for a more square picture.

▲ L-frames for prints
Even when a print does not need to be cropped, placing a black border around it when viewing helps to concentrate attention. In the case of a basically light-toned image, it also emphasizes the edges of the picture as a compositional check.

► Free cropping
Use this full-frame print as a basic image within which to construct as many different framings that, to your eye, work effectively. Any proportions are permissible.

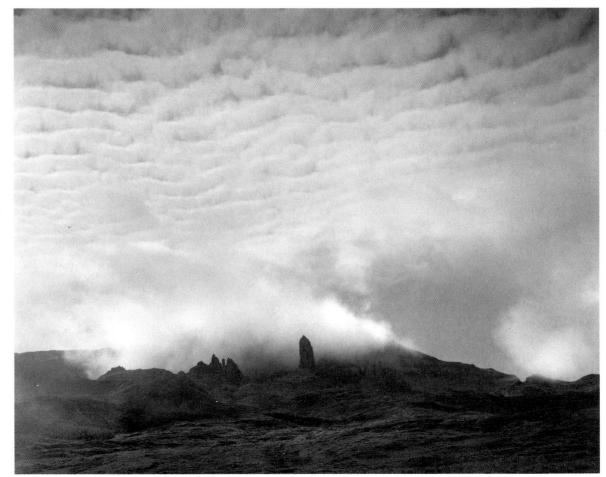

Three alternative ways of cropping the picture on page 59: panoramic, horizontal and vertical.

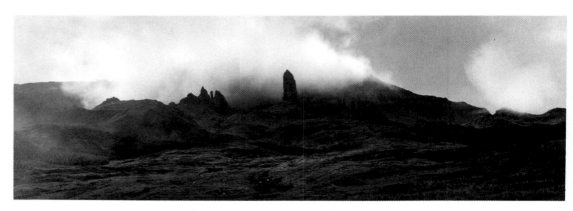

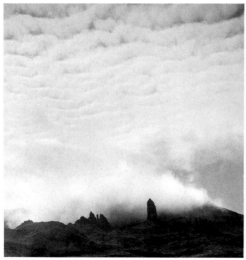

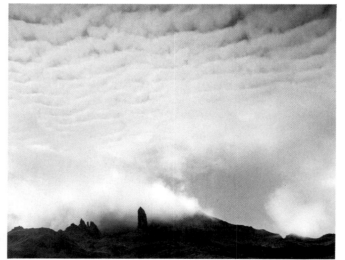

Perhaps the first, obvious crop is to ignore the high clouds and concentrate instead on the mist-shrouded qualities of the rocky pillars. Now, once we have dispensed with the clouds, there are no limits to how far down we can crop the top of the frame. In this instance, I have chosen to reverse the proportions of land to sky, and to take the opportunity of making a panorama. This is a viable alternative to the original picture, although it really needs to be considerably enlarged for the best possible effect.

Next, what if we try to crop in and still retain moderate horizontal proportions? Unfortunately, it seems that if there is to be any significant area of sky it should go right to the existing top of the frame, simply in order to have some tone and weight in that part of the picture. Cropping in at the sides does very little to enhance the importance of the pillars. The only reasonable option will be to crop the bottom, and go for a horizon line that almost coincides with the base of the picture.

Is a vertical crop possible? Given that an upright image has even more need of the tonal weight of the clouds, the best that we can do is to crop in at the sides. The choices are to do with selecting the most interesting shapes on the horizon.

The Thai landscape requires a slightly different approach. We have used a transparency here, but on a print the best technique is to make a fixed window and slide it around the picture. The temple itself must remain the dominant element in the image – there is nothing else – and the choices are in the placement of the horizon line and in whether or not to include the clump of bamboo on the left. You may find it useful to refer to pages 32–3 where the horizon is discussed in more detail. In this instance, placing the horizon low gives a more spacious, open feeling and emphasizes what is happening in the sky (sunrise and some threatening clouds). Raising the horizon line draws attention to the rice in the field.

The crops on this 4 × 5 inch transparency have all been made to one size and format of frame: 35mm.

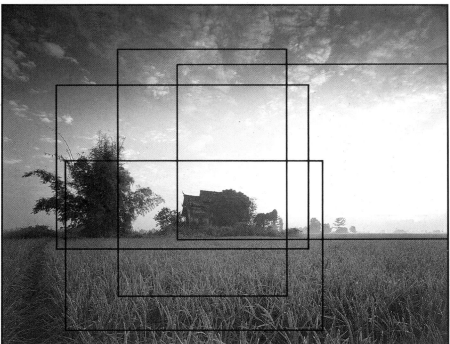

Black-and-white: The Special Medium

For most of the history of photography, black-and-white was the only medium, and even until 1965 more black-and-white film was sold than colour. Now, of course, virtually all photography is in colour.

A peculiar reversal has taken place in attitudes towards black-and-white film and prints. Whereas once it was normal and colour was considered special (even until a few years ago, major series of books on photography would include one title devoted specifically to colour, as if it were a bonus to a photograph), black-and-white is now widely thought of as the medium for photographic art. It has connotations of pure design, craftsmanship, and of news.

The existence of black-and-white photography is due to nothing more than an accident of chemistry; to the time it took to develop a system for producing colour images. Had colour reproduction been possible from the middle of the nineteenth century without difficulty, it is hard to imagine that any significant number of photographers would have willingly restricted their palette to a colourless medium.

The accident is a happy one, however, since we now have a distinct photographic medium that has an established legacy and offers some unique design opportunities. Black-and-white film and paper offer two outstanding advantages to people who have a special interest in the aesthetics and the craft of photography. By restricting the means of recording images to a range of white, greys and black, they elevate modulation of tone to a position of great importance. This in turn allows considerable refinement, and the non-colour elements of a picture, such as shape and line, acquire more meaning. As we will see when we look at colour relationships, the more limited the range of expression, the more important become the subtleties.

The second major advantage is that black-and-white materials offer the photographer more control over the image. With colour reversal film, most control ends at the moment the shutter is released (ex-tending or reducing the development is used more often as a corrective procedure than as a normal choice). Colour printing offers only a few choices and these do not include contrast grades. Black-and-white photographers, on the other hand, are accustomed to a variety of standard controls which allow them to make massive alterations to the image, if necessary, and to create their own style of printing. These include the following:

● Choice of film, giving different grain textures, according to the speed, brand and chemistry (silver halide or chromogenic).
● Choice of developer, to alter grain structure, contrast, sharpness and speed.
● Intensification or reduction of the negative, to affect not only the density of the image, but its contrast range.
● Choice of enlarger illumination, to affect contrast and the appearance of the grain.
● Wide choice of paper, in different grades of contrast, colour and surface texture.
● Easy shading and burning-in techniques.
● Choice of paper chemicals.
● Toners, to add subtle colours and alter the contrast.

A refined image
Removing the quality of colour from an image enhances the other qualities. With the modulation entirely in tone, the eye pays more attention to texture, line and shape. The textural qualities of this detail from a wrought-iron gate are clearly important to this print, and have been enhanced by using a hard paper grade to keep the background a rich, dark black.

On top of all this, retouching techniques are relatively simple, as they affect only the tone. Now, some of these choices are available in colour photography, but to a much lesser degree. Personal technique is such an accepted part of black-and-white photography, particularly in the printing, that styles are often easily recognizable. More than any other, the black-and-white print is the craftsman's medium.

Clearly, in order to realize these finely drawn image qualities, the end product must be a photographic print. Reproduction in a book or magazine loses most of the tonal and textural qualities. It is of little surprise, therefore, that while colour photography is very much the standard overall, fine art photography is still dominated by the black-and-white print.

There are considerable difficulties in reproducing on these pages the subtleties that are possible, and you should take the examples that follow only as a crude guide. Much the best way of appreciating what this medium is capable of is to visit galleries and examine original prints. As an illustration, even the best half-tone version of a good Ansel Adams print, such as Moonrise, Hernandez, New Mexico or Clearing Winter Storm, Yosemite National Park, reproduced in a book cannot prepare you for the beauty of the same image on a photographic print.

Indeed, it was Ansel Adams who likened the negative to a musical score and the print to its performance. This is not a bad analogy, because so much of the visual effect of a print is determined during the enlargement. In complete contrast to colour transparency photography, two different sets of skills at two different stages are needed. Although it is possible to think of the printing stage of black-and-white photography as a means of solving problems and correcting deficiencies, this rather misses the point. With experience, you can learn to take a photograph with the knowledge of how your printing skills can later adapt and improve it.

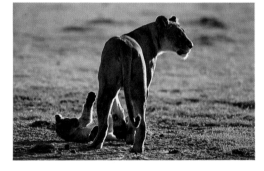

Compare these two photographs, both taken of the same subject at about the same time. The colour image, shot on transparency film, is a completely natural, realistic version. Most viewers would not stop to examine the graphic treatment, but would concentrate immediately on the subject – the actions and attitude of the lioness and cub. The black-and-white version is a little different. Lacking colour, the image is slightly more abstract, and the shape and line of the lioness become more important to the overall effect of the image.

Project: Printing controls

The printer's ability to alter the exposure selectively makes a tremendous difference to the range of brightness that can be handled in black-and-white photography. It also makes it possible to interpret an image in a number of different ways, at a stage much later than the original photography, and it can be instructive to see how, in fine art photography, individual photographers change their own printing treatment of certain negatives. As just one example, see how the later prints of Bill Brandt became much more contrasty than his earlier ones, tending towards extremes of black and white that emphasize shape. In this way, black-and-white photography is susceptible to personal taste.

To demonstrate the normal opportunities, you should work with a negative that has a contrast range about as high as the one shown here. A negative will carry less detail in the highlights and shadow areas than you can see at the time, but more than a straightforward, unmanipulated print will show. Part of the problem is that

the printing process tends to increase the contrast, part is that the brightness range of which a print is capable is limited. The limitations at the higher end of the scale are set by the base whiteness of the paper, and at the dark end of the scale by the surface finish (glossy gives better blacks than matt). Choice of paper grade is only partly the answer. Although a softer grade can reproduce a larger scale of tones, and so is traditionally the choice for a contrasty negative, it also tends to produce a flatter image, and is less lively overall. Separation in the dark areas often suffers.

Printing controls allow selected areas of the image to receive more or less light. Light is held back from certain parts of the picture to keep them lighter; this is known as shading, or dodging. Other areas can be given more exposure to darken them; this is called printing-in, or burning in. In the case of the picture shown on pages 66–7, the thinner shadow areas are shaded, and the dense highlights printed in. The result is to print a fuller range of tones, even with a normal or hard paper grade.

A primary skill is to be able to judge what printing controls are needed from looking at the negative. As an aid, with the negative you have chosen to work with, make two straightforward prints: one that reproduces the highlights well, and one that gives the best results for the shadow areas. While neither of these prints will be satisfactory in itself, the two together will show you the range of exposures that will be needed.

The usual technique, having planned what exposures to give each area, is to give a basic overall exposure, holding back any areas that need shading. Then, individual areas that need extra exposure are printed in. As this is in effect a multiple exposure, it is important not to touch the enlarger during the process. Hence, choose one aperture and vary only the length of the exposure. Some printers use tools: shapes attached to thin wires or rods, and black cards cut with holes of different shapes and sizes. Others prefer to use only their hands, moulding them under the enlarger lens to give a particular shape of light or shadow on the print.

Paper grade 2

Printing on a normal grade of paper with full exposure and slightly reduced development gives an image in which the background appears relatively dark. The immediate impression is of clouds and a gathering storm.

Paper grade 4

The exposure on this more contrasty grade of paper was adjusted to keep the elephants almost black, as before. A hard paper grade, slight under-exposure and extended development combine to give maximum contrast. Almost all details of the setting are lost, and the tree with elephants becomes isolated from the landscape.

Project: Varying grade and exposure
Certain negatives are susceptible to very different treatments, even by making such simple changes as the paper grade and the exposure during enlargement. In the background of the East African scene, the effect is a rather gloomy one of rain. A harder print that loses the setting gives a brighter, more graphic image. Over-exposure lends an abstract, ethereal quality. Experiment with this variety of treatments for yourself, by choosing an image with some degree of backlighting – between subject and setting. Try all different paper grades at a variety of exposures, as here.

Paper grade 4: High key

As with the other hard paper print, reducing the surroundings to white gives the opportunity to adjust the proportions of the subject to the frame. As shown *right*, the tree and elephants could be reduced in size considerably without becoming indecipherable.

The paler tones of the leaves of the Acacia tree are now an unusual white. This gives an overall impression of extreme illumination and something of a surreal quality.

Exposure increased to open up all shadow details. Grey is now the deepest tone in the print.

Project: Printing controls
This Norman Chapel in the Tower of London was designed for use in natural light, and it was felt that adding any artificial lighting would destroy the atmosphere. In particular, the light streaming onto the altar and down the aisle is an important feature. Because the important separation of tones is in the darker areas, a soft paper grade would have been inappropriate. Instead, a hard grade paper – 4 – was used, and the print shaded and printed in as shown.

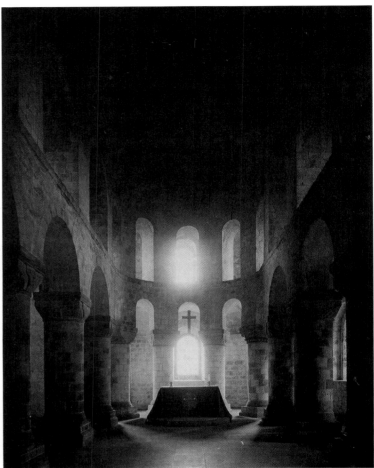

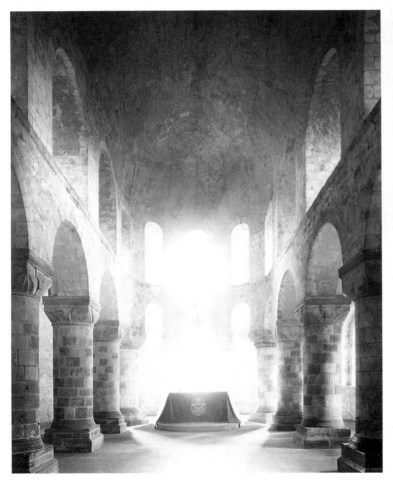

These two prints were made without any shading or printing-in, to demonstrate the range of tones and the scale of the printer's problem. The print *left* was made for the shadows, at 4 seconds and *f*16. The print *above* was made for the highlights, at 18 seconds.

Held back during basic
exposure to give 3
seconds

Basic exposure: 6
seconds at $f16$

Printed-in to give total 18
seconds

Printed-in to give total 10
seconds

Printed-in to give total 15
seconds

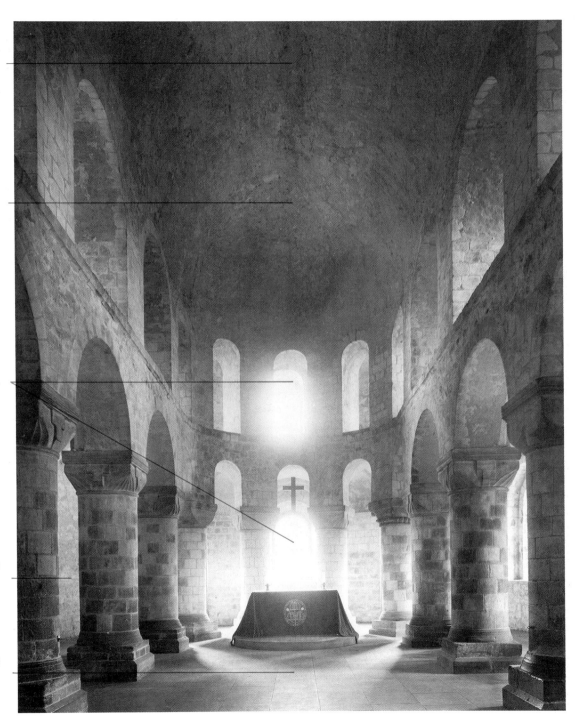

DESIGN BASICS

The vocabulary of design is made up of what we can call graphic elements, the two-dimensional forms that appear inside the picture frame. In classic design theory, which relates to painting and illustration, it is not so difficult to isolate these marks and forms on the paper from real subjects; the things that they might be used to represent. Painting and illustration offer no compulsion to be realistic, so that an abstract treatment of the basic elements is perfectly acceptable to the viewer.

In photographic design, however, this is not completely straightforward. We come back to the unique property of photography, that its images are always of real things. The marks on a photographic print are never the same as those drawn by hand. They always represent something.

This by no means invalidates the idea of graphic elements, but it does make them more complex in the way they act. We can identify such things as points and lines in a photograph just as easily as in a painting,

and the way they affect the eye is in many instances similar. What we need, however, is a rather more sophisticated way of looking at them. Despite the danger of divorcing form from content in a photograph, we need to do just this in order to arrive at workable design techniques.

One of the methods used throughout this book is simplified diagrams that highlight the graphic elements at work in a photograph. It might be to show how the arrangement of three faces in a group portrait creates a triangle, or how one photograph is made up of two principal blocks of colour that interact in a certain way. What is important is to realize that these diagrams are only intended to draw attention to a particular aspect of an image, and do not represent anything that is happening inside the frame. Opposite is a photograph that has been analyzed in this way, but from several different points of view. These represent no more than a very basic breakdown of the picture, and do not even begin

to show the influences of the subject matter. What they valuably demonstrate is that any photograph contains layers of design. Every photographic image is complex if you look into it in sufficient detail, and ask enough questions about it.

The elements which we need to consider increase in complexity, and by the end you will be able to see that virtually any photograph can be analyzed in a number of different ways. A row of points implies a line, lines can define shapes, and so on. What we choose to identify in a photograph as a point, a line, a shape, a colour or whatever, often depends on how we ourselves choose to consider an image. Here, we begin with a single point, the simplest element that any image can contain, and continue with several points, lines, shapes, and then with a coherent arrangement of these forms – rhythm, pattern and texture. Finally, we will deal with colour, the ways in which it varies and the many different effects of relationships between colours.

Six ways of analyzing this photograph of equipment inside the CERN research complex near Geneva show how it is possible to isolate several individual graphic elements. All play a part in the photograph and none on its own can be used to describe the image entirely.

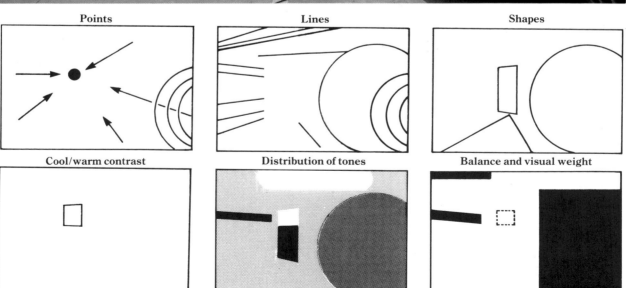

Points

Lines

Shapes

Cool/warm contrast

Distribution of tones

Balance and visual weight

Points

The single point
The most basic element of all is the point. By definition, a point has to be a very small part of the total image, but to be significant it must contrast in some way with its setting – in tone or colour, for example. The simplest form of a point in a photograph is an isolated object seen from a distance, against a relatively plain background, such as a boat on water, for example, or a bird against the sky.

There is no simpler design situation in photography than this: one element without significant shape, and a single background. The main consideration, then, is the matter of placement. This is one photographic situation where there is absolutely no doubt about the focus of attention, so that wherever the point is in the frame, it will be seen straight away. Placing it in a certain position is chiefly for the aesthetics of the picture, to give it whatever balance or interest is wanted, and to a lesser extent to suit the background.

Some of the issues involved in positioning the subject in the frame have already been covered on pages 16–27, and most of what was said applies here. To summarize: from a purely aesthetic point of view, placing a point right in the middle of the frame may be logical, but it is also static and uninteresting, and is rarely satisfactory. The choice then becomes how much off-center to place the point, and in what direction? The more eccentric the position, the more it demands some justification, so the most common range of location is that shown in the diagram *below left*. But remember that this is only a description of normal practice: it is certainly not a rule to be followed.

Free placement, however, is never guaranteed in photography, and the conditions are often such that you cannot arrange things exactly as you would like them, even with changes of lens or viewpoint. This is the case with the photograph of the outrigger canoe, but the result, according to taste, is still not so bad. This is one of many examples of design compromises in this book; what they demonstrate is how much leeway exists in photographic design. Also, a personal judgement: it is probably better to err on the side of doing something unusual than being predictable.

Practically, there are three zones in a picture frame for placing a single, dominant point. However, the limits that are drawn here for convenience are not, in reality, precise.

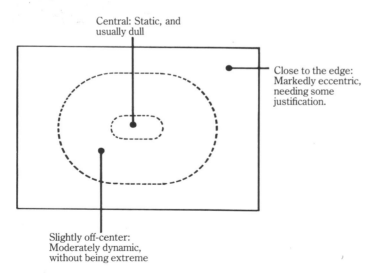

Central: Static, and usually dull

Close to the edge: Markedly eccentric, needing some justification.

Slightly off-center: Moderately dynamic, without being extreme

The tonal contrast between the white egret and its background make it a natural point. Notice that only a slight reason is needed to influence the direction of a point's location; in this case the weak patch of sunlight is sufficient to place the egret towards the top left corner of the picture, to oppose it.

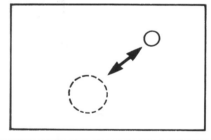

A point has two basic relationships with the frame. In one, there are implied forces that are in proportion to its distance from each corner and side. In the other, implied lines suggest a horizontal and vertical division of the frame (see pages 76–9 for more on this).

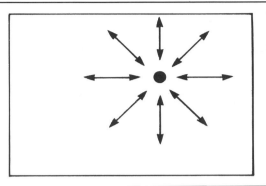 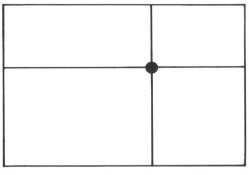

Here, light and exposure create the point. A shaft of light illuminates a small area in a market, and the exposure is kept short enough to render the background virtually black.

Placing the outrigger canoe towards the top of the frame was influenced by the distribution of light on the water (the dark point opposes the darker tones below). The position, however, had to be more eccentric than was really wanted, to avoid including a second canoe.

Several points

As soon as even one more point is added, the simplicity is lost. Two dominant points in a frame create a dimension of distance, a measurement of part of the frame. The strength of the relationship between two points depends, naturally, on how dominant they are and on how receding the background is. The examples chosen here are quite strong in this respect, but even in complex images, two-point relationships remain to some extent; additional picture elements reduce rather than eliminate them.

The eye is induced to move from one point to another and back, so there is always an implied line connecting the points. This line is the most important dynamic in a two-point image such as these here. Being a line, it has a relationship with the horizontals and verticals of the frame, and it also has direction.

The direction of the line depends on a variety of factors, but it will tend to be from the stronger to the weaker point, and towards the point that is close to an edge. Usually, it is obvious to the eye. A special case is a perfect equilibrium of direction, as shown on page 75; the lack of resolution in this creates some tension, and can even be irritating to look at.

Several points, even just two, occupy the space between them, again by implication. By this, they can unify the area. This effect, however, depends on the location of the points, and with a group the eye has an almost irresistible tendency to create shapes from their arrangement. These may serve to exclude other areas of the frame and so, in effect, break up the image.

Occupying the space
The relative separation of two points has a profound effect on the frame space. If far apart, the visual connection between them (that is, the eye crossing from one to the other) activates the area in between. The result is that they act as a cohesive force, although this depends on both being strong. If the two points are close together, their relationship tends to isolate them from the surroundings. They react inwards, and leave the rest of the space unactivated. If close enough, they can behave as a single point.

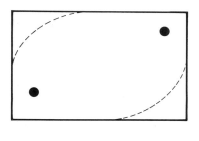

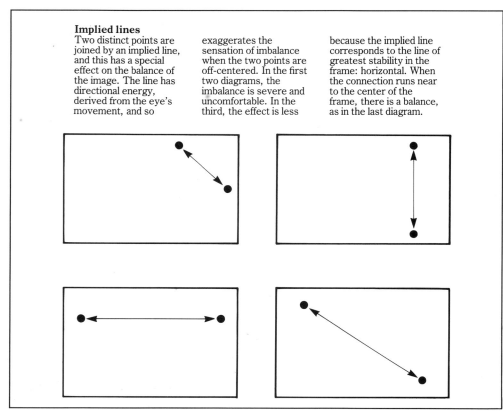

Implied lines
Two distinct points are joined by an implied line, and this has a special effect on the balance of the image. The line has directional energy, derived from the eye's movement, and so exaggerates the sensation of imbalance when the two points are off-centered. In the first two diagrams, the imbalance is severe and uncomfortable. In the third, the effect is less because the implied line corresponds to the line of greatest stability in the frame: horizontal. When the connection runs near to the center of the frame, there is a balance, as in the last diagram.

The extra energy of two points is demonstrated in this silhouetted photograph of two storks on either side of a tree trunk. Although the picture is dominated by the contrast of the tree against the sky, the opposed positions of the birds creates a strong diagonal, despite the massive vertical in the middle of the frame.

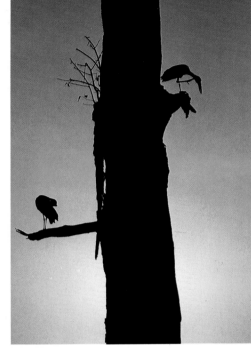

A straightforward arrangement of two objects on a featureless background. It is affected by an additional influence: the difference in size, for which reason the ferry boat is positioned a little closer to the center than is the yacht. A second effect of the size difference is that there is a directional bias from the larger to the smaller boat, although this is also helped a little by the movement of the yacht.

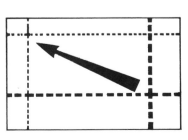

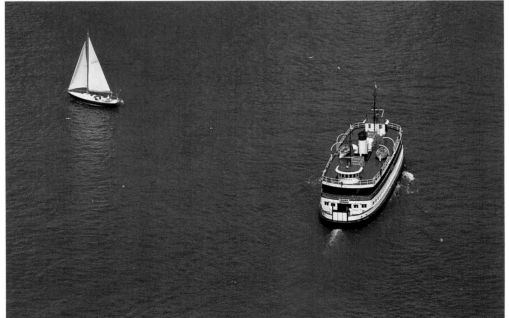

Project: Placement of points

Experiment with the placement of pairs of points, composing them both intuitively and in deliberately unusual positions, as in the diagrams on page 72. When out shooting on location, make a specific effort to identify groups of points, ideally groups which create obvious shapes. As a reverse exercise, take several identical objects for a still-life photograph, and arrange them so that they appear as a group, yet without an organized shape, as in the second picture on page 75.

Avoiding regular shapes
Whereas one of the most eye-catching occasions in unplanned photography is the unexpected appearance of regular shapes and patterns, studio photography often poses a reverse problem. In a shot like this, of jade gems on the rough jade matrix, it is clear that the stones have been arranged, and not found. Yet the style of the image is loose, not geometric. Arranging nine virtually identical objects so that they did not lock together into an obvious shape took several minutes. Creating disorder that still remains cohesive is usually more difficult than establishing order. Try a similar exercise yourself.

Instability through equilibrium

Though it may seem to contain the seed of a paradox, two well-balanced and insistently strong points can leave the eye with no place to rest. Being equal, there is no bias of direction to the line between them. This is something of a special case, but photographs like this set up a constant to-and-fro eye movement for anyone looking at them, with accompanying unresolved tension.

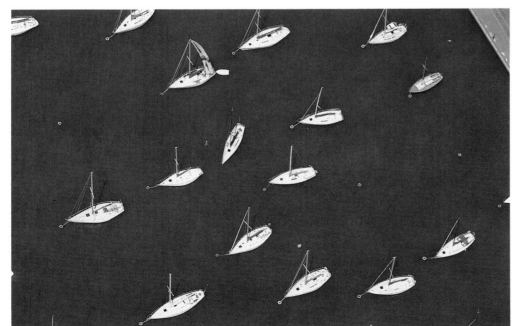

Implied lines and shapes

An aerial view of a marina gives an unencumbered image of a grouping of points. Particularly in a quick glance, the eye seeks any potential alignment, and converts the assembly of points into lines. From these implied lines it is an easy step to construct shapes, as seen here in the gaps between the lines. Note that the alignment of each boat influences the lines seen; imagine what the line and shape analysis of this picture would be if all the yachts were facing the lower right. See also how the different position of just one boat out of fifteen catches the eye and weakens the line near the middle of the frame.

Lines

Horizontal lines

Several arrangements of points, as we have just seen, produce the effect of being joined, which leads naturally on to the next major group of elements in an image: lines. Whereas in illustration a line is often the first mark made, in photography it occurs less obviously and usually by implication. In this respect it is similar to the way we actually see the world, where most lines are in fact edges. Contrast plays the biggest role in defining lines visually; contrast between light and shade, between areas of different colour, between textures, between shapes, and so on.

As you might expect, the graphic qualities of lines are rather stronger than those of points. Like the latter, they establish location, a static feature, but they also contain the dynamic features of direction and movement along their length. And, because the frame of a photograph is itself constructed of lines, these invite a natural comparison of angle and length.

Lines also have some capacity for expression. It is perhaps best not to make too much of this, but different forms of line have distinct associations. Horizontal lines, for instance, have a more placid effect than diagonal lines; a zig-zag can be exciting. Strong, definite lines can express boldness; thin, curving lines, delicacy, and so on. However, whereas in abstract art this can be used as the very basis for expression, it is not realistic to expect to make great use of it in photography.

These associations, which will be described in more detail on the following pages, are real enough, but in a photograph the subject often overwhelms them. Nevertheless, being sensitive to them pays dividends when the opportunity arises.

The horizontal is, in more senses than one, the baseline in composition. As already described on pages 50–1, there is a distinct horizontal component in the way we see. Our frame of vision is horizontal, and the eyes scan most easily from side to side. Not surprisingly, horizontal lines are visually the most comfortable. Moreover, the horizon is a fundamental reference line – the most familiar of any – and even gravity is a reminder that a horizontal surface is a base that supports.

For all these reasons, horizontal lines generally express stability, weight, calm and restfulness. Through their association with the horizon they can also suggest distance and breadth. Note, though, that such expressive qualities usually only become important when there is little real information to be had from the content of the photograph.

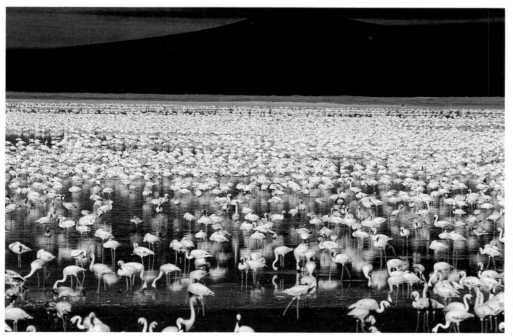

Even irregular groupings of things become resolved with distance into horizontal bands, and eventually lines. The horizontal components of this photograph of flamingoes in Ngorongoro Crater exist only because of the acute angle of view.

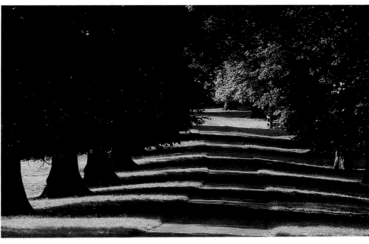

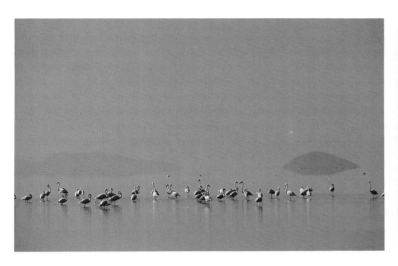

A horizontal string of points implies a line connecting them. If they are sufficiently close together, they become a line.

In a very precise example of how lines are formed by contrast, light and shade from a row of trees form diminishing bands along the driveway of an English estate.

Expressively, this helps to give a feeling of stability and tranquility to the view; graphically, the receding pattern has interest. This recession also gives a clue to the abundance of horizontal lines in views that span a distance; on a flat surface seen from only slightly above, virtually all details merge and converge on the horizon.

It is hard here to separate the graphic effect from the content of the photograph. The construction of this Pathan hamlet near the Khyber Pass is evidently fortified and ground hugging and the single, dominant horizontal line contributes to the impression of solidity and stability.

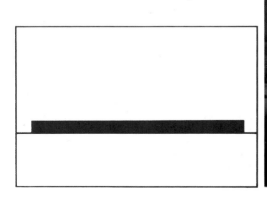

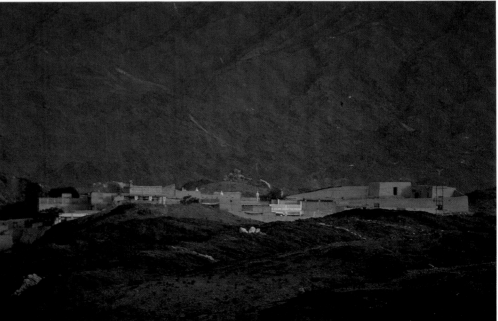

Vertical lines

The vertical is the second primary component of the frame, and so is naturally seen in terms of alignment with the format and with the sides of the picture. A single vertical form understandably sits more comfortably in a vertical format than a horizontal. A series of verticals, however, acquires a horizontal structure, as can be seen from the photograph of the leg-rowers *opposite*; here, a horizontal frame actually allows more to be made of the series.

A vertical line is the main component in the image of a human figure, and of a tree. Its direction is the force of gravity, or something escaping it. Without the inbuilt associations of a supporting base that give a horizontal line much of its character, a vertical line usually has more of a sense of speed and movement, either up or down. Seen as uprights from a level viewpoint, vertical forms can, under the right circumstances, confront the viewer. The dark tree-trunk on page 73 has some of this quality. Several vertical forms can have associations of a barrier, like posts, or a line of men facing the camera. To an extent, they can express strength and power.

On a practical level, exact alignment is very important, as it is for horizontal lines, also. In a photograph, both are immediately compared by the eye with the frame edges, and even the slightest discrepancy is immediately noticeable.

Together, horizontal and vertical lines are complementary. They create an equilibrium in the sense that their energies are perpendicular to each other; each one acts as a stop to the other. They can also create a primary sensation of balance, because there is an underlying association of standing upright, supported on a level surface. If used strongly and simply in an image, this can produce a solid, satisfying feeling.

Projects

For these and all the following analyses of the individual graphic elements, the basic projects are to find your own examples of the effects illustrated here. Special exercises apart from these are noted separately.

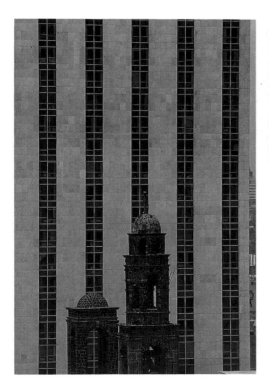

Graphically, the vertical lines on a towering high-rise building do two things for this photograph. They provide unity, and they offer a counterpoint to the image of the church. The latter quality is matched expressively by the associations of confrontation that all massed vertical lines possess.

Through its foreshortening effect, a powerful telephoto lens converts what would otherwise be diminishing perspective into a vertical design. As with most images that feature dominant lines of one type, it adds interest to have some discontinuity, in this case the ragged line of the right edge of the street.

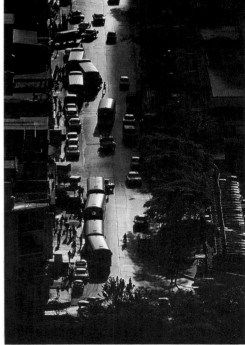

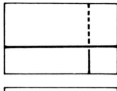

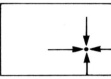

Combined horizontals and verticals

The horizontal line in this photograph of the American West is formed by the local horizon, and the vertical by a desert road rising up the slope. The static quality that these two lines create has been alleviated slightly by off-setting both in the frame. Note that there are two possible graphic effects: one is to subdivide the frame, the other is to create a point at the intersection, such as a car.

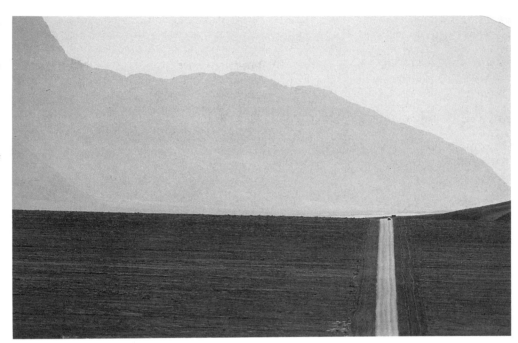

The source of the equilibrium created by combined horizontals and verticals is this simple but very basic symbol – an upright figure on a level base; gravity against a solid base.

Parallel verticals frequently fit better into a horizontal frame, which gives them a greater spread. Note that this type of shot is created by using a telephoto lens to reduce perspective and by shooting from an acute angle.

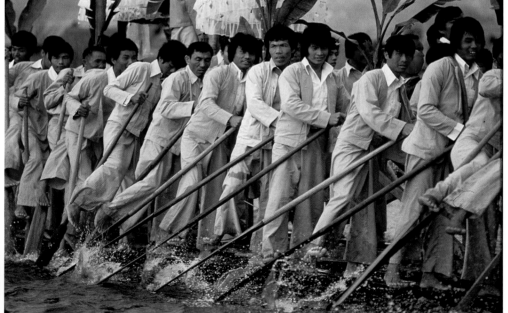

Diagonal lines

Freed from the need to be aligned exactly in the picture frame, diagonal lines have a variety of direction denied to horizontals and verticals. Practically, this means that in photographs that do not depend on a horizon or on some other absolute reference, there is an extra element of choice: the angle of the line.

Of all lines, diagonals introduce the most dynamism into a picture. They are highly active, with an even stronger expression of direction and speed than verticals. They bring life and activity precisely because they represent unresolved tension. If the relative stability and strength of horizontals and verticals is because of their symbolic associations with gravity (see pages 76–7), the tension in looking at a diagonal has the same source. It has an unresolved and unstable position; in the process of falling, if you like. Indeed, structurally most scenes and things are composed of horizontals and verticals, rather than diagonals, particularly in man-made environments. Through the viewfinder, most diagonals appear as a result of viewpoint – oblique views of horizontal or vertical lines. This is very useful indeed, because they are, as a result, much more under the control of the photographer than are horizontals and verticals. More about this in a moment.

In normal eye-level views, horizontal lines that run away from the eye converge in a photograph; this is the normal effect of perspective. By converging, they become diagonals, or at least most of them do. As this is entirely familiar, diagonals carry some associations of depth and distance, particularly if there is more than one and they converge. Considerable use can be made of this in trying to manipulate the sense of depth in an image. Including or strengthening diagonals in a landscape (often no more than a matter of aligning objects or edges) will tend to improve the impression of depth; even the arrangement of subjects in a still-life can produce, quite artificially, a feeling of distance. These techniques are explored more fully later, on pages 156–9.

These perspective diagonals appear stronger through a wide-angle lens, the more so from a close viewpoint. Much of the usefulness of such lenses – 24mm, 20mm and less on a 35mm camera – derives from this simple fact (see pages 146–7 for more on this). However, telephoto lenses also have their uses in treating diagonals. By giving a selective view, a lens with a long focal length can emphasize one distinct part of a diagonal. Oblique views from some height typically produce the kind of diagonals seen in the photograph of the bathing tents. What strengthens these particular images is the repetition of diagonal lines; the compressing effect that a long lens has on perspective makes them appear parallel.

A wide-angle lens from closer would cause them to converge in the image.

From the point of view of design, diagonals have two very important qualities. One, already mentioned, is that they activate an image, making it more dynamic and consequently eye-catching. This liveliness is greatest when other lines such as horizontals and verticals are present as contrast, but it still works without.

This is because the frame edges themselves give a certain amount of contrast, as you can see from the photographs of the Muslim women praying. This activating effect is in proportion to the angle that the diagonal forms with the edges of the frame. The maximum for a single diagonal, or parallel set, is 45°, but with two or three different diagonals combined, the strongest effect is when the relative angles are all great without being equal. There is never any point in trying to calculate these angles in advance, even in a still-life shot which would allow enough time. It is always better to do this by eye. Look at the photograph and diagrams of the Japanese shrimps *opposite* as an example.

The other essential quality is movement. A diagonal leads the eye along it, more than any other line. This makes it an extremely valuable device for encouraging the attention to move in certain directions in a photograph, something we will consider in some detail on pages 162–9.

Diagonals appear more dynamic when they form a stronger angle with the longer side of the frame.

Parallel diagonals reinforce each other; a variety of diagonals gives the greatest energy to an image.

Maximizing the diagonals
In this still-life of a Japanese dish of skewer-grilled shrimp, the glass dish was too long to include entirely in the photograph and still leave the food visible in detail. One answer in cropping was to choose a horizontal frame and close in to the edges of the dish. Although fairly satisfactory, this gave no good impression of the setting and was felt to be a little static. A vertical frame with the dish horizontal is clearly unsatisfactory, giving a truncated impression. Aligning the shrimps with the vertical sides was thought too contrived. The chosen arrangement has all lines as diagonals, and so sets up the greatest contrast of angles.

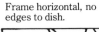
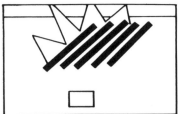

Frame horizontal, no edges to dish.

Shrimps diagonal, dish horizontal.

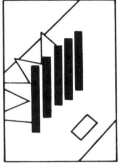

Shrimps vertical, dish diagonal.

All lines diagonal.

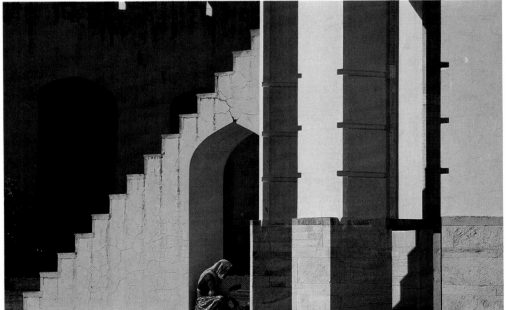

Diagonal/vertical contrast
Here the diagonal is, for once, a real construction rather than an optical effect. The group of vertical lines formed by the buttresses and their shadows are used for contrast, and the shot framed so that the diagonal steps exactly bisect a section of the frame. The figure in the archway adds another kind of contrast.

Imposing a diagonal structure
One solution with a subject which has the potential for confusion is to impose a simple graphic structure. In this example, maintenance work on an F4 aircraft was just such a design problem. A corner-to-corner diagonal line is frequently quite easy to construct, given a wide-angle lens and some length to the sunset. The arm of the engineer here completes the line, and the silhouette emphasizes it by reducing tones.

Zig-zags
Oblique views of right angles produce zig-zags, a chevron effect of multiple diagonals. The angles are joined, so the impression of movement along the diagonal is maintained, but with a sharp kink. As can be seen from this pair of photographs of rows of bathing tents, both taken within moments of each other, this type of dynamic effect is different. In the diagonal picture, the graphic movement is single-minded (the bias of direction is set by the walking figures). In the zig-zag version, the change of direction produces more internal activity.

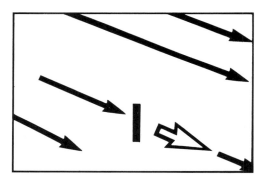
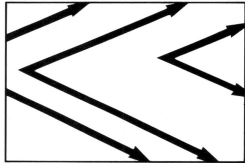

Telephoto perspective
An oblique view with a telephoto lens gives a different diagonal effect from the expanding perspectives of a wide-angle lens. If the viewpoint is raised, parallel lines, such as these rows of women praying at a Muslim festival, can give a consistent and definite effect. To make the most of this, it is important to fill the frames with the subject; here, to have shown the edges of the crowd would have ruined the consistency which gives the picture much of

its appeal.
A second, very important design point, is that the figure of the child makes an important contrast. Far from spoiling the overall graphic structure, it actually gives emphasis to the orderliness of the shrouded women. Strong graphic situations such as this are usually most valuable when they are used in contrast. To have altered the framing to exclude the child would have reduced the rows to a pattern, and the picture would have been more bland as a result.

Diagonals reinforced by movement
As shown in the diagram, there is only one significant diagonal line in this center picture – the railing – yet the photograph is full of "diagonality". What gives this is simply the perceived movement,

the mass of commuters all marching in the same direction across London Bridge. This is reinforced by the lorry and cyclist travelling in the opposite direction, which act as a counterpoint. The shot was composed and timed for just this opposition.

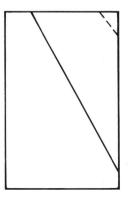

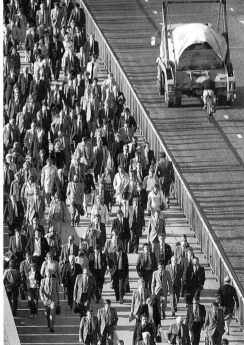

83

Project: Creating diagonals

Apart from changing focal length and viewpoint in order to manipulate the perspective effect on diagonals, tilting and rotating the camera can be used. If, however, the horizon or similar reference is included, the effect may look contrived. It is obviously easier in strongly upward-and-downward looking views, and probably easiest of all in close views; still-life images in particular lend themselves to this (they also usually allow rearrangement of the objects themselves in order to create diagonals). Apart from the examples here, you can see this in several other photographs in this book, for instance of the gold bars on page 14, the seventh picture in the sequence on page 130, and the cloth on page 103.

Perspective effects are ultimately responsible for most of the diagonal lines that appear in photographs. The steepness of the angle varies according to the viewpoint.

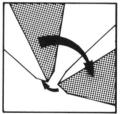

Project: Creating diagonals

As long as some absolute standard remains in the picture, such as the horizon or a level base, there are limits to how much the angles can be manipulated. Once these disappear, however, there are no implied restrictions on the camera angle.

Take a situation similar to the one illustrated in diagram **1** of high-rise buildings. With a wide-angle lens, approach close and tilt the camera strongly upwards. Consider the design as an abstract arrangement of lines. The diagonals will already be strong even if the camera remains aligned horizontally (**2**). However, experiment by rotating the camera, and combine this with any other movements, like a change of viewpoint (**3**). Work for the maximum diagonal effect, with the greatest combined contrast of angle.

Much of the dynamic quality of diagonal lines comes from the unresolved tension of their position between flat and upright.

Diagonal/horizontal contrast

There is little in the content of this photograph of an old tool chest, and what strength the image has lies in its contrast of lines and tones. Consequently, the camera has been aligned carefully so that the horizontals are exact and one diagonal shadow line bisects the frame from corner to corner. Including the block of shadow at the lower left prevents the line intersections from being completely repetitive.

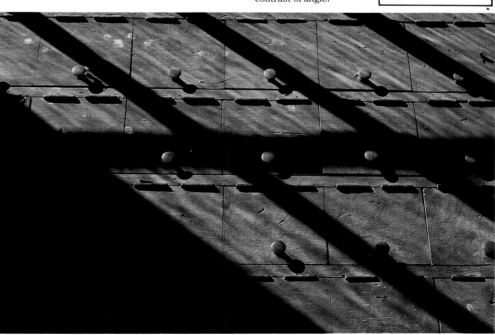

Wide-angle perspective
A wide-angle lens close to a long wall produces a predictable diagonal that radiates from the vanishing point. In this case, the wall is Hadrian's Wall in northern England, the lens 20mm, and the composition chosen to introduce some visual drama. A head-on view would have shown this section of the Roman wall as little more than an ordinary escarpment. Note that the diagonals have been enhanced by the use of a neutral graduated filter, angled as shown so as to darken the sky in alignment with the diagonal line of the top of this wall.

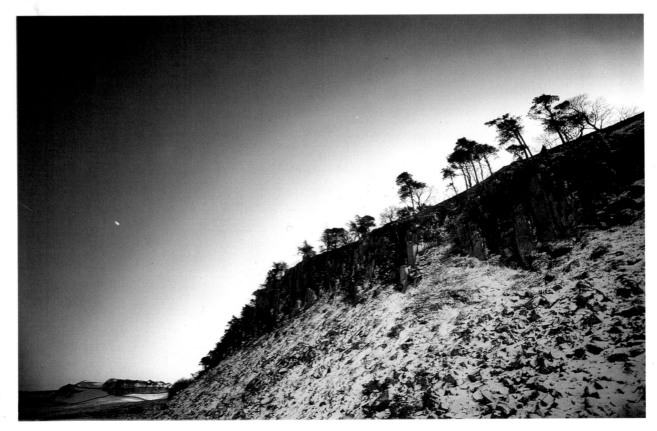

Curves

So far, we have been concerned only with straight lines. Curves have entirely different qualities, both graphically and expressively. As a line, the unique feature of a curve is that it contains a progressive change of direction, and so avoids, on the face of it, any direct comparison with the horizontal and vertical edges of the frame. Many curves are, however, aligned mainly in one direction or another, as can be seen from the examples shown here; in another way a curve can be thought of as a series of straight lines at progressively changing angles. For these reasons, curves do interact with straight lines in an image.

The progressive quality of a curve gives it a rhythm which straight lines lack (zig-zags are an obvious exception). The sense of movement along a curve is also greater. For example, if you were to animate the image of a vehicle by streaking its tail lights behind it, the greatest impression of speed would be if these were slightly curved.

This movement, however, is smooth, and many of the other associations of curved lines are in the areas of being gentle, flowing, graceful and elegant. Curves are inherently attractive to most people, particularly when they undulate. Just as diagonals have a specific character – active and dynamic – and a quality of movement, so curves have a character – smooth and flowing – and also carry the eye along them. They are, therefore, a useful second device in controlling the way in which people will look at a photograph.

Curves are, however, less easy than diagonals to introduce into a picture. While a diagonal is usually a straight line of any direction that is altered by viewpoint, curves must usually begin as real curves. They can be exaggerated by being viewed at a more acute angle, but the only optical method of actually creating them that is open to photographers is to use a fish-eye lens, and this simply bends all the lines into curves without discrimination. Nevertheless, it is sometimes possible to produce a curve by implication; by an arrangement of points, as in the photograph of the pelicans, or with a number of short lines or edges.

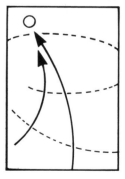

In this wide-angle shot of an eighteenth-century stone instrument for reading azimuths, in the Jaipur Observatory, India, the circular lines of the subject are emphasized by two means: the use of a 20mm lens from close, and severe cropping to eliminate most other elements in the scene. The figure of the man is retained to act as a focus for the upward curve of the shadow.

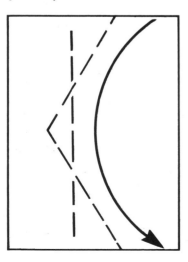

Although a curve is continuously changing direction, it has implied straight-line components, particularly at either end.

A curve can also be seen, at least in part, as a section of a circle. This helps to explain the enclosing sensation of curves.

As with any other kind of line, several concentric curves reinforce each other. The strong sense of movement can be especially felt, even with these static subjects, because the rows approach the camera. This photograph also demonstrates how a low viewpoint, giving an acute angle of view to the lines, strengthens the curvature.

High angle Shallow angle

The same technique as used in the photograph of the cemetery (shallow angle of view with a medium telephoto lens) here gives a graphic unity to a picture of volcanic ash landscape in Death Valley, California. The landscape itself is fairly weak in features, and so benefits from this assistance.

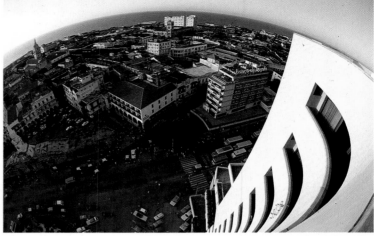

Fish-eye lenses
Pronounced barrel distortion creates the curved lines in this view. Although almost fully corrected in regular lenses, curvilinear distortion is deliberately maintained in fish-eye lenses. This full-frame fish-eye represents a cropped view of a circular image in which an entire 180° view is projected onto a circle. As a result, all lines except radial ones are curved: the further from the center, the more extreme the curve. Under limited circumstances, this kind of lens is useful for

introducing curved lines, which can help to unify the different elements.

Implied curves
Another, less extreme method of creating a curve is by aligning other elements. In this case, pelicans in flight appear, from the camera position, to form a curve, and this becomes the structure of the photograph.

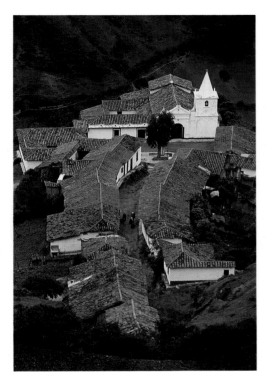

A simple curve also symbolizes the bending of a straight line by a bowing action, so curved lines in a picture can also contain a secondary element of movement, in the direction of the flexing of the curves, as shown in the diagram. This is much less evident in curves that are seen in perspective, which tend to be more dynamic (see the cemetery photograph on page 87).

The curves of two spiral staircases need no analysis diagram, they are so strong in this image. The structure of the photographs is the intertwining of several undulating curves and the result is a graceful looping of balustrades. In a situation like this, there are clearly many possible viewpoints and arrangements. A radically different design would be an upward or downward view to emphasize the spiral.

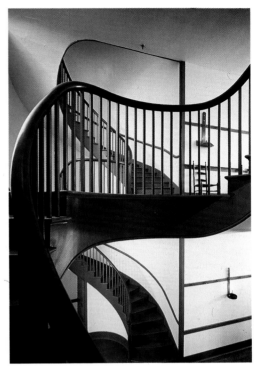

Contrast of line
Curved lines make a more substantial contrast with straight lines than do the different types of straight lines among themselves. Here, the contrast is used quite gently: the intricate curved pattern of oil globules in sea-water forms a background for the diagonal line of baby shrimps.

Shapes

As a row of points creates a line, so an enclosure of lines becomes a shape, and the eye is more than ready to conjure up a shape in an image. All discrete objects have a shape, but the shapes that have the most graphic interest in an image are those that occur a little less obviously, from the congruence of different elements. Subtly formed shapes that are implied and understated are some of the most useful of all; they help to order an image into a recognizable form and allow the eye the satisfaction of discovering them by making a little visual effort. The photograph of the old oak forest on page 97 is just such an example; the circular form is not what would normally be expected in vegetation, and organizes the mass of leaves and branches without being immediately obvious.

Although it might seem that there is an infinity of shapes, there are only three basic ones: the rectangle, triangle, and circle. All others, from trapezoids to elipses, are variations on these, and as their importance in design relies on their fundamental recog-nizability, there is no need to go beyond these three basic planar figures. Each is intimately connected, both graphically and expressively, with the different lines that have just been considered. Rectangles are the product of horizontal and vertical lines, triangles are built from diagonals, and circles from curves.

As the principal design value of lines is to direct the eye, so that of shapes is to organize the elements of an image. At an order higher than that of lines, shapes have a more advanced function in composing a picture. Shapes also, as might be expected, have expressive characters that can contribute to the mood of a photograph.

Rectangles

The shape that bears the closest correspondence to the frame of a photograph is a rectangle, and in many ways is the most natural. If you think about sub-dividing the frame, as in the project on pages 28–31, the most natural method will almost certainly be in a rectilinear fashion. A high degree of precision is called for, as the most usual way of arranging rectangular shapes in a frame is to align them with the horizontals and verticals of the frame itself. Misalignments are then easy to spot.

Rectangles have associations of gravity, solidity, precision and sharp limitation, a result of their connotations with the two kinds of lines – vertical and horizontal – that compose them. They tend to be static, unyielding, and formal. As the perfect form of the rectangle, the square exhibits these qualities the most strongly.

At least one major reason for most of these expressive qualities is that completely natural rectangles are rare, and most are man-made (buildings in particular). Moreover, for a rectangular form to appear rectangular in the picture, it must be photographed square-on and level. Angled views and wide-angle lenses tend to distort rectangles into more triangular shapes. Hence, the manner of shooting that uses rectangular structures is itself usually formal and considered.

A distant telephoto (and hence undistorted) view of a modern downtown cityscape is the epitomy of an assembly of rectangular shapes.

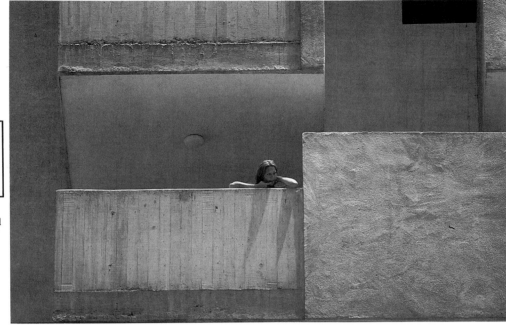

This view of a set of cheerless concrete balconies was deliberately taken from a frontal viewpoint. Seen as rectangular blocks, the balconies have a depressing, crushing effect on the single figure in the middle: an intended effect. An oblique view would have given a livelier image which, although more interesting, would not have reinforced the point of the picture in the same way.

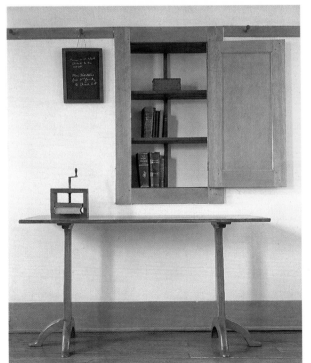

This is an example from a book which was photographed entirely with a motif of rectangular shapes. The subject is Shaker architecture and crafts, and the severe, functional nature of the material suggested an appropriate treatment. The defined regularity of rectangles makes them especially adaptable to design that stresses balance and proportion.

Triangles

In photographic design, triangles are considerably more useful shapes than rectangles, for a number of reasons. They are more common, partly because they are simpler to construct or imply (they need only three points for the apices, and these do not need to be in any particular arrangement) and partly because of convergence – the natural graphic effects of perspective make convergent diagonals very common in photography, particularly with wide-angle lenses. They are also the most basic of all shapes, having the least number of sides. Moreover, they have the interesting combination of being both dynamic, because of the diagonals and corners, and stable – provided that one side is a level base. Triangles are thus a useful compositional device.

The triangle is such an inherently strong shape that it appears easily to the eye, not only through converging lines, but with three points alone. With lines, often two are sufficient; the third can be assumed or else an appropriate frame edge can be taken as one side. As for points, any three prominent centers of interest will do, particularly if they are similar in content, tone, size or some other quality. Unlike rectangles and circles, both of which need to have their principal components in an exact order, triangles can be formed in almost any configuration. The only arrangement of three points that does not create a triangle is a straight row. For example, a portrait of three people will almost inevitably contain a triangle, with each face an apex.

The natural tendency of linear perspective is for lines to converge on a vanishing point in the distance, and form two sides of a triangle. If the camera is level, the prime apex of the triangle will be pointing more or less horizontally (you could think of the triangle formed by a receding row of houses as lying on its side, with the apex on the horizon and the base the nearest upright to the camera). If the camera were pointing upwards instead, at a building, trees or any other group of vertical lines, the apex would be at the top of the picture, and the base level, at the bottom. This is also the most stable configuration of a triangle.

The sense of stability inherent in many triangles comes from structural associations; it is the shape of a pyramid, or of two buttresses leaning in towards each other. Therefore, arranging three objects so that two form a base and the third an apex above creates a stable form, and this association is carried into the image. It is the classic three-figure shot, and in photography that allows the subjects to be manipulated, it is a standard and usually successful technique to reposition things in this way. The two diagonals in such a triangle help it to escape the heaviness of a square or rectangular arrangement.

The reverse configuration, with the base at the top of the picture and the apex at the bottom, is an equally useful shape to introduce into a design. It has different associations: less stable, more aggressive, and containing more movement. The apex points more obviously, probably because it appears to face the camera and viewer, and there is the kind of tension that you would expect from a shape that symbolizes extremely precarious balance.

Triangles by implication
Any arrangement of three objects (except in a straight line) produces an implied triangle.

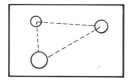

Triangles by convergence
Convergence caused by linear perspective, particularly a wide-angle lens, creates at least two sides of a triangle.

Vertical surfaces which recede to the horizon create triangles that appear to lie on one side. The principal apex is directed towards the vanishing point.

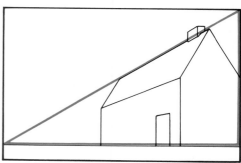

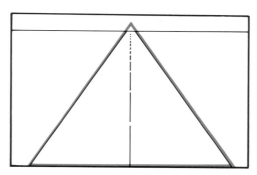

A special use for inverted triangles in design occurs in still life and other group pictures where objects are of different sizes yet need to be unified in one shot. Placing the smallest nearest the camera, at the apex of the triangle, and the larger objects behind, spreading out radially away from the camera, is one useful solution. This same technique of arrangement can be used with one small and one large figure: for instance, a man standing in front of a large vehicle or a building. In these examples, a wide-angle lens will help to reduce the relative size of the objects behind. A wide-angle lens, used from a raised position looking slightly down, will emphasize the proportions of an inverted triangle, just as a wide-angle lens pointing up will create upward converging verticals.

Incidentally, emphasizing the triangular structure of an image like this is principally a matter of removing from view other dis-tracting points, lines and implied lines. Simplification can be achieved by various means, and these usually depend on the particular circumstances of the shot. Alter-ing the viewpoint may be important (for instance, lowering the camera may hide some ground-level details from view; moving closer can tighten the composition), as may changing the lighting (or waiting for natural light to change), and physical re-arrangement of objects in view.

Under what circumstances is it useful to try to impose a triangular structure? It is important to see implied triangles as one of a few devices for bringing order to an image, or of arranging the things being photographed. The occasions when such organization is needed are usually those when there is a need for clarity. This is common in still-life photography and in various forms of reportage when the most important thing is to make a clear represen-tation of something, often in a visually untidy setting. As this is a common con-dition in professional photography, the idea of structuring an image in a simple graphic arrangement is principally professional.

Projects: A variety of triangles
Make a series of three-person group por-traits, using more than one triangular struc-ture. Experiment with different positions for the three people (two sitting and one standing, two standing and one sitting, and so on) to produce a variety of triangles. Use the faces as apex points, and also use the lines of the figures. For a second project, take a group of household objects, such as tableware or kitchen utensils. Select differ-ent sizes. Make an inverted triangular com-position so that the objects are tightly grouped and mainly visible (that is, avoid one object hiding important features of another behind).

An upward-tilted view with a wide-angle lens creates a triangle by convergence.

Three-figure shots usually contain the potential for a triangular structure. Here it has been deliberately strengthened by the viewpoint, which not only shows a triangular relationship in the heads, but a triangle in the outline of three figures.

The arrangement of the two seated figures only mildly suggests a triangular shape in itself, but a standing shot looking down with a 20mm lens strengthens the structures by convergence.

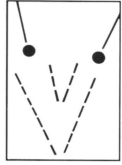

Here, the upward convergence with a 20mm lens is only partial, but sufficient for the eye to complete the sides of the triangle.

Inverted triangles for groupings

A triangle with its apex at the front of the picture makes a useful configuration for groups of objects: either objects of disparate shape, *below left*, or a large number of similar ones, *below right*.

Another use of a triangular structure is to focus attention more strongly on the apex, when the converging sides draw the eye towards this point. This technique works particularly well if the triangle is inverted, which gives prominence to the apex. In this instance, the device was chosen because the subject, the rice, was visually bland.

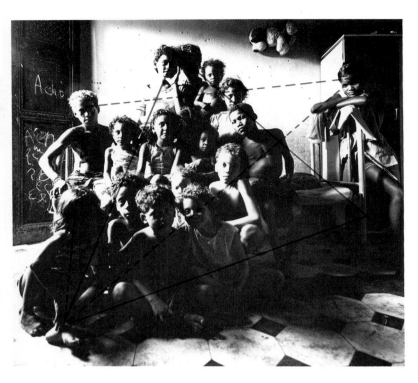

For a group portrait (always potentially untidy), these children were arranged by the photographer in a loose triangular shape. Unless the result is deliberately intended to be formal, it is important not to make too precise and rigid a shape. Here, a secondary triangle, to the same apex nearest the camera, enlivens the image.

Implied triangles are strengthened by both movement and human figures. Without the figure of the man, the triangular structure would be formed by the windows alone, and would be so dominated by the two on the right as to be weak. The figure attracts attention because it is a person (see Visual Weight on pages 178-9), so emphasizing the apex and its sideways direction.

Circles

Although circles are difficult to create by implication (their curvature and completeness means that they would need a large number of points and lines, all precisely arranged), they exist naturally in some abundance, as flat discs and as images of spheres. Radial growth produces a circle (head of flowers), equalization of pressure produces a sphere (a bubble). A circular section holds the greatest area for the least circumference, hence the large number of round containers, while things that revolve are circular (wheels). At least half of the world's faces appear more or less circular from the front.

Circles have the most enclosing effect on the eye; they have no axis and no direction, so their energies appear to be aimed inwards. They have a concentrating effect in an image, tending to exclude the surrounding area while drawing attention towards their center. Even more than a square (see pages 54–5) a circle has a strong sense of center. There is some slight implication of movement around the circumference, because of associations of rotation.

Derivatives of circles are ellipses, other flexing, cyclic shapes, and more or less any squat shape made up of curves rather than lines and corners. Ellipses represent a special case in photography, because this is the shape that a real circle projects onto the film when seen from an angle. To an extent, the eye resolves ellipses such as the table in the photograph of food on page 165 into assumed circles.

The design value of a circle is that it structures an image even more completely than does a triangle. Whatever it encloses immediately becomes the focus of attention, but equally the surroundings may suffer. The circle also usually has to exist in real life. A fish-eye lens is one major exception to this – it creates a circle which is centered in the frame, given the appropriate line in the subject – but it is an extreme solution, with such a pronounced effect that it can only be used occasionally.

The basic dynamics of a circular structure are evident in this food shot. The circle concentrates attention inwards and draws attention away from the surroundings. In this picture, the raw ingredients above the dish are of secondary importance: because of the excluding effect of the circle, they can be placed close to it without fear of them being intrusive.

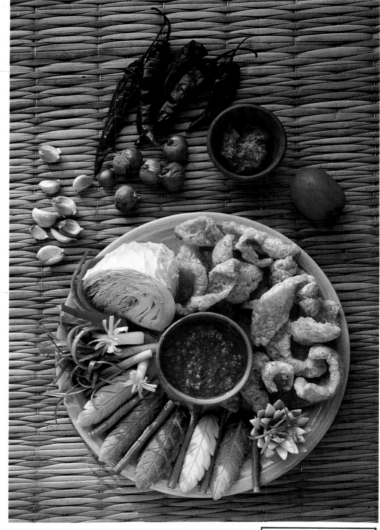

The subject is a fairly dense oak forest, but the design problem is its lack of structure. The solution here was to find one view with a little potential structure (the prominent curving branch), and then exaggerate this by using a full-frame fish-eye lens.

In this photograph of Javanese soldiers off parade, the potential for implied circles was noticed, and used simply because it was unusual. The tight, cropped framing was important, as the circular structures are only partial; any further back and there would be no such illusion.

Rhythm

Already, in looking at points, lines and shapes, we have seen something of rhythmical structure; a sequence of points in alignment, zig-zags and S-shaped curves. Repetition is a necessary ingredient, but alone does not guarantee a sense of rhythm in a picture. There is an obvious musical analogy, and it makes considerable sense. Like the beat in a piece of music, the optical beat in a picture can vary from being completely regular to variations similar to, for instance, syncopation.

Rhythm in a picture needs time and the movement of the eye to be appreciated. The dimensions of the frame, therefore, set some limits, so that what can be seen is not much more than a rhythmical phrase. However, the eye and mind are naturally adept at extending what they see, and in a photograph such as that of the row of soldiers, readily assume the continuation of the rhythm. In this way, a repeating flow of images is perceived as being longer than can actually be seen.

Rhythm is a feature of the way the eye scans the picture as much as of the repetition. It is strongest when each cycle in the beat encourages the eye to move (see the examples shown here). The natural tendency of the eye to move from left to right (see pages 14–15) is particularly evident here, as rhythm needs direction and flow in order to come alive. The rhythmical movement is therefore usually up and down, as vertical rhythm is much less easily perceived. Rhythm produces considerable strength in an image, as it does in music. It has momentum, and because of this, a sense of continuation. Once the eye has recognized the repetition, the viewer assumes that the repetition will continue beyond the frame.

Breaking the rhythm
Part of the interest of the rhythmical structure to the elephant shot *top right* is that rhythm is unusual for that subject. When the rhythm is predictable, as in this palace façade in Jaipur, India, the reverse is often the case. The repetition is frequently boring. In this case, an anomaly that interrupts the rhythm can make the image more dynamic. Here, a man sweeping provides the necessary break. Note that, as the eye naturally follows a rhythmical structure from left to right, it works better to place the figure on the far right, so that the eye has time to establish the rhythm.

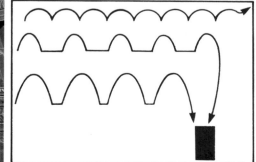

The regularly ordered line of these Thai soldiers, photographed obliquely with a long telephoto lens (600 mm), provides the necessary setting for an uncomplicated rhythm. The rhythm itself comes from the way the eye scans the image. Faces, which are always dominant in a photograph (see pages 178–9), provide the key points to which the eye keeps returning, leaving each one to dip down along the lines of each uniform. The result is an optical beat.

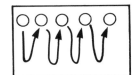

A more interesting beat is created by these silhouetted elephants. The difference in size due to perspective sets up a progressive rhythm, and the curved outlines produce a natural flow.

Here, the content of the photograph, a line of wildebeest standing in pouring rain (their progress had been halted by the photographer's vehicle, and they were waiting for it to pass), is not immediately obvious. The slight abstraction helps the rhythmical structure shown in the diagram, as does the strong horizontal component to the picture.

Pattern

Like rhythm, pattern is built on repetition, but unlike rhythm it is associated with area, not direction. A pattern does not encourage the eye to move in a particular way, but rather to roam across the surface of the picture. It has at least an element of homogeneity, and, as a result, something of a static nature.

The prime quality of a pattern is that it covers an area, thus the photographs that show the strongest pattern are those in which it extends right to the edges of the frame. Then, as with an edge-to-edge rhythm, the phenomenon of continuation occurs, and the eye assumes that the pattern extends beyond. The photograph of the bicycle saddles illustrates this. In other words, showing any border at all to the pattern establishes limits; if none can be seen, the image is taken to be a part of a larger area. At the same time, the larger the number of elements that can be seen in the picture, the more there is a sense of pattern than of a group of individual objects. This operates up to a quantity at which the individual elements become difficult to distinguish and so become more of a texture (see pages 102–5). In terms of the number of elements, the effective limits lie between about ten and several hundred.

Irregular pattern
To be irregular and yet still appear as a pattern, the objects must still be grouped closely; the irregularity is not quite so disordered as it may seem. The effectiveness of a pattern also depends on how much area it covers. If the elements reach the borders of the frame all round, as in this photograph, the eye assumes that they continue beyond.

Regular pattern
Ordered rows and other geometric arrangements of large numbers of things make regular patterns. The alignment in an example like this is not particularly attractive, and the interest of the photograph depends very much on the nature of the objects: bottle tops would be much less appealing than these small religious plaques. Note that the sense of pattern depends on scale and numbers; an enlargement, as illustrated in the diagram, is no longer a pattern.

A third variety of pattern develops in one or two directions. Natural patterns, such as these stripes on the flanks of a zebra, often take this form. Again, providing the pattern fills the frame, the phenomenon of continuation occurs.

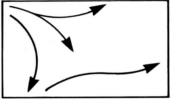

Breaking the pattern
Patterns tend to be directionless, and so often make better backgrounds than subjects in themselves. In this example, however, the mass of jeans is the subject (they are counterfeit jeans, tagged for evidence at a manufacturer's, and the subject of the photograph is a story about counterfeiting). To show quantity, they were arranged so as to reach beyond the four edges, but to make a picture out of the arrangement it was necessary to add another visual element, the man: in other words, to break the pattern in order to emphasize it.

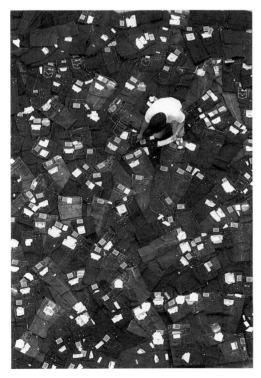

Project: Pattern and scale
Take a large number of objects, at least a couple of hundred, which can be easily assembled: map pins, matchsticks, or something equally available. Arrange all of them in an evenly spaced pattern (it can be irregular). Photograph the entire group, making sure that they reach the frame edges. Take successive photographs, closing in, ending with just four or five of the objects (for which you will need a macro lens). Determine from the results at what scale the pattern effect is strongest.

One thing you should notice is that, unless the form of the pattern or the subjects themselves are interesting, the pattern alone will not make much of a picture. It will, however, make a very effective background. Place another, preferably related object against the grouping, in a way similar to the photograph of the jeans on this page.

Texture

As shown on the previous pages, a pattern seen at a sufficiently large scale takes on the appearance of texture. Texture is the primary quality of a surface. The structure of an object is its form, whereas the structure of the material from which it is made is its texture.

Like pattern, texture is determined by scale, and this is relative to the form of the object. As an illustration, consider the appearance of the tread of a tyre on a motorcycle wheel. The fine pattern of lines and zig-zags is the texture of the tyre, particularly if viewed from a distance. By contrast, imagine how the surface of an earth-mover's tyre looks: the structure of the tread is so deep and massive that it is more a part of the tyre's shape. And the texture of the larger tyre? This is the fine, nearly smooth texture of the rubber compound. So, although the rougher it is the more dominant is the texture of a surface, the roughness itself sets a limit.

Texture also depends on the scale of magnification. The texture of a piece of sandstone is the roughness of the individual compacted grains, a fraction of a millimeter across. Then think of the same sandstone as part of a cliff; the cliff face is now the surface, and the texture is on a much larger scale, the cracks and ridges of the rock. Finally, think of a chain of mountains that contains this cliff face. A satellite picture shows even the largest mountains as wrinkles on the surface of the earth: *its* texture.

As these illustrations suggest, the first step in working texture into the design of a photograph is to recognize it. We are accustomed to thinking of texture at relatively small scales – on the kind of objects that might be used in a still-life shot – but make a practice of looking for texture at all scales. Look for the texture in a landscape, or the texture of the surface of the sea. Anything that appears sufficiently level to qualify as a surface has a texture, as the photograph of a crowded stadium on page 105 demonstrates.

Texture is a quality of structure rather than of tone or colour, and so appeals principally to the sense of touch. Even if we cannot physically reach out and touch it, its appearance works through this sensory channel. This explains why texture is revealed through lighting – at a small scale, only this throws up relief. Specifically, the direction and quality of the lighting are therefore important.

Relief, and thus texture, appears strongest when the lighting is oblique, and when the light is hard rather than soft and diffuse. These conditions combine to create the sharpest shadows thrown by each element in the texture, whether it is the weave in a fabric, the wrinkles in leather, or the grain in wood. You can see the change in effect when looking at, for example, a wall which faces west or east. On a sunny day, notice the relief when the sun strikes the wall obliquely at midday, and the loss of relief when the sun moves round to shine fully on it. On a cloudy day the texture will appear weak.

As a rule, the finer the texture, the more oblique and hard the lighting it needs to be seen clearly. The deep relief of rough texture is often obvious even in diffused lighting. The anomaly of this principle

Oblique direct lighting
The classic lighting technique for revealing texture at its strongest is at an active angle and with a direct (that is undiffused) source. The sun in a clear sky is the hardest light source available, and here, almost parallel to this wrought-iron grille, it makes the texture dominate the image.

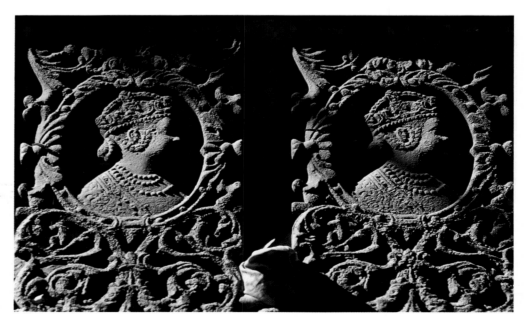

comes when dealing with reflective surfaces, especially polished metal. The texture in most surfaces is enough to scatter light, but when the surface is particularly smooth, the light is reflected in one direction only. The result is that the surface reflects its surroundings, including the light source. The texture is so fine that no directional light will show it; instead, the area and appearance of the light itself must be considered, as this is what will appear in the surface. The larger the area of light source, the smoother and less complicated the reflective surface will appear.

Project: Lighting control

Textural control in a photograph is, as we have seen, principally control over lighting, so the most useful exercise is to shoot one textured surface under different lighting conditions. You can do this in a studio, with photographic lights, or outdoors by choosing a suitable location and shooting at different times of the day. Two things should be varied: the angle of the light to the surface, and its degree of diffusion.

1

2

3

Lighting angle versus relief
An extremely acute lighting angle is not a universal answer to showing relief strongly. In diagram **1**, the angle shown is about the most effective, casting strong shadows of each raised part. However, the same lighting on deeper relief just skims the surface (diagram **2**), and hides most of the deeper parts. Some of the texture is actually lost this way. A higher lighting angle may well be better, as in diagram **3**.

Two levels of texture
All surfaces have different textures at different scales, but for some, two of these scales are sufficiently close together that both contribute to the character of the material. Certain fabrics, notably silk, have this quality. The first photograph, with the fabric lying flat, shows only one level of texture. The solution to showing both is to fold the material slightly, effectively altering the lighting angle for some of the surface.

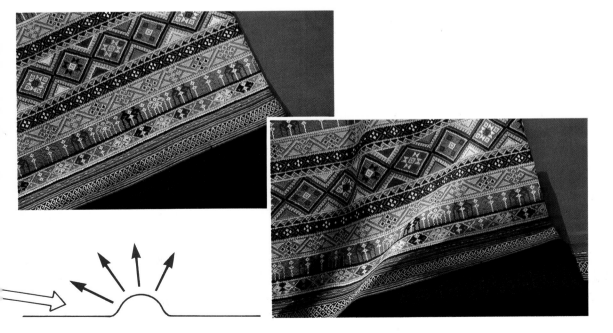

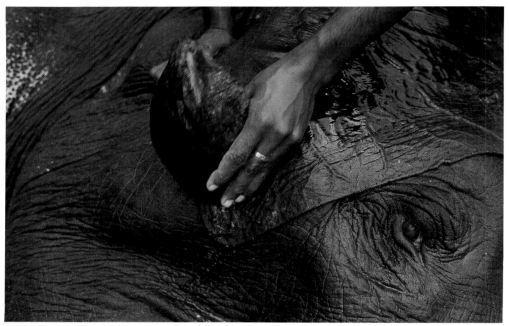

Texture display
As the photograph of the silk demonstrates, two textures in one usually makes a more interesting picture. This occurs frequently when a surface is wet. The rougher the original texture, the better: in this example, the wrinkled surface of an elephant's hide contrasts with the soft texture of the water being used to scrub it with.

Contrasting textures
Following the contrast theory of design (pages 8–11), textures are easiest to appreciate when they are contrasted with others that have different qualities. Here, the smoothness of the polished metal and the wrinkled old leather enhance each other. The only limitation in side-by-side texture is that a single type of lighting must be chosen: in this case, diffused for the benefit of the silver.

Metallic texture
Surfaces that have
extremely fine texture –
to the point where it feels
completely smooth – do
not scatter light. Instead,
they reflect it in one
direction. The result
is that the light source
itself is reflected in the
surface; hence, for an
uncomplicated image, the
light itself must usually
be large in area – that is,
diffused. The light source
here is a cloudy sky.

Large-scale textures
At a distance, and in
quantity, things that
would normally be
subjects in themselves
become elements in a
texture. In a stadium,
the crowd becomes a
surface, and the people
its texture.

Colour Theory

If used well, colour can be by far the most powerful element in a photograph. Our response to colours is much more complex than a purely visual one; they invoke reactions at an emotional, subjective level. If the use of colour in an image is powerful *and* strikes a sympathetic chord in the viewer, it can be the very essence of the photograph. In this, it differs from the other graphic elements. The arrangement of lines, for instance, may create a sensation of movement or stability, but colour invokes responses at different levels, including some that are not always possible to describe. Nevertheless, the difficulty of finding an exact terminology does not lessen the importance of what Gauguin called the "inner force" of colour. It is often more appropriate to say that we experience rather than simply see a colour.

Before looking at this multi-level sensation of colour, let us examine the basic theory of colour aesthetics. The starting point is the palette of pure colours, and these begin with three primary hues (called primary because all other colours can be made from them): yellow, red and blue. If these are mixed in pairs they produce secondary colours: orange, (from yellow and red), green (from yellow and blue) and violet (from red and blue). If these secondaries are mixed yet again with their adjacent primaries, another six intermediate colours are produced: the tertiary colours, yellow-orange, red-orange, red-violet, blue-violet, and so on.

All of these colours can be laid out in a continous progressive sequence, but if this sequence is arranged as a circle, the relationships between all the hues become clearer. The circle is also a great help in understanding the reasons for colour harmony and balance (see pages 124–41). It is the basic tool of colour theory.

This description has been simplified in order to avoid having to consider conflicting colour theories. The trichromatic colour circle shown here is the most widely accepted, and it is no coincidence that it is reasonably faithful to the colour spectrum, which can be seen through a prism or in a rainbow. At first glance there might appear to be a conflict with the three basic colours used in film chemistry – yellow, magenta (a mixture of red and blue) and cyan (a mixture of green and blue) – but in fact here we are looking at the visual effect of colours, and not at the technical problems of producing them. There is no value in trying to draw parallels between the two.

Most of the theory of colour aesthetics has been developed with painters in mind, and none of it has been applied specifically to photography. I shall attempt to redress this balance a little in the following pages. Clearly, concepts such as mixing hues to produce a third are an irrelevance, and unless you are constructing a set in a studio, you will hardly ever have an opportunity to build up groups of colours, adjusting their values and balancing their proportions. In nearly all cases, using colour in photography is a matter of selection, of choosing from what is available in real life.

This does not, however, mean that only painters can control the colours they use. Photography offers ample scope for rearranging the hues of an image; change of viewpoint, different framing, moving the subjects, altering the lighting, and the careful use of filters are all standard techniques. One of the special advantages that photography enjoys is that it records ready-made colours; with very little effort, striking combinations can be captured, needing only a decisive eye and a ready camera to select the moment.

Yellow Red Blue

Primary colours

Yellow Orange Red Violet Blue Green

Primary + secondary colours

The usefulness of colour theory for a photographer is that studying it will refine your discrimination and judgement. It is too easy to evaluate colours and colour relationships on the simple, subjective scale of "like/don't like". Certainly, most people do judge colour in this way, but this is analagous to enjoying music without having any musical training; while the lack does not inhibit the pleasure of listening, a study of music will definitely enhance it. Moreover, if as a photographer you want to become skilled in creating powerful colour effects, the theory will give you the means. Although I stressed earlier that colour provokes a subjective response in a viewer, it does obey definite laws; as we will see in a few pages, when we consider relationships between colours, the principle of harmony is not a matter of whether an effect seems pleasing, but depends on the actual, physical relationships, and can be measured.

The effects of colour work mainly on three levels. Sometimes we respond to all three simultaneously, at other times only to one or two. They are:

- Visual: the objective, immediately obvious level.
- Expressive: the emotional level, evoking sensations that are often subjective and non-visual.
- Symbolic: the cultural level, where certain colours and combinations are associated with things that we have been brought up with.

We will look at colour values in this order.

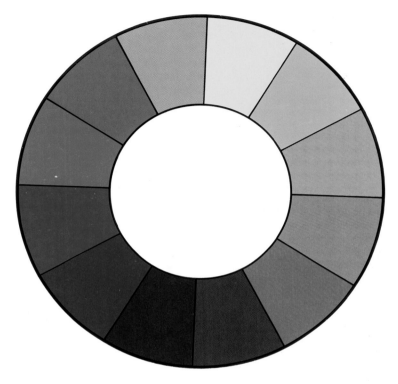

The 12-hue colour circle of primary, secondary and tertiary colours.

Varieties of hue.

Colour Quality

It is important to be able to describe a colour accurately. Without training, most people do this in terms of hue – distinguishing between yellow and green, or violet and purple – but this is only one of three ways in which a colour varies. A colour can be defined in terms of its hue, its brilliance and its saturation.

Hue

Hue is very much the prime quality of a colour, and is what gives the colour its uniqueness. The colours arranged around the circle are all different hues, and although they are close to their neighbours,

they are distinct. In photography, the two main ways in which you can influence a hue are by using a different colour of light (for instance, waiting for the orange cast at sunset instead of the neutral white light from a midday sun) and by using a coloured filter over the lens. In either case, however, it is only possible to change the overall hue, not that of individual objects.

Brilliance

The two other qualities, brilliance and saturation, are a matter of degree of a hue. Brilliance is the lightness or darkness of a colour; white and black are the extremes of

this scale. It is sometimes a little difficult to distinguish brilliance from saturation, but it may help to remember that, in varieties of brilliance, the colour remains pure and unadulterated.

The actual range of lightness and darkness differs between hues, and this can cause difficulties in matching the brilliance. Yellow can only vary between a medium tone and very light; there is no such thing as a dark pure yellow. Red, as you can see from the scale *opposite*, becomes pink when very light, and so loses its main qualities. Blue, however, covers the full range. Orange does not have dark pure versions,

Meter reading −1 stop

Exposure as meter reading

Meter reading +1 stop

Meter reading +2 stops

Altering brilliance with light level
With most colour reversal films, slight underexposure increases the intensity of colours (more simply darkens them towards black). Increasing over-exposure, as shown in the progressive steps of this sequence, reduces the brilliance, creating paler and paler tones.

because of its closeness to yellow, but the range of greens is affected more by the blue component than by the yellow, and can be very light or quite dark. Violet changes its character at either end of the scale, becoming lavender when light, but hard to distinguish from deep blue when dark.

Brilliance depends very much on the light level, and in photography is the one quality that can be changed most easily. Test this for yourself by photographing any scene that has a strong colour, and bracket the exposures over a range of several stops. The result will be a very accurately graduated scale of brilliance.

Saturation

Saturation is a variation in the purity of a colour. At one end of the scale are the pure, intense colours of the colour circle. As they become less saturated, they become more grey, less "colourful", and dirtier. Colours become unsaturated when they are mixed with white, black, grey or their opposite colours. Although this has no immediate practical concern for a photographer, it has a direct bearing on his material, since most colours in nature are unsaturated.

Most photographic subjects are things found rather than built by the photographer, so adulterated or broken colours are the staple palette. In nature, greys, browns and dull greens predominate, and it is for this reason that the occasional pure colour is often prized and made the feature of a colour photograph when found. Rich colours are therefore more often seen as desirable by the majority of photographers than are pastel shades. There is no judgement intended here – rich combinations and pale combinations can make equally powerful images – but it goes some way to explaining the attraction of intense colours. If they were a more dominant component of the landscape, more photographers would perhaps be drawn towards the subtler shades.

Brilliance

Light ⟵⟶ Dark

Saturation

Saturated ⟵⟶ Unsaturated

Colour Values

Before experimenting with the ways in which colours combine, we should look at each of the principal hues, one by one. The three primaries and three secondaries have distinct characteristics, and understanding the personality of each lays the foundation for appreciating the wide range of colour relationships.

Project: Looking at colours

All other colours derive from these six (and dilutions with white, black and grey), and the characteristics of such mixed hues follow roughly in proportion. Look at the examples given here, then go out and photograph your own versions. For the single colours, search out as many different ways of producing them as you can; do not limit your effort to paintwork on buildings and similarly easy versions. In the process of looking for the purest examples of each colour, you should find that some hues are more widely distributed than others, and that some are adulterated more often than others. The ubiquity of clear skies makes blue an easy colour to find, while violet is relatively rare in any quantity. It is important to use transparency film for this project. Colour negative film gives no clue to the colours when examined directly because of its orange integral mask, and the printing stage is an uncertain variable. Only a colour transparency or instant film give a direct, one-step reproduction of a found colour.

We will look at each hue on the three levels already mentioned on page 107 – visual, expressive and symbolic – beginning with the primaries yellow, red and blue.

Yellow

Yellow is the brightest and lightest of all colours. In fact, it does not exist in a dark form unless it is degraded; the darkest pure yellow is still brilliant in comparison with all other colours. As it is most often found against darker tones, yellow often seems to radiate light in a picture. Matching its brilliance with other colours is difficult: a similar blue, for example, would have to be quite pale. There is very little latitude in yellow; to be pure it must be an exact hue, while even a slight tendency towards yellow-green is obvious. As gold, yellow tends slightly towards orange and has a metallic flavour (see pages 122–3). Yellow (and every other colour) expands, contracts and changes its character when seen against other colours. It is most intense against black, and most insipid against white. Out of orange and red it extends the spectrum in the direction of brightness. Against violet and blue it is strong.

Expressively, yellow is vigorous and sharp, the opposite of placid and restful. Probably helped by association with lemons (a commonly perceived form of yellow), it can even be thought of as astringent, and would rarely be considered as a suitable setting for a food photograph, for example. Other associations are mainly either aggressive or cheerful.

There is no clear line separating the expressive and symbolic associations of yellow (this is true of most colours). Much of its vigour derives from the source of its most widespread symbolism: the sun. (The sun when high appears white rather than yellow, but is too strong to look at. When it is low enough in the sky to see without discomfort it is usually yellow.) By extension, yellow also symbolizes light, and strong light in particular. A second symbolic association with a very concrete base is for gold, although yellow-orange is usually more appropriate.

Pure yellow is not common on any large scale in photography. Certain objects are customarily painted yellow, for example school buses in North America, post boxes in West Germany, and road warning signs in some countries. In nature, some autumn vegetation, such as aspens, are yellow, as are some fruits: lemon, melon, and starfruit. Gold-painted and gilded objects can be yellow, as is anything bathed in the light of a low sun. This can be emphasized by shooting into the sun, particularly with a telephoto lens which is allowed to flare.

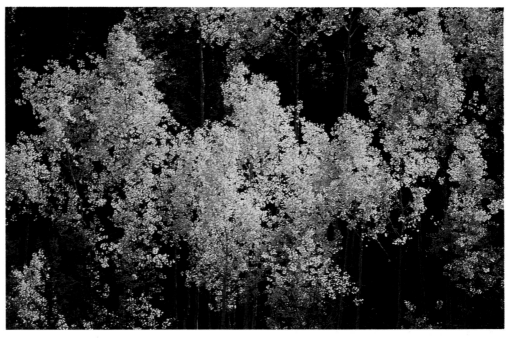

Varieties of yellow can be found in gold surfaces. The purer the gold, the yellower the hue, but this is always modulated by the surroundings, which the metal reflects.

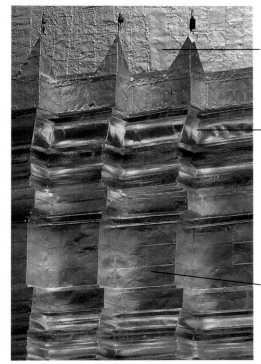

Pale yellow: direct reflection from sunlight.

Intense yellow: doubling effect of secondary reflections from other gold surfaces.

Near grey: reflections of blue sky in shaded areas neutralizes inherent yellow of gold.

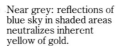

Apart from painted surfaces, good strong yellows are relatively hard to find. The energy of the yellow in these aspen leaves photographed in the autumn in Colorado is helped by two things. First, they are backlit, and so show the full colour without being diluted by surface reflections. Second, the dark shadowed backdrop acts as a neutral contrast. As the colour squares *left* demonstrate, a bright colour like yellow receives energy from a dark setting, but is drained by a pale one.

Red

Visually, red is one of the most insistent, powerful colours, and immediately attracts attention. When set against cooler colours, green in particular, red advances towards the viewer. It has considerable kinetic energy, and produces some of the strongest vibration effects against other colours, as we will see later.

In contrast to the transparency and luminosity of yellow, red is relatively dense and solid. In terms of its characteristic of redness, it has considerable latitude; in other words, it can move a way towards orange or towards violet and still be seen as essentially the same colour. At the far end of its bluish range, it produces a variety of exotic hues, including magenta and purple. Even when adulterated towards russet, and when dark, red remains recognizable.

While yellow can be felt to radiate light, red radiates the most energy. Emotionally, red is vital, earthy, strong and warm – even hot. By extension, red can connote passion in one direction, and in the other, the infernal. If we add the obvious association with blood, there are connotations of warfare and fiery destruction. These temperature associations have obvious origins, and indeed, red is commonly used as the symbol for heat. Perceived as a very powerful colour, it is a symbol for warning and prohibition, such as to indicate "stop" at traffic lights. Red has also, from its expressive associations with blood and war, been a symbol of political revolution. During the Chinese Cultural Revolution some traffic lights were left unused because of the supposedly negative use of red!

Red is fairly abundant for photography. It is relatively popular as a paint finish on buildings, vehicles and signs. In nature, many flowers are red, and display interesting varieties of hue. Embers and other burning things glow red at a certain temperature, and the richest of sunsets and sunrises, when the sun is extremely low, are red, lighting clouds to the same colour.

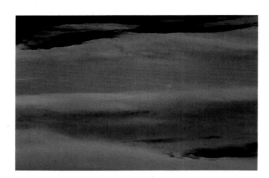

◄Although most sunsets are varieties of orange, some conditions favour rich reds, particularly the aftermath of a tropical storm when high cloud remnants catch the last rays of the sun.

Objects bathed in red-filtered artificial lighting take on a peculiar tonal quality. Deep shadows are virtually black, but highlights remain red, and do not lighten as would be normal in a full spectrum. The result is a limited tonal range. You can reproduce this effect by using a Wratten 25 red filter over the lens in normal light.

The power of red can be demonstrated in a paired exercise like this. The red arrow is tiny, but it attracts the attention like a magnet, entirely altering the dynamics of the picture. Spot colour of any hue has an eye-opening effect, but nothing works as powerfully as red.

A clear sky is the most accessible source of blue for photography, here also reflected in the plate glass façades of office buildings. The modulation of the colour across the sky is due to the use of a wide-angle lens; the intensity peaks near the zenith, becoming paler near the sun and the horizon. Note that the blue loses nothing of its essential character even when it becomes closer to cyan in the light part of the image.

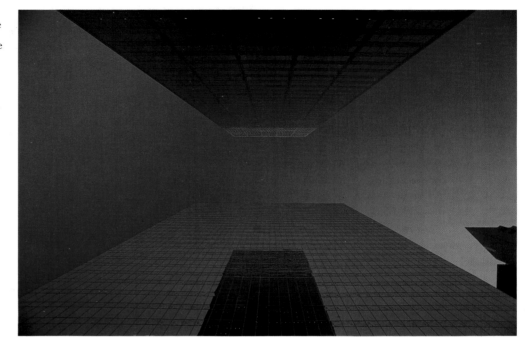

Blue

Blue recedes visually, being much quieter and less active than red. Of the three primaries, it is the darkest colour, and it has its greatest strength when deep. It has a transparency that contrasts with red's opacity. Although pure blue tends towards neither green nor violet, it has a considerable latitude, and is a hue that many people have difficulty in discriminating. Identifying a pure, exact blue, is less easy than identifying red or yellow, particularly if there are no other varieties of blue adjacent for comparison. One of the interesting parts of this colour project is assembling different transparencies which were taken on different occasions, all of which were of things you considered to be one colour. The variations in hue are often a surprise; without colour training, the eye tends to imagine that hues are closer to the standard of purity than they really are.

Expressively, blue is, above all, cool. Used in decoration, it even produces the sensation that the actual temperature is lower than it is. The contrast with red also occurs in other ways: blue has associations of intangibleness and passivity. It suggests a withdrawn, reflective mood. The primary symbolism of blue derives from its two most widespread occurrences in nature: the sky and water.

Photographically, pure blue is one of the easiest colours to find. A clear daytime sky is blue, as are its reflections (in the form of shadows and on the surface of the sea and lakes). Water absorbs colours selectively, beginning at the red end of the spectrum, so that underwater photographs in clear deep conditions have a rich, deep blue cast.

Orange

Orange is the mixture of yellow and red, and absorbs some of the qualities of both. It is brilliant and powerful when pure and, since yellow radiates light and red radiates energy, it is by association very much a colour of radiation. When lighter, as pale beige, and darker, as brown, it has a neutral warmth. Orange is the colour of fire and of warm late afternoon sunlight. It has associations of festivity and celebration, but also of heat and dryness. Symbolically, it is interchangeable with yellow for the sun, and with red for heat.

In nature, pure orange can be found in flowers, and in a slightly adulterated form in the light cast by tungsten bulbs and other sources of low (less than 2000 K) colour temperature. The 85B standard filter used with type B film (film adapted for tungsten light) in daylight is a slightly dull orange, to compensate for the blue cast of the film.

Violet

The mixture of blue and red stands out among colours as being the most elusive of all. Many people have great difficulty distinguishing pure violet, often selecting a purple instead. When you examine your own attempts, compare the transparencies very carefully with the colour patch printed on page 106.

The difficulty in recognizing violet is compounded in photography by the problems in recording it. The dye response in some colour films and papers is particularly unsuccessful with this colour. (This is also true of yellow.) You can be reasonably certain of testing this for yourself if you photograph a number of different violet-coloured flowers.

Pure violet is the darkest colour. When light, it becomes lavender, and when very dark it can be confused with dark blue and blue-black. If reddish, it tends towards purple and magenta; if less red, it simply merges into blue. The difficulty of discrimination, therefore, is in the zone between violet and red.

A mass of wedding garlands in a Delhi flower-stall produces a typically strong, brilliant orange. Most colour reversal films reproduce this colour clearly and brightly; this was shot on Kodachrome, slightly underexposed for extra intensity.

Although not completely faithful to the original bloom, this close-up view of an orchid contains similar varieties of violet.

Violet has rich and sumptuous associations, but can also create an impression of mystery and immensity. A violet landscape can contain suggestions of foreboding and other-worldliness. By extension, purple has religious and superstitious connotations. Violet symbolizes piety in Christianity, and quasi-religious beliefs, including magic and astrology. It is sometimes used to represent apocalyptic events.

Violet is a relatively difficult colour to find for a photograph. In nature, some flowers are violet, but are often difficult to record accurately on film. The wavelength of ultra-violet used as "black light" appears on film as a pure violet. Under certain conditions, the light before dawn and after sunset can appear as a reddish version of violet. Reciprocity failure on Kodachrome film caused by using it at long exposures (several seconds or more) enhances this colour effect. (This is looked at in more detail in volume IV, *Film.*)

Green

Between yellow and blue, green has the widest distinguishable range of effects. It can take on many different forms – depending on how yellowish or bluish it is – with distinct characteristics. Although of medium brightness, green is the most visible of colours to the human eye: at low levels of illumination, we can see better by green light than by any other wavelength.

Green is the main colour of nature, and its associations and symbolism derive principally from this. Plants are green, so it is the colour of growth; by extension it is a positive colour, with suggestions of hope and progress. For the same reasons, yellow-green has spring-like associations of youth. Symbolically, green is used for the same purposes as its expressive associations – youth and nature, with plant-life in particular. Even more specifically, it signifies "go" at traffic lights, as opposed to the prohibition of red.

In nature at least, greens are very common. Pure green, however, is not easy to find, as you can see by taking a number of images in this colour and comparing them with a standard reference, such as a Wratten 58 green filter. Most vegetation is considerably adulterated and subdued towards varieties of grey-green, although leaves often show a purer green when backlit than they do by reflected light.

Green chilis photographed in daylight. The sky was overcast, and so reasonably neutral in colour, but even so, a slight coldness comes through – evidence of green's sensitivity to slight colour differences.

Photography's Colour Controls

Colours in photography cannot be handled in the same way as in painting, with the same precision and construction. Selection is the main technique, but even though the limitations are obvious – the colour must be there to start with – there are several methods of changing the colours and their relationships. The following feature at some point or other in this section of the book.

Colour of daylight
Colour temperature variations range from blue (in shadow under a clear blue sky and also at dusk opposite the sunset or sunrise) through cool white (cloudy), pure white (midday sun), to yellow, orange and even red when the sun is low on the horizon.

Available light sources
On daylight film, tungsten lights are between yellow and orange-red (the lower the wattage, the more red), fluorescent lights are green to blue-green, mercury vapour lamps are blue to blue-green, and sodium lamps are yellow to yellow-green.

Film types
Tungsten-balanced film used in daylight appears strongly blue, false-colour infra-red film produces a variety of colours with appropriate filters (red or violet vegetation is a hallmark), photomicrography film used without filters has a magenta cast, and any reversal film given colour negative processing produces complementary colours.

Filters
Colour compensating filters give small additions of colour and are available in six hues; they can be combined for intermediate effects. Colour balancing filters cover a range from bluish through straw-coloured to a dull orange and are available in different strengths. Many filters are available in strong pure colours for massive changes. Graduated filters in certain colours allow a part of the image to be tinted, while various trick filters produce prismatic and other extreme effects.

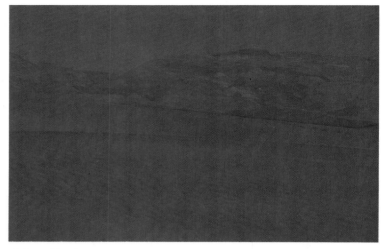

Colour from long exposures
Most of the violet tinge to this desert view at dusk comes from the reciprocity characteristics of Kodachrome 64. Used at an exposure of a few seconds, it experiences a colour shift due to differences in the response of the three layers, each sensitive to a different colour.

A hazy atmosphere close to sunset spreads the orange colour of the light across this landscape. Deliberately encouraged flare in the telephoto lens used for this photograph diffuses the colour across the film even more.

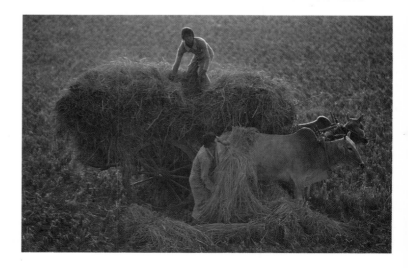

Colour control circle
Interpreting the 12-hue colour circle on page 107 for photography, this shows the principal means of producing or increasing the various hues. Filters are on the outer of the circles, light sources on the inside.

Adjacents lighten

Opposites darken

HUES

FILTER NUMBER

DAYLIGHT FACTOR

TUNGSTEN FACTOR

Orange · Light red · Deep yellow · Yellow · Light yellow-green · Yellow-green · Green · Deep green · Red · Deep red · Magenta · Violet · Deep Blue · Blue · Cyan · Deep bluish-green

21 · 23A · 15 · 8 · 11 · 13 · 58 · 61 · 25 · 29 · 33 · 34A · 47B · 47 · 44 · 65

Neutral colours

Although they lack hue and fit nowhere on the colour circle, the three neutral shades of black, white and grey are essential components of colour photography. Not only do they exist as counterpoints and settings for the colours just described, but they are mixed with these pure hues in varying degrees to make adulterated browns, slates, and other subdued colours. We should treat them as a special, but essential, part of photography's colour palette.

Black

Black, being the extreme of density and solidity, needs the contrast of another shade or colour in order to make any kind of picture. As a result, it is used in images mainly as a background, as a shape (such as in a silhouette), or as a punctuation. In photography, black is produced as the maximum density on film and paper: D-max, as it is known. Black can never be too dense; indeed, the limitations of emulsion and photographic paper are sometimes such that it appears weak, like very dark grey. This slight weakness is particularly unsatisfying in a black, which ought to represent a solid anchor for all the other colours and shades, wherever it occurs in a picture. Overexposure, fogging, or altered processing will create this weakness in the D-max.

Where black shades to grey, the grey is very sensitive to its neutrality or otherwise. Any slight hint of a colour cast is immediately recognized, and then inferred to be a part of the blackest areas. Certain colour emulsions do actually have a slight cast in their maximum density. You can check this by taking an unexposed area of transparency film that has already been developed and holding it up against a small intense light source, such as a naked lamp. The dimly visible light will show any colouration. The neutrality of black outweighs most of its associations and symbolism, but where it appears extensively in an image it can be heavy and oppressive. Depending on how it is used, it can be either dense, like a solid wall, or empty, as in featureless space.

Photographically, black is the absence of light. Partial shading, using a mask held in front of the lens, can therefore blacken areas of the image. If you want to guarantee that an area reproduces as black, you may need to take precautions, since the eye is sensitive to even a slight lightening of tone. For instance, black paper is *not* likely to produce an adequately dense background in a straightforward studio still life. Black velvet is the material of choice.

White

White is the absence of any tone whatsoever: clear film in a transparency or unexposed printing paper (negative/positive). Nevertheless, just as a black object must contain tonal highlights and modelling in order to be recognizable, so a white image needs at least the modulation of pale greys or off-whites. These slight modulations are very susceptible to colour cast, however – even more than with black – and achieving complete neutrality is not easy.

The key tones in an essentially black image are the grey highlights.

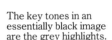

The density of black depends critically on the exposure; an incident or substitute reading is usually necessary.

(This is a problem chiefly associated with grey, and is looked at below.)

Photographically, white needs care in exposure. Slight underexposure makes it appear muddy; slight overexposure destroys the hint of detail and usually gives an unsatisfactory sensation of being washed out. Although its neutrality robs white of strong expressive association, it generally symbolizes purity.

Grey

The number of greys is almost limitless, ranging not only between black and white, but also varying in hue depending on slight colour casts. If a colour is heavily unsaturated, it becomes a type of grey rather than a greyish hue.

In its purest form, grey is the essence of neutrality, deadening the sensation of colour in proportion to its area in the picture. For this reason, it may be desirable to have any grey slightly tinted in a colour photograph in order to give it some life.

Without any qualifying description, grey is assumed to be mid-grey, and this has a special place in photography. Mid-grey is exactly halfway between black and white, and reflects 18 per cent of light falling on it. Hence an 18 per cent grey card, as it is known, is sometimes used for exposure calculations; it is the standard for an average subject. A through-the-lens reading of 18 per cent grey gives exactly the same exposure value as a hand-held incident meter reading. (This is covered in volume I, *Cameras and Lenses.*)

Pure grey has leaden, mechanical associa-tions, with connotations of being uninteresting (the word is used this way to describe people). Bluish grey expresses coolness; reddish and orange-grey warmth. Grey is the colour of stone, and so also borrows associations of solidity and weight. As a group, greys are very common, not only in nature (rocks, dark clouds, water on an overcast day) but in man-made environments (concrete, plaster, streets, buildings, smoky atmosphere). Pure neutral grey is difficult to record, however, because of the eye's sensitivity to colour bias. Use the colour block printed here as a reference; better still, buy an 18 per cent grey card from a photographic manufacturer. Underexposure of white produces any shade of grey; neutral density filters are also pure grey.

As with blacks, exposure is critical with white subjects. Even after careful metering, bracketed exposures are recommended.

The shadows offer a reference tone for the white of this wooden wall.

The very neutrality of grey reveals any slight colour, either inherent, due to the lighting or to film manufacturer.

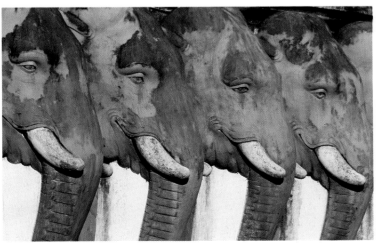

Broken colours

In traditional colour theory, pure colours have prominence, and painters are trained to construct hues from the primaries and secondaries. In contrast, photography deals almost exclusively with the colours found in the real world, and its colour priorities are consequently different. As we have seen through cataloguing the principal hues, they are not particularly common in nature. Most found colours are broken: that is, they are seen as a mixture of hues that gives a deadened, unsaturated effect.

Such broken colours are, however, very rewarding to work with, because of the great variety of subtle effects. Colour theory gives an artificial stress to the pure primary and secondary colours, as these are the foundations of all others; it would be a mistake to infer that pure hues are inherently more desirable in a picture. The differences between broken colours are on a much narrower range than the pure colours, and working constantly with them trains the eye to be more delicate in its discrimination, and to prize rare colours.

Russet, sienna, olive green, slate blue – these and an almost limitless variety of others, including the chromatic greys, make up the basic palette of colours available for photography. This is one of the important differences between photography and other graphic forms: the choice of colour is mainly limited to what is naturally available.

Project: A unifying colour theme

If you are taking a set of pictures that are intended to be displayed together, there may well be an advantage in linking them graphically. There is hardly ever any point in trying to force this, but one opportunity that sometimes arises is colour. The subjects may have a particular range of hues, or, quite commonly, the setting may have certain colours characteristic of it. The example here will give you a better idea of how this can work.

In this case the subject was a hill-tribe from the Golden Triangle in south-east Asia. One thing that became apparent once the shooting was under way was the predominance of browns. The earth, the build-ings of wood and bamboo, even the skin tones were in a variety of shades of brown. Although not an insistent characteristic, it was prevalent in most of the locations and seemed relevant to the life of these people, emphasizing visually the close relationship they have with their environment. A small point, and better understated than made too much of, but valuable because it helped to give a unity of design to the photographs.

In practice, the way of exploiting such a colour theme is a matter of editing and selection, cropping the shots in such a way that colours outside the chosen range are excluded. This was hardly possible in all situations, but once having recognized the possibility, it became a stylistic addition to the photography. Clearly, this is a project that you can reasonably expect to do only when there is a genuine colour characteristic in the setting. Also, it lies very much within the realm of broken colours, partly because these are the most commonly found hues, and also because their modulation is quieter and less overpowering than that of pure colours.

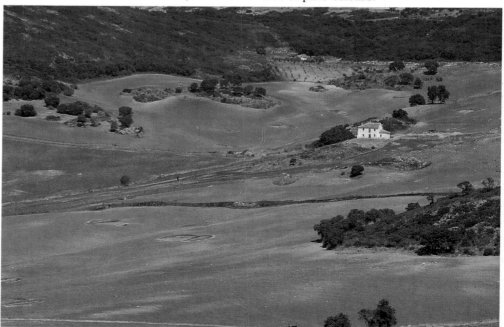

Browns and chromatic greys make up the earth colours of this Andalusian landscape.

The predominant warm browns of these hill-tribe villages in the Golden Triangle created a visually unifying element for a long photographic assignment.

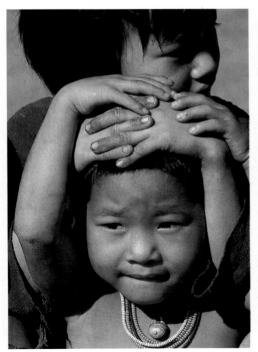

Metallic colours

Metallic colours comprise another group that has unique characteristics. What distinguishes these colours is the special gradient of shading towards the highlights, and the extremely subtle shift of hue which accompanies it. In particular, metallic surfaces have a fairly high reflectivity and so pick up the tones and colours of their environment. As this is overlaid on the inherent colour of the metal, the effects can be interesting and dynamic. The type, quality and direction of the light source makes all the difference, and if you have sufficient control to alter it, experiment with the variety of effects.

The reflections of direct artificial lights over a parking lot are intense and concentrated in the polished metal of these cars. Note the slight colour shifts that accompany the variations in tone.

The leaden finish of this Javanese statue appears metallic because of its particular reflective qualities. The textured surface and diffused light from an overcast sky produce a relatively even gradient of tone.

Gilded bas-relief figures on the doors of a Thai temple contain distinct but soft-edged highlights on the convex parts of their surface.

123

Colour Relationships

Even when describing single colours alone, it is impossible to avoid their settings, as we have seen in the preceding pages. The energy of any hue changes significantly as it moves from a white background to black. Colours are never, in any case, seen totally in isolation, and two different colours side by side will each react to the presence of the other. They do this in two ways: the characteristics of each are altered, and the combination itself creates visual and expressive effects.

Colours, then, change according to their context. Ultimately, despite the inherent qualities of a hue, the effect is determined by contrast. This is why the first project in this book was a scale of contrasts; the relationship between different graphic elements is at the heart of design. We can be more specific about this, and identify several different types of colour contrast alone, each of which will be covered in more detail on these pages. For now, the principal colour contrasts are:

● Contrast of hue. That is, combinations of the hues that have been individually described on pages 106–123, and their relationships across the colour circle.

● Contrast of brightness. Even though each colour can be dark or light within a range, the standard pure versions vary between hues, from violet at one extreme to yellow at the other.

● Contrast of saturation. As we have already seen, colours can be adulterated from pure all the way to grey. Usually, the contrast of a diluted colour with a pure hue benefits the former; it gains life from the pure colour, which itself loses energy.

● Cool/warm contrast. Our associations of temperature with colour are so strong that we automatically perceive a difference on this scale, particularly between a colour with a strong blue-green component and another containing orange-red.

● Successive and simultaneous contrast. These are both special-case phenomena. Successive contrast, also known as after-image, causes the eye to "see" the opposite hue immediately after looking at a strong colour. If you stare at the patch of red on page 106 for a minute, and then close your eyes tightly, you will see a green after-image. What is happening is that the eye supplies its own reaction. The effect is strongest with a bright colour, and if you stare at it for a long time – at least, until the eye tires.

Seen in another context, this effect becomes simultaneous contrast when a patch of grey on a background of a single hue appears tinged with the opposite colour. Although much slighter, this same contrast occurs between two non-complementary colours; each seems tinged just a little with the opposite (see page 141).

● Spatial contrast. As seems logical, the bigger the area of a colour the more dominant it is. Nevertheless, the contrast effects of size are more interesting when a strong colour appears very small. It seems to fight more for attention, drawing the eye to it as a focus of interest. The position in the frame of the areas of colour, and their shapes, also influence the nature of spatial contrast.

The following pages will be devoted to exploring the great variety of colour relationships. Central to this is the theory of colour harmony, for which there are some reasonably precise principles. Harmony is widely, but wrongly, thought of as a description of similarity, arrived at subjectively on the grounds of appearing to be pleasing. In fact, harmony is a function of balance and equilibrium, and we have already seen how this applies to other graphic elements, on pages 22–7.

The clue to the way harmony works lies in successive contrast: the after-image. By supplying an opposite colour, the eye is, in effect, restoring a balance. This is one of the main principles of virtually all colour theories: that the eye and brain find colour satisfaction and balance only in a mid-grey. We should qualify this by saying that an actual grey does not have to be present, only colours that would give grey if combined. The eye and brain appear to mix the colours received.

This is where the colour circle really comes into its own. Any two colours directly opposite each other on the circle give a neutral result when mixed. I say neutral rather than grey, because it depends on whether coloured lights are being combined, or pigments. Exercises with pigments are irrelevant for photography, but photographic lighting gives an opportunity to try this out for yourself.

With two appropriate gelatin filters – for example, a Wratten 25 red and a Wratten 58 green – and a pair of flash units, set up a still life as follows: use a single, more-or-less rounded subject, and arrange one flash on either side of the camera so that part of each light overlaps the other. Put the red filter over one flash head and the green over the other. The result will be an image that is red on one side, green on the other, but white on the front of the subject where the two lights mix. Now take the two gelatin filters and hold them together against the light; combined they make a neutral very dark grey, almost black.

The same would apply to any opposing pairs on our colour circle. The combined result is neutral (it does not matter in this case whether it is white, grey or black). Such pairs of colours are called complementary, and their combination is harmonious, in a real, demonstrable sense. We can take this further. Any combination that is symmetrical around the middle of the circle has a potential blend that is neutral and, therefore, balanced. So, three evenly-spaced colours like the primaries yellow, red and blue make a harmonious group, as do yellow-orange, red-violet and blue-green. Sets of four colours can also be harmonious, as can intermediate and unsaturated hues.

There is a very important caveat to this principle of colour harmony. You can apply it with complete success, but its foundation is the psychology and physiology of perception and no more. Used precisely it has something of a mechanical, predictable effect, and what you gain in producing a satisfying sense of equilibrium you are likely to lose in character, interest and innovation. Colour harmony can show you how to make an image look calm and correct, but it is hardly conceivable that anyone would want all or most pictures to generate this im-

pression. You should know the base-line of colour harmony, but only as a foundation. Good use of colour involves using dissonance and conflict where appropriate.

Another consideration that has practical relevance is the degree of choice you are likely to have in photography. As we have said, colour theory has been worked out principally for painters, not photographers, and a tacit assumption has always been that colours can be chosen exactly as wanted, the only limiting factor being the skill and aesthetic sense of the colourist. However,

as you will find out by undertaking the colour relationship projects that follow, this is not so easy in a photograph. To a large extent, you may have to put up with what you can get; the opportunities for creating colour relationships are restricted.

This lack of control over colouration actually teaches a pragmatic and resourceful approach. Where the hues are not quite complementary, for example, their proportions could be altered in the image. Working with found colours frequently means making compromises.

Colour harmony
Using the colour circle from page 107, harmonious colour relationships can be worked out very easily. The only requirement is that the colours used are arranged symmetrically around the circle's center. Given this, pairs and groups of three, four and more produce a sense of balance.

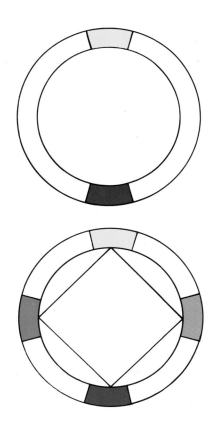

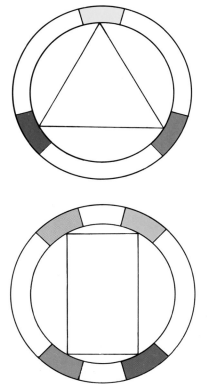

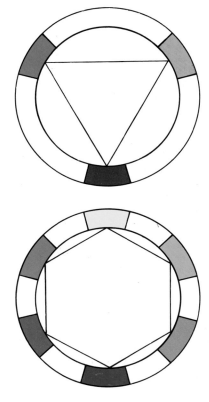

Harmonious Proportions

It is not quite enough to say that certain pairs and combinations of colours are harmonious. Each colour has an intrinsic brightness, so complete balance requires that the combinations are seen in certain proportions. In photography, this is complicated by the details of texture, shape, and so on. The colour in photographs is enmeshed in the structure of the subject.

As a start, however, we can look at the basic combinations of primaries and secondaries. The complementary for each primary colour is a secondary: red/green, orange/blue, yellow/violet. However, we have already seen something of the differences in brightness among these six colours, and the strength of each in combination follows this. In descending order, the generally accepted light values, determined by J.W. von Goethe, the German poet and playwright, are yellow 9, orange 8, red and green 6, blue 4 and violet 3. When they are combined, these relative values must be reversed, so that violet, for example, occupies a large enough area to make up for its lack of strength. The areas needed for these colours are, therefore; violet 9, blue 8, red and green 6, orange 4 and yellow 3.

The colour blocks below illustrate the ideal balance proportions of the three complementary pairs and the two sets of three. Other combinations can be worked out in the same way. For simplicity and continuity, the proportions shown here are for pure standard hues, but the principle applies to any colour, whether intermediate on the colour circle, a mixture, or poorly saturated. The brightness or darkness of the hue also affects the proportion.

Although exact harmonious proportions could be worked out for any colour image, the exercise would be quite pointless and impractical. Under no circumstances should these proportions be followed rigidly, according to formula. Although the principles exist, and it is important to be familiar with them, design should never follow rules. If you want to create harmony in a photograph, intuitive judgement of the balance of colours is sufficient; indeed, it is the only practical method which allows an imaginative and dynamic approach. The principles of harmony should not be neglected, but are for preparation only.

Using the relative brightness of pure colours explained in the text above, the balanced combination of complementaries, and of the basic three-colour sets, looks like these individual blocks.

The areas of red and green in this sign are approximately equal in size and brilliance, resulting in equilibrium.

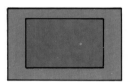

The purity of the colours also enhances the optical vibration at the edges of the lettering where the two colours meet.

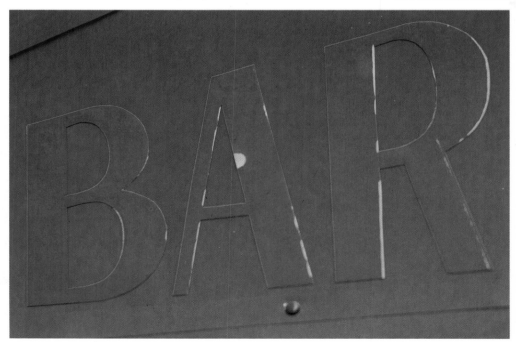

Red/green harmony

Pure red and pure green have the same luminosity, and so combine harmoniously in equal proportions. This, however, presupposes that both colours are pure and exact, and as this rarely happens, in practice there is little point in measuring the areas precisely. As a project, look for red/green combinations, but the furthest that you need to go is to keep the proportions approximately equal: a quick judgement by eye alone is sufficient. In nature, red/green combinations are mainly limited to plant-life; although green is abundant in many landscapes, red is much less so. Urban settings offer more variety of choice.

Red and green, with their same luminosity, produce a special colour effect known as vibration. You can see this in the colour patch on page 126 along the edge between the two colours. The edge seems to be optically unstable; if you stare at it for long enough you can see a light and dark fringe. This optical vibration makes pure red/green combinations unsettling to look at for long, and even irritating. Nevertheless, the effect is eye-catching and dynamic, and greatly enhances the energy of these photographs.

To a greater or lesser extent, vibration occurs between any two brilliant colours, but nowhere is the effect as strong as it is between red and green. This is because they are complementary as well as naturally having the same luminosity. Blue against red and blue-green against orange-red are the next most energetic combinations.

Unless you shoot freshly painted man-made combinations, it is not particularly easy to achieve very strong vibration in photographs; as we have already seen, saturated colours are relatively uncommon in nature.

As you might expect, changing the proportions weakens the harmony. However, when the balance is extreme, the smaller colour acquires extra energy. As you can see in the aerial photograph of the farm buildings, the red roof, far from being overwhelmed by the green of the fields, draws attention to itself insistently. Instead of a colour combination, we have a colour accent. The effect is stronger when red is on a green background than vice versa, because of the tendency of warm colours to advance while cool colours recede.

Colour harmony is still present when the red and green are less pure, but is correspondingly weaker. Here the main relationship is seen as being between the palm tree and its shadow.

Colour accent
The strength of the red in the roof of a barn seen from the air is out of proportion to the space it occupies. Being so small, the red reacts to compete for attention.

Orange/blue harmony

Orange is twice as luminous as blue, so that the best balance is when the blue is twice the area in a picture. Compared with red/green combinations, this makes for less optical confusion about which colour is the background. It also drastically reduces the vibration, so that orange and blue are generally more comfortable to look at.

Of the three classic colour harmonies, orange/blue is probably the easiest to find photographically. Orange and blue lie very close to the ends of the colour temperature scale, so that they can be found in many common lighting conditions. A low sun, candle-light, and low-wattage tungsten light bulbs are some of the sources of orange – not pure, but close enough. A clear sky, and the light from it, is a ubiquitous blue. The photogaph on this page of cliffs at sunset is an easy example. As well as contrasting in brightness, orange and blue have the strongest cool/warm contrast of any primary/secondary complementary pair. This produces an advancing-receding impression, and with the appropriate setting, a relatively small orange subject stands out powerfully, with a strong three-dimensional effect.

Project: Colour proportions

Continue the basic project of finding your own versions of the examples shown here, in approximately the ideal proportions (but do not waste time trying to measure them). In addition, add two other exercises in proportion: one is to reverse the areas of the two colours, the other is to use "spot colours" within a neutral setting. These are two variations on the basic projects that can be performed with any colour combination, but orange and blue are probably the easiest hues to work with.

If you reverse the proportions so that the orange dominates a small blue area, the classic effects are by no means completely lost. As the photograph below illustrates, the combination of the two hues alone is enough to produce a general sense of harmony. And, as we have seen with the red colour accent on page 127, the eye is drawn to the smaller area of colour. In focusing just on this part of the image, the eye receives a local impression that is more balanced, with the blue seeming more powerful than its area merits.

Spot colour combinations occur when the setting is relatively colourless and the two purest hues occupy localized areas. In this instance, the separation of the orange and blue (or, indeed, of any combination) greatly reduces the significance of proportions. Certainly, the extra brilliance of the orange tends to draw the eye more strongly, but the matrix of tones and unsaturated hues confuses the judgement of area. The complementary nature of these two colours creates a stronger sense of relationship than would exist between two asymmetric hues. Needless to say, spot colour combinations depend completely on a neutral setting; other distinct colours overwhelm a simple paired relationship.

Ceremonial parasols in a Balinese festival make a prominent contrast with the intense blue of the sky. Being brighter than the blue, these orange areas produce the best equilibrium when approximately half the area of the sky.

The orange light from a setting sun enhances the colour of these cliffs. In this colour combination, the large area of visible sky makes it easy to adjust the proportions: by changing viewpoint, focal length, and framing.

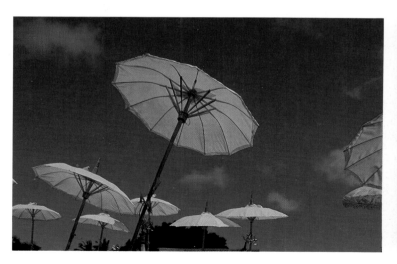

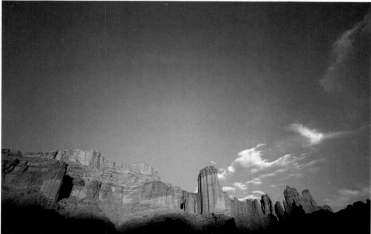

Reverse proportions of orange and blue retain the essence of colour harmony, but produce a more dynamic effect. The eye is drawn towards the blue ashes in an attempt to restore the expected proportions.

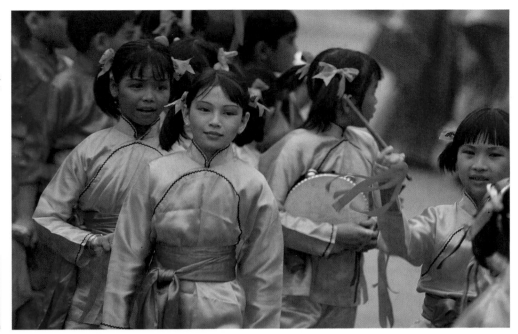

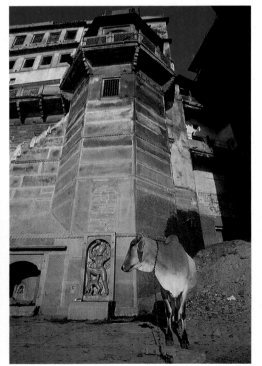

Spot colours
Although the limited extent of the orange and blue gives nothing like the harmonious relationship seen in the other photographs, it helps to move the eye diagonally across the image between the two patches.

129

Project: Proportion

One practical method of dispelling the idea that the traditional balance proportions are "correct" is to take a situation which allows you to vary the proportions of two complementary colours. The easiest circumstance is a single-colour background and an object of manageable size: one that you can move, walk around, and shoot from different distances and viewpoints. Here, I have taken the most readily available complementary pair – orange and blue – in an easy form. We start with a composition which organizes the two colours in approximately balanced proportions – 1:2 in favour of orange – and then change the viewpoint, lines and designs progressively. The object of this exercise is less to improve the image than to understand the variations in tension and balance.

The same view, with a standard lens, but vertical. Although the proportions are the same as before, the vertical composition with the jug at the bottom of the frame gives extra weight to the dense block of blue above.

Pulling back alters the proportions substantially. The blue sky dominates, but the orange fights back. The result is a more dynamic, unsettled picture.

In this setting, the only way of altering the placement of the orange colour is to include the white wall on which the jug is resting. The white and grey tones add some complexity to the image: white reduces the apparent intensity of the orange, but the combination of white and orange opposes the blue sky in brightness.

Placing the jug of orange high in the frame severely reduces the orange/blue combination by emphasizing the shapes and tones of the balustrade. The area of blue sky has not really been reduced by very much, but it appears less significant through being split up into three areas.

Pulling back further nearly kills the orange, which is now overwhelmed by the shapes and shadows of white and grey.

A return to simplicity, using a wide-angle lens and a low viewpoint. The white wall is uncomplicated by shadow, and acts in concert with the orange to give a tonal balance with the dark blue of the sky.

Stepping right back with the same 20mm lens reduces the orange to the status of spot colour see page 127). The extreme brightness of the white however, overwhelms it.

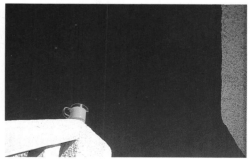

Yellow/violet harmony

This third complementary pair combines the brightest and darkest of all the pure hues. As a result, the contrast is extreme and the balanced proportions need to be 1:3, with the yellow occupying only about a quarter of the image. At these proportions, the yellow is almost a spot of colour, and the sense of a relationship between the two is correspondingly weak.

The relative scarcity of violet in subjects and settings available for photography makes yellow/violet an uncommon combination, particularly as in the ideal proportions the violet must occupy a large area. One of the few reliable natural combinations is in flowers; the close-up of the center of a violet is a classic example.

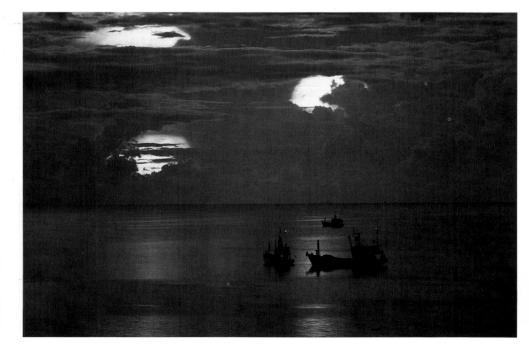

▲ The center of a violet contains the colour harmony of yellow and violet. By closing in with a macro lens, the proportions can be adjusted.

Yellow-violet colour harmony is the principal reason for the attractiveness of this dawn view of fishing boats in the Gulf of Siam. Even though the two hues are pale, the harmony is persistent, and contributes to the calm, placid feeling. The violet comes partly from the reciprocity failure of the film used – Kodachrome 64, exposed at one second.

Multi-colour Combinations

While red/yellow/blue is the most powerful mixture of pure hues, other combinations of unbalanced colours can have similarly impressive effects. As you can see from the pictures on these and the following two pages, there is a major difference between groupings of strong, bold colours and those of delicate, pastel shades. Pure hues fight intensely for attention, and the strongest combinations are those of three colours. Even a fourth introduces excess competition, so that instead of building each other up, the colours dissipate the contrast effects.

Wherever you can find groups of pure colours, they make easy, attention-getting shots. Being unbalanced in their positions around the colour circle, they do not mix to grey in the visual cortex, and so contain the element of tension missing from the primary and secondary mixes on pages 126–31. Considered as part of an overall programme of shooting, strong colour combinations are the short-term, straight-between-the-eyes images. They fit well into a selection of less intense pictures as strong punctuations, but several together quickly become a surfeit.

Three-way colour balance

We can extend the balancing principle of complementary pairs to three and more colours. Going back to the colour circle, three equally spaced colours mix to give a neutral colour (white, grey or black depending on whether light or pigments are mixed). The most intense triad of colours is, as you might expect, primary red, yellow and blue. The colour effect in a photograph depends very much on how saturated they are and on their proportions: equal areas give the most balanced result.

Three-way colour balance
Evenly spaced around the colour circle, the three primary hues form an equilateral triangle. Together they cancel each other out, mixing to produce neutral grey.

Also evenly spaced around the circle, the secondary hues balance each other in exactly the same way as the primaries.

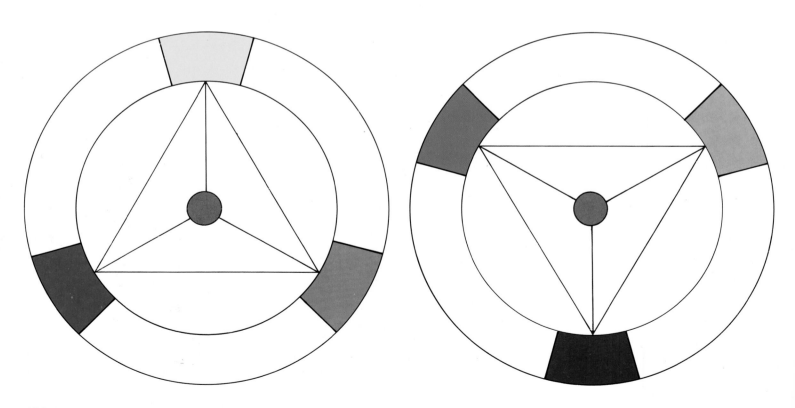

The classic primary combination is of the three pure colours red, yellow, and blue, shown here on coloured balloons. The areas of the three colours are roughly equal, and the combination of colours gives a satisfying effect as opposed to an exciting one.

Although they are set among other, mainly neutral hues, and scattered over the image, the intensity of the three pure primaries punches through to dominate this image of painted Balinese fishing boats. No other colour combination has quite the same power and intensity, even in small quantities.

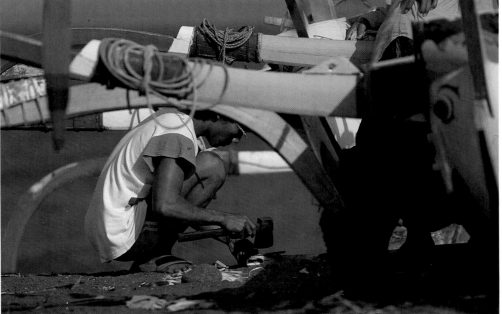

133

Red, blue, gold and pale blue make a bright, dynamic combination in these painted wooden puppets. The familiarity of the first three colours stands in contrast to the rarer and more interesting light blue at the top of the picture.

The proportions of this balanced triad of secondary colours takes account of their relative brightness. The orange is inherently more energetic, and its small area in this picture offsets the larger but more subdued green and violet (actually closer to purple). Shooting from closer would have made equal proportions possible; pulling back would have reduced the orange even more.

Light contributes strongly to this three-colour combination of blue, gold and green. The blue of the sky is intense at twilight, the gold more strongly coloured by orange tungsten lighting, while fluorescent lamps are predictably green. Overall there is a metallic feeling to these colours.

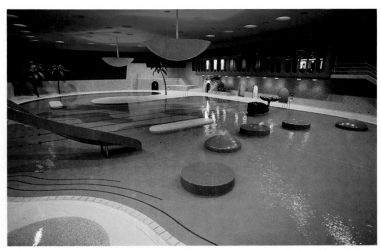

Soft colours
Diminishing the range of colour intensity has the interesting effect of refining the eye's discrimination. The differences in hue between unsaturated colours are less obvious than with fully saturated colours, and the eye pays more attention in assessing the differences and relationships. The precise colours are usually inherently more interesting because they are less familiar than the pure primaries and secondaries. Appreciating these more subtle colour relationships takes a little longer, so that in terms of viewing, this kind of photograph is normally a slow starter, but lasts. There are more opportunities for exploring colour relationships with pastel hues.

There is a hidden consistency in this four-way combination. The dominant hue, green, acts as a setting for the three other limited areas, which are the classic primaries.

Pastel shades
Apart from the contrast of hue, the three colours green, blue and orange share a similar quality of desaturation. This helps to make a coherent image.

In spite of the extreme subtlety of colours in this photograph of a shack, the original hues from which they were derived are fairly close to the primary triad of yellow, red and blue. The interplay between these delicate shades is on a very fine level of texture, and the natural visual effect is calm and soothing.

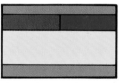

Colour Contrast

There are natural associations between temperature and colour. Flame and things glowing with heat are either orange, or close to it on either side on the colour circle (that is, yellow-orange, or towards red). The hottest colour as perceived by most people is, in fact, orange-red. Its complementary, opposite on the colour circle, is blue-green, and this gives the coldest effect (these temperature associations are real; a room decorated in shades of blue-green does feel physically colder than one in orange-red, even if both are identical in temperature).

The colour circle can be divided in half, between cold and warm. The centers of the two half-circles are blue-green and orange-red respectively. These two poles always have temperature associations, but the colours on either side depend on context for the strength of their effect. Green, for instance, may appear cool if contrasted with a distinctly warm colour like orange, but will not generate this impression if combined with yellow-orange.

This cool/warm contrast, an additional way of dividing the colour circle, can affect the other qualities of colours (the individual qualities of particular hues, the harmonious effects of proportions). One particularly important association is the suggestion of distance. Cool colours recede, warm colours advance; blue-green and its neighbouring colours are associated with backgrounds and distance. If the colour of a subject is warm, and that of its background cool, the impression of depth will be heightened (see pages 158–61). This is a different depth sensation from the one created by light/dark contrast, but if the two are combined (a pure orange against a deep blue, for example), the impression is slightly stronger. As a result, a small area of a warm colour set in a larger cool-coloured frame, such as in the photograph of the laboratory on page 139, always looks appropriate.

Cool/warm contrast has other associations, also related to our experience. Cool colours suggest transparency and airiness. This comes in part from the blue colour of a clear sky, in part from the pale blue of things seen at a distance through atmospheric haze. The opposites for warm colours, opacity and earthiness, are not such strong associations, but exist by virtue of the contrast. Also, cool colours, blue-green in particular, suggest wetness – a natural association with water – while orange-red and similar hues suggest a dryness – from the effect of heat. Cool/warm contrast occurs frequently in both natural and artificial lighting conditions. The contrast between sunlight and blue sky, which is also the contrast between sunlight and shadow, occurs everywhere, and when the sun is low is exaggerated. At dusk, the colours in the direction of the setting sun are warm; in the opposite direction they are cool. Twilight gives a particularly cool background. Artificial lighting produces even stronger opposites. Tungsten lighting is yellow-orange on daylight-balanced film, and the lower the wattage and the dimmer the lamp, the more orange it appears. Fluorescent lighting appears greenish to blue-green on daylight-balanced film, and strongly blue-green on type B film.

Most of these are colour temperature effects, and it is important to understand the differences between this scale and the cool/warm contrast of the colour circle. They are similar, but not identical. For instance, the colour temperature scale goes from hot (orange) through white hot to extremely hot (blue). This is physically accurate, but outside our normal experience. On the contrary, we associate blue with cool things, not with extreme heat. The second difference, a small one, is that the range of colour temperature is not along a scale of pure colours; both the orange and blue at either end are a little dull in comparison with those of the colour circle.

Cool and warm poles
At right angles to the light-dark split of the colour circle (centered on yellow and violet respectively), the cool-warm division looks like this. The cool pole is blue-green; the warm pole orange-red. The temperature associations of the colours on either side is not always consistent, and depends on their context.

Cool colours
Underwater views
always appear cool
because of the selective
absorption of light.
Although the sunlight
striking the surface of the
sea is virtually white – a
mixture of all the colours
of the spectrum – water
absorbs the spectrum
progressively. That is,
as the depth increases,
more of the spectrum is
lost, from the red end
towards blue. Here, at
about 20 feet (6m)
in clear water, all red
and orange has been
absorbed, leaving only
the cool colours.

Warm colours
Close to sunset, the
sunlight becomes more
orange. The closer the
sun is to the horizon, the
more atmosphere its rays
pass through, and this
filters out the cooler
colours – the shorter
wavelengths – by
scattering. This is
progressive, like the
absorption of warm
colours by water; as the
sun sets, the colour
moves from white to
yellow, and then towards
orange and red.
Atmospheric conditions
determine the exact
colour.

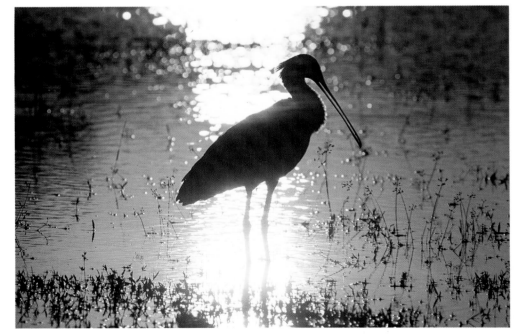

25,000 K

Daylight
(deep shade)

5500 K

Noon
daylight

Domestic
tungsten

2000 K

Candlelight

The scale of colour temperature, from amber to bluish, is based on the colour that an object would glow if heated up to various temperatures. Measured in degrees Kelvin, it has a special relevance to photography because most of the important light sources used for shooting lie on it. Although the contrast between the two ends of the scale does not correspond exactly with the red-orange/blue-green contrast shown on page 136, it is a fairly close match, and can be made use of quite easily, as the examples on these pages show.

Colour from film
Tungsten lighting is much warmer than sunlight in appearance, and has considerable use in photographic lamps, so some colour film is balanced for it by the manufacturer. If used in daylight, this type B film appears bluish: the complementary of tungsten light's orange colour. Conversely, normal colour film that is balanced for daylight records tungsten light as orange.

Cool/warm contrast 1
One available source of cool and warm colours in a picture is when tungsten light is used in combination with fluorescent light. In this case, the small microscope light is tungsten at a low wattage (and so more orange than a photographic lamp) and the overall room lighting is cool fluorescent. This film is daylight balanced.

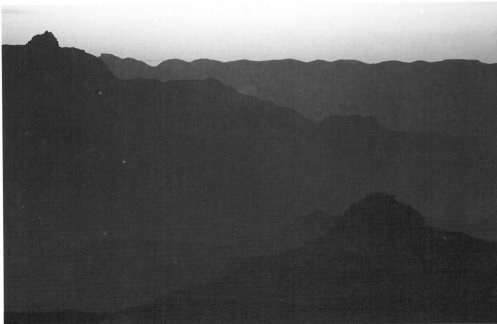

Cool/warm contrast 2
Combinations of cool and warm colours can also be found frequently in natural lighting conditions. When the sun is low in a clear sky, there is a natural contrast across the sky. The sunset, as in this view of the Grand Canyon, is warm in colour. Facing it is the cool colour of the blue sky, which illuminates the shadows.

Interference colours

A special assembly of colours occurs through a phenomenon known as interference. Interference effects occur when a material slows some of the light rays passing through it or reflecting off it, and when these interact with other rays to create a play of colours. As a prism, or drops of water in the area of a rainbow, split light into its spectrum, so interference colours are also produced from white light. Interference colours are produced by, among other things, oil slicks, ordinary soap bubbles, pearl and mother-of-pearl.

Simultaneous contrast

When presented with any colour, the eye requires the opposite, its complementary, and if this is not there, the eye attempts to make it up for itself. This is simultaneous contrast. Go back for a moment to page 124, where we discussed successive contrast. There, after staring at an object for enough time for a patch of colour to impress itself on the retina, in looking away to something neutral a complementary after-image was produced. With simultaneous contrast it is not necessary, however, to look away to see something of the same effect.

In the pair of colour diagrams on page 141 the two grey patches are identical. The sensation in looking at them, however, is that they are slightly different; there seems to be a difference of hue. The grey that is surrounded by orange appears tinged with blue. The other patch of grey, embedded in blue, has the opposite appearance: it seems slightly orange. Each, in other words, takes on a little of the complementary colour to the one that surrounds it. You can see this effect more strongly if you cover everything on the page except for the colour patch.

This simultaneity of contrast can also be seen in the photograph on page 141. It occurs to a lesser extent between any two non-complementary hues. In the absence of an exact opposite of colours, the eye sees the two as being shifted towards their complementaries, which increases the tension.

Cross-polarization also produces a strong play of colours in some transparent materials. Here, a polarizing screen covers the light source, which is underneath this plastic syringe, and a polarizing filter is placed over the lens. Rotating the lens blocks nearly all of the direct light, but stresses in the plastic allow through a variety of spectral colours.

A close-up view of the inner surface of an abalone shell displays a play of colours caused by light interference. In the same way as pearl and mother of pearl (see the photograph on page 176), the surface is transparent to very shallow, but varied, depths.

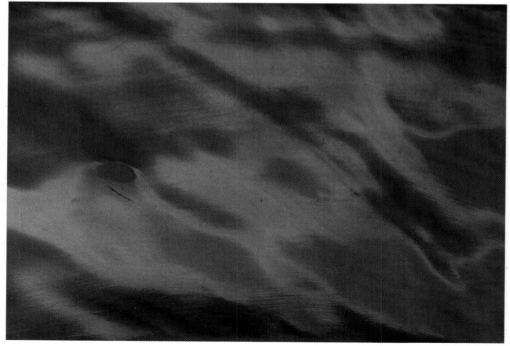

The neutral grey coat of arms on this intense red coach cover appears slightly tinged with green as the eye seeks to compensate automatically for the absence of red's complementary.

In a simple demonstration of simultaneous contrast, compare the two circles of grey on this page. They have both been printed with exactly the same tone and neutral colour, yet the upper one appears to be tinged with blue and the lower tinged with orange. Our perception of them is altered by their settings.

USING DESIGN

The value of design lies in the use that can be made of it. It may be instructive to see which graphic elements are at work in different examples, and to be able to analyze a picture in different terms (its lines, shapes, colours and so on), but the function of design is to take better photographs rather than to explain ones that have already been taken. We need to do the latter in order to achieve the former, but at this point in the book it is time to start using the design vocabulary that has been described on pages 68–105.

Design in photography can be used in two ways, one passive, the other active. The passive role, by no means inferior, is to improve the aesthetics of the picture. This sounds a little too grand, but there is no other adequate way of phrasing it: good judgement of balance, contrast, colour and all the other elements that comprise an image, and the knowledge of how to execute this. As the preceding sections of the book should have demonstrated, there are independent principles of design – independent, that is, of subjective tastes. Using these principles inevitably helps the effectiveness of a picture.

The second way of using design is to manipulate the viewer's response to the picture. In the most straightforward manner, this means directing the attention where you want it to be. At its simplest this can be a matter of making sure that what you see as the center of interest, the viewer also sees. A more sophisticated use is to encourage the viewer's eye to follow a certain path around the picture, or, if the impact of the photograph demands it, to persuade the viewer to look at one area of the frame before passing on to the ultimate focus of attention.

There is more than a touch of the professional attitude in all this. In professional photography, the photograph itself is functional. It is taken for a purpose (advertising, journalism, or whatever) and with an audience in mind. Hence everything in the making of the photograph is, or should be, geared to an end. Although this book is not trying to teach professional photography, most professional methods are applicable to photographs taken for personal pleasure. There is no reason why this pleasure should be in any way spoilt by applying the principles of design. If you know why you are taking a photograph and understand what you hope to get out of it, and have good design skills at your disposal, you can certainly make the image work.

Through a combination of design elements, this photograph of novice monks in a Burmese temple is organized to be seen in just one way. Although the moment for taking the shot was very short – just the time taken for the gesture and glance of the second boy – the photographer had plenty of time to prepare and to anticipate most of the possibilities, including the fact that the gilded statue in the background could be taken as looking at the foreground. The actual coincidence of expression on the face of the two boys was, of course, unplanned, but anticipation of other details, such as the exposure, focus, and overall balance of the image, made it easy to recognize the potential and shoot in time. The result is a very structured image, as the different analyses of points, shapes, lines and eye-lines demonstrate.

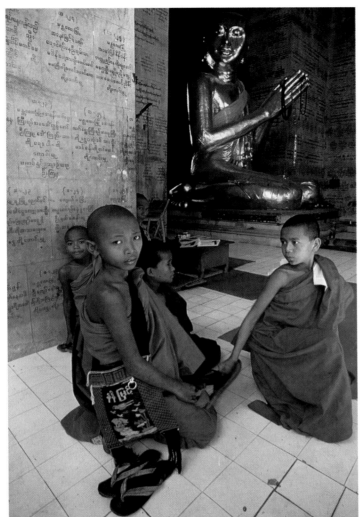

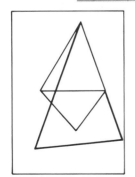

Timing

Timing is not only an essential quality in taking most photographs, it has a direct effect in many situations on the actual design of the image. Photographs of all except static subjects – and this means the majority of photographs – must be timed. One of the fundamental properties of photography is that it has to be performed according to what happens in front of the camera. To take a photograph is to make a picture of an event. The event may be rapid – a matter of milli-seconds in catching the moment – or it may be slow enough, as in the change of daylight over a landscape, that the timing is chosen in terms of hours.

Whatever the action, whether it is a person walking through the scene or clouds gathering over a mountain, it will certainly have to move *across* the picture frame. The action, therefore, inevitably affects the design of the picture, because it alters the balance. Take, for example, the picture of the man walking past the white wall of a Spanish house on page 95. The diagrams on this page already show the effect of the man's presence on the balance and structure of the picture. In the actual taking of a photograph, it was clearly necessary to anticipate the graphic effect.

This may seem obvious in retrospect, but the natural reaction in any photographic situation is to follow movement and to make what seems intuitively to be the most satisfying composition at any moment. If, however, a particular design of image is planned in advance, it is important to work this out by imagining the result when everything will be in place. To make a precise composition of this kind of situation, it is usually easier to frame the view as it will be, and wait for whatever movement is involved to pass into the frame.

Project: Anticipation
Anticipating events, even if it is straightforward movement, takes more effort and attention than you might at first think. It involves working out where and when the thing that is moving will be, and also what the final position will do to the balance of the composition. A common situation is when you have to wait for a passer-by to complete the image, as in the photograph of the man and columns on page 149. Choose a similar setting, in which you have to anticipate the final result. (This is covered in more detail in volume I, *Cameras and Lenses*.)

Anticipating structure
Taking the example of the photograph on page 95, with its triangular structure, the natural method of shooting would be as illustrated in diagram **1**: picking up the figure of the man before the moment chosen for shooting, and panning to the left. This gives a satisfactory triangular structure at the time, but makes it difficult to stop and hold the frame when the man reaches the far door. The method actually used was to anticipate the shot and compose it in advance, waiting for the man to walk into position **2**.

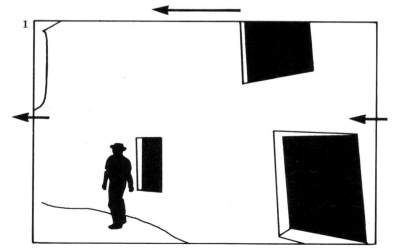

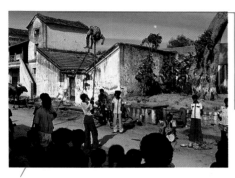

In this sequence of itinerant acrobats in an Indian town, only the second shot counts; the first and third simply show the technique.

In this first photograph, the image is framed exactly, with no spare room above the buildings

It is obvious that the girl is about to be tossed in the air, but how far?

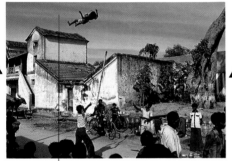

As the girl is thrown upwards, the camera is raised. What has happened is that the photographer has taken the risk of following the movement and still making a good composition.

The risk does, in fact, pay off, but in retrospect a higher framing to start with would have been safer.

The camera is panned down very slightly to correct the balance as the girl – the focus of attention – falls. In the event, she is difficult to distinguish against the buildings.

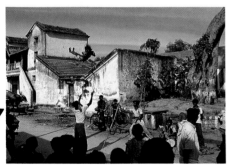

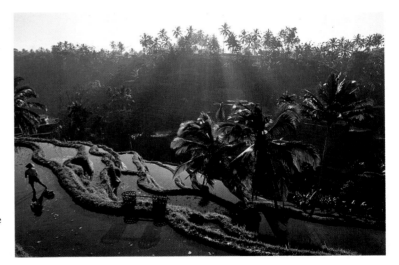

With more time available, the situation was fairly simple to plan in advance. The ideal position for the man planting rice was felt to be at the far left, to occupy the brightest part of the flooded rice terrace and so be clearly visible. The photographer assumed that the man would move back towards the baskets, but nevertheless took one shot immediately, for safety. In the event, the man moved as anticipated.

145

The Appropriate Lens

The image in photography is formed optically, so the choice of lens is an essential part of the design process. Lenses are interchangeable on a single-lens reflex camera, and for design reasons alone the variety of focal lengths and types is worth using. Instead of changing to a wide-angle lens just to increase the coverage, or to a telephoto only to magnify a distant subject, think of the lenses as a means of altering the character of the image and of solving design problems. From this point of view, maximum apertures and lens quality are less interesting than those characteristics that actually change the geometry of the image. Principally, this involves different focal lengths, although there are some special optical constructions, fish-eyes and shift lenses, which will also change the shape of things in the photograph.

First, focal length, dealt with exhaustively in volume I, *Cameras and Lenses*. Here we are concerned just with the design characteristics of the different focal lengths. In terms of the equipment of photography, they are the principal means of changing the character of the image. All that actually varies among the range of lenses is the angle of view, but this has pronounced effects on the linear structure of an image, on the perception of depth, on size relationships and on more expressive, less literal qualities of vision. Focal length can, for example, affect the involvement of a viewer in the scenes; a telephoto lens will distance a subject, but a wide-angle lens will draw the viewer into the scene.

The reference standard is the focal length that gives approximately the same angle of view as we have ourselves. Only approximation is possible, because human vision and lens imagery are quite different. We see by scanning, and do not have an exactly delineated frame of view. Nevertheless, for a 35mm camera, a focal length of around 50mm gives roughly the same impression. Hold a camera fitted with this lens to your eye, but keep the other eye open as well. The two views should more or less coincide.

Wide-angle lenses
Wide-angle lenses have shorter focal lengths; the angle of view is directly proportional to the focal length as the table on this page shows. By convention, certain focal lengths have become standard for most lens manufacturers, and of these standard focal lengths there are only four common wide-angle lenses for 35mm cameras. These are 35mm, 28mm, 24mm and 20mm, and of these, 35mm is sufficiently close to the standard 50mm that it is regarded by many people as an alternative to that rather than having wide-angle characteristics. Shorter focal lengths are available, but their expense and extreme effects confine them to specialized roles.

Wide-angle lenses affect the structure of the image in three main ways. They change the apparent perspective and so the perception of depth; they have a tendency to produce diagonals (real and implied) and consequently dynamic tension; and they induce a subjective viewpoint, drawing the viewer into the scene. The perspective effect depends very much on the way the lens is used, specifically the viewpoint. Used from the edge of a cliff top or the top of a tall building, with no foreground at all in the picture, there is virtually no effect on the perspective; just a wider angle of view.

However, used with a full scale of distance, from close to the camera all the way to the horizon, a wide-angle lens will give an impressive sense of depth, as in the example on page 148. (See pages 156–9 for more on the techniques of enhancing depth perception.) As this contributes to realism in photography, wide-angle lenses used this way are a useful standby for the representative photography of landscapes.

The diagonalization of lines is linked to this effect on apparent perspective. The angle of view is great, so more of the lines that converge on the scene's vanishing points are visible, and these are usually diagonal. Moreover, the correction of barrel distortion in the construction of a normal wide-angle lens results in rectilinear distortion, a radial stretching that is strongest away from the center of the frame. A circular object, for example, is stretched to appear as an oval in the corner of the frame.

Wide-angle lenses tend to be involving for the viewer because, if used as shown here, they pull the viewer into the scene. The foreground is obviously close and the stretching towards the edges and corners wraps the image around the viewer. In other words, the viewer is made aware that the scene extends beyond the frame.

Focal length of lens	Angle of view across horizontal	Angle of view across diagonal
15mm	180°	180°
20mm	84°	94°
24mm	74°	84°
28mm	65°	75°
35mm	54°	63°
50mm	40°	46°
85mm	24°	28°30′
100mm	20°	24°
135mm	15°	18°
200mm	10°	12°
300mm	6°50′	8°15′
400mm	5°10′	6°10′
500mm	4°	5°
600mm	3°30′	4°10′

This pair of photographs, of the same subject but from different distances, illustrates the principal characteristics of wide-angle and telephoto lenses. The first picture was taken with a 20mm lens, the second with a 400mm.

20mm

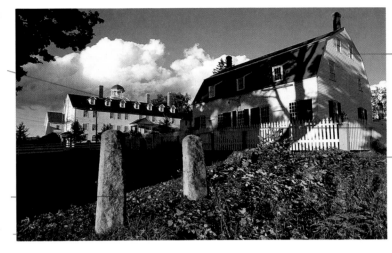

Size relationships exaggerated. Building behind appears much smaller.

Diagonal lines prominent

Angular coverage greater

Slight upward camera angle causes convergence of vertical lines.

The reference for both pictures is the width of this building. In both photographs it occupies half the frame width.

400mm

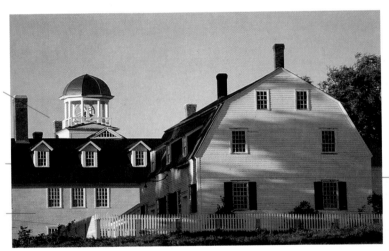

Small angle of coverage

Horizontal and vertical lines more prominent than diagonals.

Size relationships altered by compression; building behind appears relatively larger.

Although camera is still slightly lower than buildings, greater distance needs smaller upward tilt and there is virtually no convergence.

Wide-angle lens line structure: mainly diagonal

Telephoto lens line structure: mainly horizontal and vertical

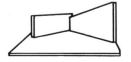

Wide-angle lens plane structure: deep, angled

Telephoto lens plane structure: flat, close

Telephoto lenses

On the other side of the standard lens are the telephotos (actually a construction of long focus lens, but now the most commonly used term). There is a greater variety of focal lengths than among wide-angle lenses, as the table on page 146 shows. The extremes of this group of lenses, beyond 500mm, are expensive and specialized; most of the examples of telephoto images in this book were taken with focal lengths between 180mm and 400mm.

Telephoto lenses have various effects on the structure of the image: they appear to reduce the impression of depth by compressing the planes of the image; they give a selective view, and so can be used to pick out precise graphic structures; they generally simplify the line structure of an image, with a tendency towards horizontals and verticals; they make it relatively easy to juxtapose two or more objects; and they create a more objective, cooler way of seeing things, distancing the viewer from the subject (as, of course, the photographer is distanced).

The compression effect, which can be seen in all the examples here, is valuable because it is a different way of seeing things (the unusual can be attractive for its own sake), and also because it makes it possible to compose in a two-dimensional way, with a set of planes rather than a completely realistic sense of depth. A specific practical use is to give some height to an oblique view of level ground. With a standard lens, the acute angle of view tends to interfere; a telephoto lens from a distance gives the impression of tilting the surface upwards, as the photograph of the freeway shows.

The selectivity that the narrow angle of view gives makes it possible to eliminate distracting or unbalancing elements. So, for example, nearly all the previous projects to do with points, lines, shapes and colours are easier to perform with a telephoto lens. Precise balance is also often easier, needing only a slight change in the camera angle; the arrangement of areas of tone or colour can be altered without changing the perspective. For the same reason, the direction of lines tends to be more consistent. Whereas a wide-angle lens used close pulls lines into a variety of diagonals, a telephoto leaves parallel lines and right angles as they are. Expressively, this often makes for a more static, less dynamic character.

Wide-angle perspective effects
Two perspective effects are combined here by a 20mm lens: linear perspective from the lines that converge on the horizon, and diminishing perspective from the apparently similar shapes.

Strong linear perspective

Strong diminishing perspective

Wide-angle: dynamic lines
With the appropriate camera angle, a wide-angle lens produces strong diagonals, particularly if the foreground is included.

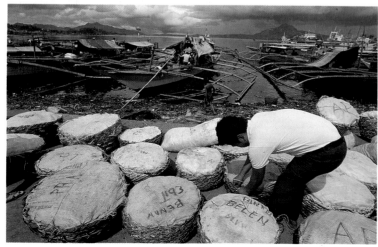

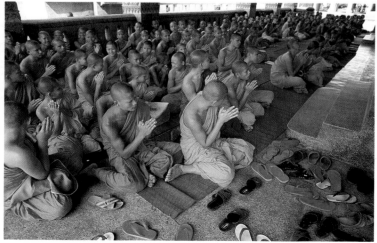

Juxtaposition is a major design use of telephoto lenses. To make a particular point, it is often necessary to show one thing in relationship to another. This can be done with any lens simply by changing the viewpoint or by moving one of the objects, but only a telephoto lens allows it to be done without major changes to the rest of the image. Moreover, when the two things are a distance apart, the compression effect of a telephoto lens helps to bring them together.

Finally, the way that a telephoto lens is normally used – from a distance – communicates itself to the viewer and leaves an objective, less involved impression. There is a major difference in visual character between shooting within a situation with a wide-angle lens, and across-the-street views away from the subject.

Telephoto: compression
One of the distinctive visual impressions of a telephoto distant view is as if the planes of the subject have been tilted upwards to face the camera, as in this shot of a Canadian freeway.

Telephoto: juxtaposition
By reducing any apparent difference in scale between things at different distances from the camera, a telephoto lens can be used for juxtaposition. The object in this example was to show off-shore shipping while including a view of Singapore. The apparent effect is to bring the plane of the buildings forward.

Telephoto: selectivity

Narrow angle of view makes it possible to exclude everything except the columns.

Distant view with long focal length allows small upward tilt for best framing, gives virtually no vertical convergence.

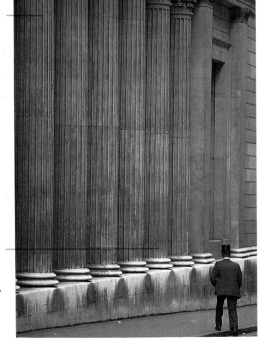

Special optics

Certain other designs of lens, apart from variations in focal length, alter the shape of the image. Their intended uses are specialized, but enable the image to be stretched or curved in various ways.

One such lens is the fish-eye, of which there are two varieties, circular and full-frame. Both, in fact, operate on the same principle – an extreme angle of view, 180° or more, is projected onto a circular image – but in the full-frame version the projected circle is slightly larger than the normal rectangular film frame.

The pronounced curvature is, of course, highly abnormal, and the effect on the design of the photograph extreme. At best, it has only occasional use, mainly because even for the most unknowledgeable viewer the effect is instantly recognizable. Little subtlety is possible with this type of lens, unless the subject lacks obvious straight lines (such as in the forest photograph on page 97).

A second and more adaptable way of changing the image structure is by tilting the lens or film, or both. There is one such perspective-correction or tilting lens available for 35mm cameras, but this procedure is relatively common in view camera photography. Tilting the lens tilts the plane of sharp focus, so that, even at maximum aperture, the sharpness in an image can be distributed more or less at will. Tilting the film, which is not possible in a 35mm camera, also controls the sharpness distribution, but in addition distorts the image, stretching it progressively in the direction in which the film is tilted. The example of the raindrops here shows how this works.

Another lens movement also alters the shape of the image: shifting it up, down or sideways. To make use of this movement, the lens has to cover a much wider area than that of the picture frame. In effect, what happens is that another part of the image is slid into view. This can be done with either a view camera or a 35mm and perspective-correction lens.

Fish-eye: curvilinear distortion
A photograph taken from only a few inches above a carpet of fallen leaves with the camera pointing straight down, produces strongly curved lines towards the edges of the picture, evident even though there are no straight lines in the subject.

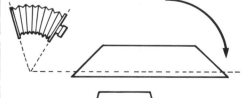

Tilt lens: altering sharpness distribution
By tilting either the lens or the back of the camera (the latter only possible with a view camera), the plane of sharp focus can be tilted from its normal vertical position facing the camera. The angles are related as shown in the diagram. In the example, a close view of raindrops, front-to-back sharpness was possible (depth-of-field adjustment by means of the aperture would not have been sufficient). Tilting the film in the back of the camera has the additional effect of creating distortion in the direction of tilt, as shown in the lower diagram.

Shift lens: restoring converging verticals
With either a shift lens or a view camera that has a sliding lens panel, converging verticals can be corrected by first levelling the camera and then shifting the lens upwards to slide a higher part of the image into view.

Uncorrected view

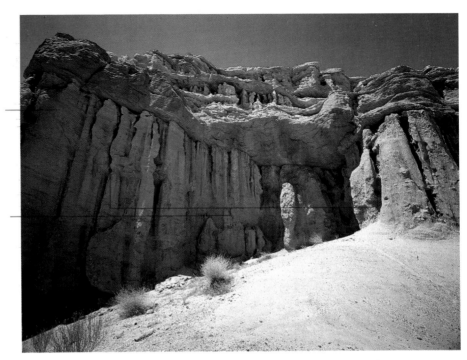

Camera tilted up to take in entire view of cliff face

Vertical lines in cliff appear to converge diagonally

Corrected view

Camera level

Lens panel shifted upwards to slide top of image back into view

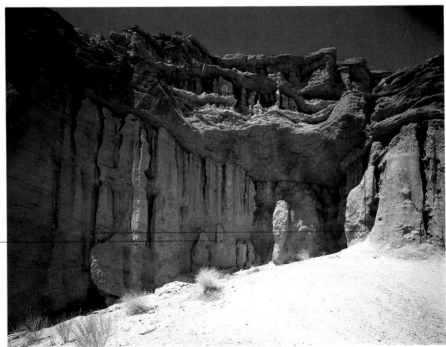

Verticals now appear vertical

Altering the Viewpoint

At least as important as the choice of lens is the camera position. In many situations, indeed, it is an alternative to solving design problems. Among the basic repertoire of techniques, it should be one of the first considerations.

Changing the viewpoint is the one action that alters the real perspective in a photograph. That is, it alters the actual relationship between the different parts of a scene. Its effectiveness, therefore, depends on how much of the scene you can see as you move, and this naturally favours wide-angle lenses. It is perhaps fair to say that only a small change of viewpoint is needed with a wide-angle lens for a substantial change to the image. The juxtaposition effects that make telephotos so valuable (see page 149) are controlled by viewpoint, but with a long

lens you need to move further to see the relationship change.

With a single object, viewpoint determines its shape and its appearance. Moving closer alters the proportions of its different parts, as the sequence of the windmill demonstrates. Its circular base is hardly noticeable in the distant pictures, but in the closest shot it makes up a good third of the building and is an important contrasting shape to the diagonal sails. Moving around a subject gives even greater variety: the front, sides, back and top.

The viewpoint controls the relationship between an object and background, or two or more objects, in two ways: position and size. Simply the action of bringing two things together in one frame suggests that there is a relationship between them; this

is a major design tool. Relationships depend on who chooses to see them, and what one photographer may see as significant, another may ignore or not even notice. The sequence of the Acropolis is a case in point. Isolating it with a telephoto lens at sunrise places it deliberately out of context; all relationships have been deliberately avoided to give as timeless a view as possible: the historical version. The last view, by contrast, makes a point of juxtaposition; a decidedly unromantic relationship between the Acropolis and a modern city.

Project: Changing viewpoint with a wide-angle lens

For this project, find one prominent subject and a reasonably open setting. Both should be fairly large, so that you can alter the

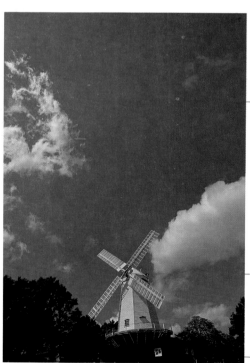

Vertical format exaggerates the excess of empty sky

Windmill centered laterally for symmetry

Surroundings cropped at bottom to simplify colours and shapes

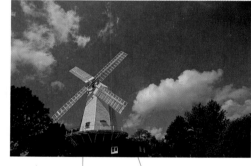

Frame kept high to limit appearance of trees and vegetation

Image of windmill shifted left for more balanced composition

Shot timed and positioned so that clouds clear sails of windmill

perspective substantially and move around for a variety of viewpoints. Our example here is a windmill in a rural setting, and the lens 20mm, one of the shortest focal lengths, with a pronounced wide-angle effect.

We begin with a medium-distance view, from a little less than 100 yards (90m) away. The whiteness of the windmill is particularly striking, and in an attempt to keep the graphic elements simple, this first shot is framed so as to exclude the surroundings, to make a high-contrast, blue-and-white image. The sky is a particularly deep blue, which should, and does, make a powerful contrast with the windmill. It also seems possible to make something of the whiteness shared by the clouds and the windmill. In the event, the picture is only a partial success. The symmetry of the wind-

mill encouraged a central placement in the frame, but it does not balance the two areas of cloud as well as it might. Also, placing the windmill low in the frame, to avoid seeing the surroundings, gives too much sky.

The second shot has more normal proportions and more careful organization. The intention is the same as in the first photograph, but realized with more success. The viewpoint is closer, so that the windmill fills more of the frame and is off-centered to give a better balance, and has been moved to the right, so that the windmill just occupies the space between the clouds.

The potential of a symmetrical image remains. To make the most of this, the viewpoint is changed so that it is exactly facing the front of the windmill. Moving closer to remove the clouds from view

reveals an interesting distortion of the base; its curve makes a pleasant contrast of shape with the triangular structures above, and still contributes to the symmetry.

From this, the camera position is changed radically, to as distant a view as possible, while maintaining the windmill as the focus of attention. This is the classic depth-enhancing use of a wide-angle lens, showing as much of the foreground as the depth of field allows. To this end, the camera position is low, and the windmill placed high towards one corner. The last photograph in the sequence is basically the same type of shot, but with an improvement in the location. A new viewpoint has been chosen which shows more distinctive detail in the foreground, to make this part of the picture more prominent.

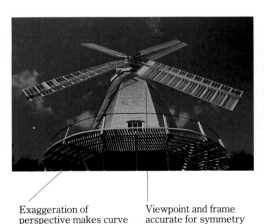

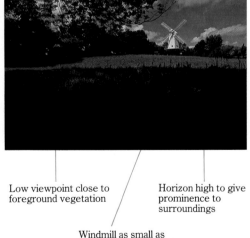

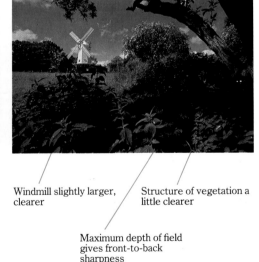

Exaggeration of perspective makes curve dominant

Viewpoint and frame accurate for symmetry

Low viewpoint close to foreground vegetation

Horizon high to give prominence to surroundings

Windmill as small as possible while remaining recognizable

Windmill slightly larger, clearer

Structure of vegetation a little clearer

Maximum depth of field gives front-to-back sharpness

Project: Views from above

Walking around a subject and changing the distance are the usual ways of altering viewpoint. Less often explored are downward views from overhead. While they are limited by availability, high viewpoints are usually worth trying out. Choose a building with a high balcony, preferably over a busy street or wherever there is plenty of activity. The location in this example was the Centre Pompidou in Paris, on a Saturday afternoon. Use a telephoto lens in this project for its selectivity; you can expect, as here, a simplification of the image; the background is likely to be plainer.

Project: Altering viewpoint and lens together

Use whatever focal length of lens seems appropriate for this project, so that you can take all the opportunities offered by different viewpoints. In fact, go further than this, and from different viewpoints make a point of trying out all the lenses you have. Not all of them will be worth using from every camera position, but by changing position you will usually find at least one wide-angle and one telephoto possibility.

In order to be able to make full use of the extremes of focal length, it is important to find a subject that is visible from a distance.

The version of this project shown here is a sequence of photographs of the Acropolis in Athens, and specifically the Parthenon, the central building.

The first two shots use a wide-angle lens (20mm) from close to, and make deliberately pronounced graphic arrangements; in the first picture these are triangular, in the second radiating diagonals from the horizontal line. Both pictures use the exaggeration of converging verticals that a wide-angle lens creates.

The third photograph, also from fairly close to the building, uses a telephoto lens to isolate a pattern of verticals from the row of columns, choosing an oblique viewpoint to close the gaps between them. The triangular shadows at the top of two of the columns are deliberately included to relieve the regularity of the vertical lines.

Then, from a distance. Whereas the close views experimented with shape and line, the fourth photograph deliberately sets out to give a romantic, atmospheric impression of the Acropolis, isolated from its modern surroundings. To this end, a telephoto lens gives a selective view, and the dawn lighting conceals unnecessary modern details in a silhouette. With a longer focal length from the same viewpoint, the graphic possibilities are explored: these are chiefly ones of blocks of tones and horizontal and vertical lines.

At the same time of day, the Acropolis was hardly distinguishable on the skyline with a wide-angle lens; instead, this view was made during the afternoon, when the whiteness of the stone helped it to stand out. With a nearby hill as foreground, and plenty of sky, the setting diminishes the visual importance of the city. Finally, to make a distinct contrast with modern Athens, a viewpoint was chosen to show the very ordinary, drab streets that surround the Acropolis, and the composition gives them prominence. A standard lens was used to give the feeling that this is a normal view, such as a passer-by might glimpse while walking along.

From ground level, a photograph of this man in a yogic position would have had a fairly ordinary visual effect, even though the subject is unusual. From directly overhead with a telephoto lens, it is graphically strong, simple and unexpected.

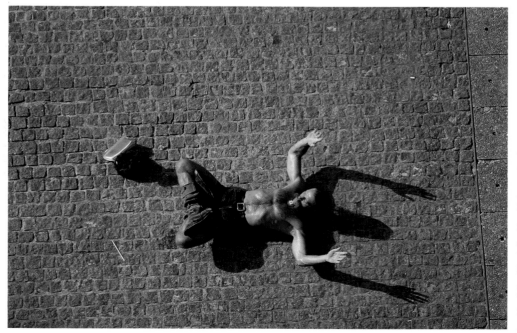

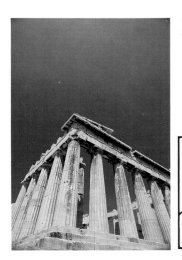

Wide-angle: close

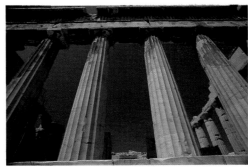

Telephoto: close

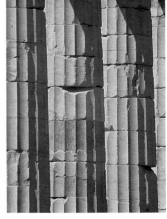

Wide-angle: close

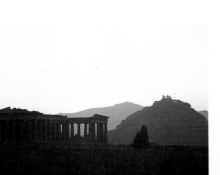

Telephoto: distant

Telephoto: distant

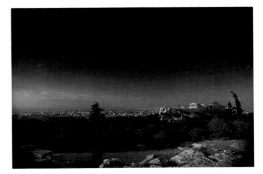

Wide-angle: distant

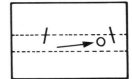

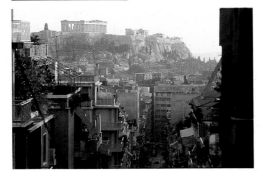

Standard: distant

Controlling the Sense of Depth

Photography's constant relationship with real scenes makes the sense of depth in a picture always important. This is, after all, the way in which three-dimensionality is conveyed and this, naturally, influences the realism of the photograph. In virtually every photograph, a certain sense of depth is carried across to the viewer, even without the photographer's intervention. How strong or weak this is depends on a considerable number of variables. Knowing what these are is a step towards using them. The sense of depth can be controlled, and it is an important design skill.

Perspective is the appearance of objects in space, and their relationships to each other and the viewer. This is its broadest sense. More usually, in photography it is used to describe the intensity of the impression of depth. The various types of perspective and other depth controls are described in a moment, but before this we ought to consider how to use them, and why. Given the ability to make a difference to the perspective, under what conditions will it help the photograph to enhance, or to diminish, the sense of depth? A heightened sense of depth through strong perspective tends to improve the realism of the photograph. It makes more of the representational qualities of the subject, and less of the graphic structure. What Edward Weston, the American photographer, called "straight" photography is better served by use of perspective effects than by techniques that emphasize the purely graphic elements.

However, these graphic elements may themselves be sufficiently interesting to merit being the subject of the picture. In photographs such as that of the blue-uniformed soldiers on page 99 and of the dockside bathed in red light on page 112, the form of the image is at least as important as the content. These are both cases where any available methods of reducing perspective are likely to be worthwhile, provided that they do not conflict with the original purpose of the shot.

The following types of perspective contain the main variables that affect our sense of depth in a photograph. Which ones dominate depends on the situation, as does the influence that you can exercise over them.

Linear perspective

In two-dimensional imagery, this is, overall, the most prominent type of perspective effect. Linear perspective is characterized by converging lines. These lines are, in most scenes, actually parallel, like the edges of a road and the top and bottom of a wall, but if they recede from the camera, they appear to converge, towards one or more vanishing points. If they continue in the image for a sufficient distance, they do actually meet at a real point. If the camera is level, and the view is a landscape, the horizontal lines will converge on the horizon. If the camera is pointed upwards, the

Linear perspective
A 20mm wide-angle lens and a viewpoint that shows the parallel lines of a wall (Hadrian's Wall) receding directly from the camera provide classic conditions for strong linear perspective.

Height of camera above the wall determines vertical distance that is visible in the photograph. This in turn determines the degree of convergence.

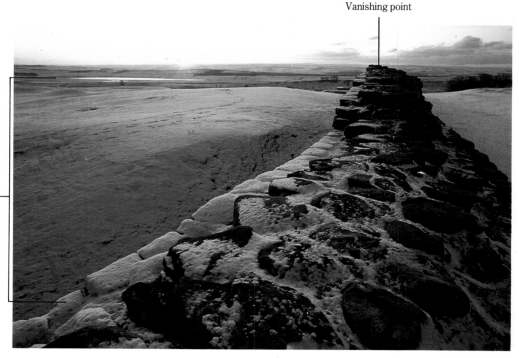

Vanishing point

vertical lines, such as the sides of a building, will converge towards some unspecified part of the sky; visually, this is more difficult for most people to accept as a normal image.

In the process of convergence, all or most of the lines become diagonal, and this, as we have already seen (pages 80–5) induces visual tension and a sense of movement. The movement itself adds to the perception of depth, appearing to happen into and out of the scene. By association, diagonal lines of all kinds contain a suggestion of depth. This includes shadows: if seen obliquely, they can appear as lines. A direct sun, particularly if low, will enhance perspective if the shadows it casts fall diagonally. Viewpoint determines the degree of convergence. The more acute the angle of view to the surface, the greater the convergence. A minimum angle is, however, necessary: for ground lines to converge, the camera must be at a reasonable height, as the diagrams here show.

The focal length of lens is another important factor in linear perspective. Of two lenses aimed directly towards the vanishing point of a scene, the wide-angle lens will show more of the diagonals in the foreground, and these will tend to dominate the structure of the image to a greater degree. Hence, wide-angle lenses have a propensity to enhance linear perspective, while telephoto lenses tend to flatten it.

Diminishing perspective
This is related to linear perspective, and is in fact a form of it. Imagine a row of identical trees lining a road. A view along the road would produce the familiar convergence in the line of trees, but individually they will appear to be successively smaller. This is diminishing perspective, and works most effectively with identical or similar objects at different distances.

For similar reasons, anything of recognizable size will give a standard of scale; in the appropriate place in the scene, it helps to establish perspective. Also associated with diminishing perspective are placement (things in the lower part of the picture are, through familiarity, assumed to be in the foreground) and overlap (if the outline of one object overlaps another, it is assumed to be the one in front).

Ways of strengthening perspective	Ways of weakening perspective
Choose a viewpoint that shows a range of distance.	Alter the viewpoint so that different distances in the scene appear as unconnected planes, the fewer the better.
A wide-angle lens enhances linear perspective if used close to the nearest parts of the scene, and can show a large foreground-to-distance range.	A telephoto lens compresses these planes, reducing linear perspective, if used from a distance.
Place warm-hued subjects against cool-hued backgrounds.	Place cool-hued subjects against warm-hued backgrounds.
Use more direct, less diffused lighting.	Use frontal lighting, diffused and shadowless.
Use lighting or placement to keep bright tones in the foreground and dark tones behind.	Equalize or reverse the distribution of tones, so that light objects do not appear in the foreground.
Where applicable, include familiar-sized objects at different distances to give recognizable scale. Ideally, have similar objects.	Maximize the depth of field so that, ideally, the entire picture is sharply focused. With a view camera or tilt lens, use the movements to increase overall sharpness.
Allow the focus to become unsharp towards the distance.	Reduce atmospheric haze by using ultraviolet or polarizing filters.

The same viewpoint with lenses of different focal length gives a more diagonal convergent image from the wider-angle lens.

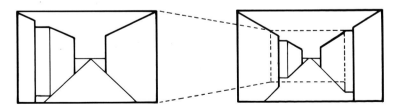

Low

The angle of view to the surface that carries the converging lines determines the strength of the perspective effect. Too low fails to read clearly, too high shows little convergence.

Medium　　　**High**

Aerial perspective

Atmospheric haze acts as a filter, reducing the contrast in distant parts of a scene and lightening their tone. Our familiarity with this effect (pale horizons, for example), enables our eyes to use it as a clue to depth. Hazy, misty scenes appear deeper than they are because of their strong aerial perspective. It can be enhanced by using backlighting, as in the example here, and by not using filters (such as those designed to cut ultraviolet radiation) which reduce haze. Telephoto lenses tend to show more aerial perspective than do wide-angle lenses if used on different subjects, because they show less of nearby things that have little haze between them and the camera.

Tonal perspective

Apart from the lightening effect that haze has on distant things, light tones appear to advance and dark tones recede. So, a light object against a dark background will normally stand forward, with a strong sense of depth. This can be controlled by placing subjects carefully, or by lighting.

Colour perspective

As explained on pages 136–9, warm colours advance and cool colours recede. Other factors apart, therefore, a red or orange subject against a green or blue background will have a sense of depth for purely optical reasons. Again, appropriate positioning can be used as a control. The more intense the colours, the stronger the effect, but if there is a difference in intensity, it should be in favour of the foreground.

Sharpness

Good definition suggests closeness, and anything that creates a difference in sharpness in favour of the foreground will enhance the impression of depth. Atmospheric haze has something of this effect. The most powerful control, however, is focus. If there is a difference in sharpness across the image, the eye tends to assume that the sharper area is in the foreground.

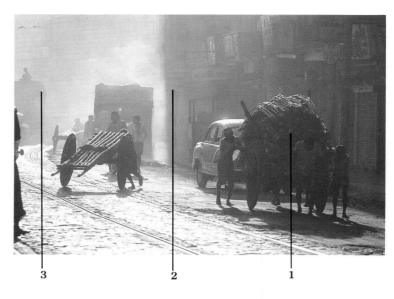

Aerial perspective
Progressively lighter shadow tones (marked **1, 2,** and **3**) indicate the effects of an increasing depth of atmospheric haze, and so establish depth. The effect appears strongly in back-lighting similar to this.

Lack of aerial perspective
Frontal lighting and clear weather are the two conditions that reduce aerial perspective, as in this early morning dockside photograph. The tones and local contrast in the background and foreground, as marked, are very similar, and give little sense of depth.

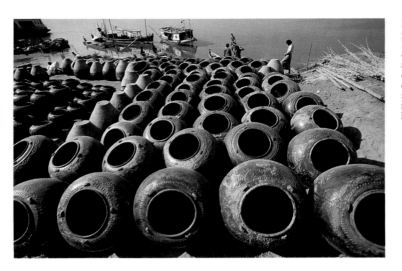

Diminishing perspective
In this mass of jars, the eye assumes that they are identical. Their diminishing size establishes a strong sense of depth. Overlap is also present, and some linear perspective.

Sharpness
Selective focus not only isolates a subject and makes it stand out more clearly from its setting, it also establishes depth.

Colour perspective
Warm hues advance, cool ones recede, thereby enhancing depth, as in this photograph of an orchid. That the colour contrast is responsible for this effect is demonstrated by the accompanying monochrome version.

159

Dynamic Tension

We have already seen how certain of the basic graphic elements have more energy than others: diagonals, for instance. Some design constructions are also more dynamic; rhythm creates momentum and activity, and eccentric placement of objects induces tension as the eye attempts to create its own balance. However, rather than think of an image as balanced or unbalanced, we can consider it in terms of its dynamic tension. This is essentially making use of the energy inherent in various structures, and using it to keep the eye alert and moving outwards from the center of the picture. It is the opposite of the static character of formal compositions.

Some precaution is needed, simply because introducing dynamic tension into a picture seems such an easy and immediate way of attracting attention. Just as the use of rich, vibrant colours is instantly effective in an individual photograph but can become mannered if used constantly, so this kind of activation can also become wearing after a while. As with any design technique that is strong and obvious when first seen, it tends to lack staying power. Its effect is usually spent very quickly, and the eye moves on to the next image. As a result, it is better suited to, say, a magazine layout than to a coffee-table book; the magazine is likely to be consumed more rapidly. This is, of course, to some extent an opinion, but nevertheless these problems do arise and should be taken into consideration.

The techniques for achieving dynamic tension are, however, fairly straightforward as the examples here show. While not trying to reduce it to a formula, the ideal combination is a variety of diagonals in different directions, opposed lines, and any structural device that leads the eye outwards, preferably in competing directions. Reviewing some of the previous projects, this argues against, for example, using circular enclosing structures, and suggests that good use can be made of a powerful standby, eyelines.

Diverging lines and movement are the key to dynamic tension. Here, the branches of the tree and its strong curving shadow have powerful outward movement, exaggerated by the 20mm wide-angle lens. The distortion and placement of the building make it seem to move left, out of frame.

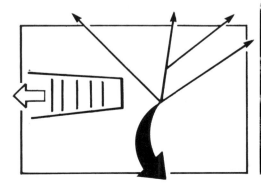

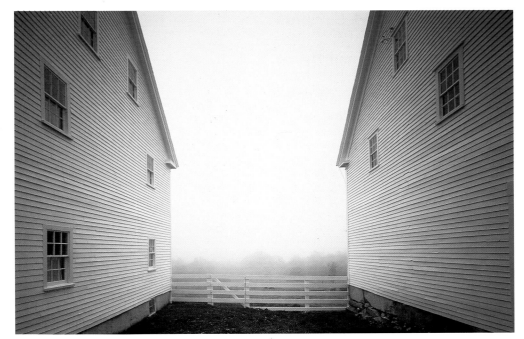

Even though symmetrical, the lines here have considerable movement and tension. The distribution of tone is important in establishing that the movement radiates outward rather than inwards: the central bright glow pushes attention out to the more conventionally exposed parts of the picture.

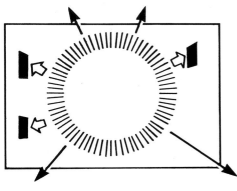

Eye-lines and the way things appear to face are responsible here for the diverging lines of view. The man faces left, and the line of his stance contributes to this. The hopper with molten metal faces forward and to the right. The two pull against each other visually.

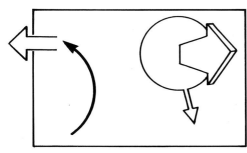

Lines of View

We have seen how readily the eye follows a line, or even the suggestion of one. This tendency is the most important single device available to a photographer in designing an image so that it will be looked at in a certain way. In principle at least, if you can so balance a picture that the attention is first taken by one predictable point, and then provide a line which suggests movement in one direction, you will have provided a route for the eye.

Although the audience for a photograph can suit itself in the way it looks at the picture, and will, if left to study it long enough, look at every part of the frame, lines can be used successfully to provide a bias, an encouragement to follow certain pathways. At the very least, a well-placed line will make sure that the focus of attention is not missed, even if it lacks outstanding graphic qualities. It may be, for example, that what you want to point out needs to be small in the frame, and lacks the contrast necessary for it to stand out clear-

ly. In such a case, a line that points to it can prevent it from becoming lost.

The strongest lines that you can use in this way are those with the most direction and movement. Diagonals, therefore, are particularly useful, and if there are two or more, and they converge, so much the better. Curves also have a feeling of movement, and on occasion even of speed and acceleration. However, the opportunities for using real lines are limited by the scene, naturally enough, and they are often not available when you want them. Implied lines, of the types we have seen in the previous section of the book, are not as definite and obvious, but can at least be created by the photographer, using viewpoint and lens to make alignments. These alignments may be of points, or of different short lines, such as the edges of shadows, as shown in the photograph on page 80.

Another device is any representation of movement. The image of a person walking contains a suggestion of direction, and this

has momentum. The eye has a tendency to move a little ahead of such an image, in the direction that is being taken. The same thing happens with any object that we can see which is in movement. Because real movement in both photographs is frozen, even the direction in which an object is facing imparts a slight suggestion of movement; it needs to be recognizable, as in the case of a car, for example.

This brings us to one of the most valuable implied lines that can be used in designing a photograph. So strong is our attraction to images of the human face that we pay instant attention to any face that appears clearly in a photograph. In particular, if the person in the photograph is looking at something, our eyes naturally follow that direction. It is simple, normal curiosity, to see where the eyes are looking, and it creates a strong direction in the image. Known as eye-lines, these are nearly always important elements in the structure of the image.

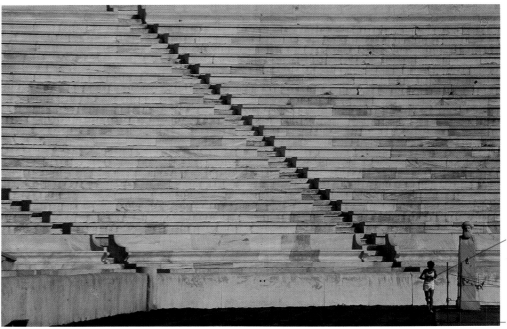

Single diagonal line
In this straightforward use of a convenient, prominent diagonal line, the intention was to take a shot that showed something of the stadium with the added activity of an athlete. The difference in scale between the two subjects was a potential problem; showing a substantial part of the stadium might reduce the figure to insignificance. The solution was to use this diagonal to direct attention. The natural direction along the diagonal is downwards, and the athlete was allowed to run into position at the foot of it. The framing was chosen so as to give as much length as possible to the diagonal.

The picture was framed in anticipation, and taken when the runner appeared in this position.

Placing the ground level right at the bottom of the frame gives the maximum space to the diagonal.

Diagonal eye-line

Another straightforward use of a directional line of view, in this case an eye-line. The painting of the Virgin, for a public celebration held in the Philippines, was, of course, already positioned to appear to look at the cardinal on the stage. To make the most effective use of this in the photograph, the painting was placed at the extreme edge of the frame, so that the line would dominate. In other words, as the eye is naturally drawn first to the strong image of the Virgin's face, placing this at the edge means that there is no distraction on the other side (to the right) of the eye-line. The attention starts at one predictable place and moves in one predictable direction.

Eye-line crosses this point on the stage.

Converging diagonals

This is an arranged shot, intended to show the equipment and procedure for seeding a pearl oyster. It was decided that the style of the photograph would be clean, spare and clinical, in keeping with the idea that the process is rather like a surgical operation. The ingredients needed were the oyster, the special surgical tools, the seed (actually a small sphere) and, of course, the action of inserting it.

The seed is the central element, but also the smallest, hence the graphic structure is designed to focus attention on it. The basic form is three lines converging on the seed so that, despite the bulk of the oyster as it appears in silhouette, the seed is very much the center of attention. The angle of the lines was chosen so as not to be symmetrical, which would have been a little predictable and dull.

Two additional touches; the instruments on the right were fanned to avoid every line pointing severely at the center (again, this would have been too predictable), and the open mouth of the oyster introduces a sense of movement into it. The eye moves to the seed at the center, and then a little down and left to the oyster. The action is made clear by the lines.

Unifying groups

In another view of pearls, this photograph was designed around the need to show the major varieties of pearl. It was also designed to be a magazine cover, and so had to work especially well as an attractive and simple image. The problem here was that quite a number of pearls needed to be shown; too many to arrange effectively in one group. The solution was to split them up into three groups but then to tie these together visually in such a way that the arrangement looks fairly natural, and the eye can move smoothly around the picture.

Much of the success of this photograph lies in the choice of a variety of shells as background. The colour helps to unify the image, and the shapes of the shells can be used to build lines. The principal line is a gentle S-shaped curve that the eye can follow easily up and down. The three groups of pearls are arranged in a central triangle, which alone helps to make them prominent. In addition, however, the enclosing suggestion of the concave curves tends to pull the eye in towards the upper and lower groups. The remaining single pearl, isolated because it is a particularly fine specimen, is placed in the most central dark area, so that it is revealed by tonal contrast.

Center of attention is this main group of pearls

Interference colours typical of pearls give a consistent, unifying background

Combined lines and shapes

Here, the subject is food: a Thai dish and accompaniments. Partly because this type of oriental cooking tastes better than it looks in detail, and partly because an attractive location was available, it was decided to shoot it in a setting.

With this decision already taken, the important issue was the balance of attention. There is no point in going to the trouble of arranging a good location if the audience cannot see enough of it to get some atmosphere. On the other hand, the subject is the food. Fortunately, as already explained, there was no compelling reason to show the food in great detail. Before setting up, it was decided that the food would occupy about one third of the frame, and that the structure would attempt to move the eye between the background and food, so that both would receive proper attention.

The result was a variety of lines and shapes. The food was placed at the bottom of a vertical frame, which alone will encourage the eye to drift down. The circular tables concentrate attention locally inwards. The trunk of the palm gives a major downward thrust from the setting to the food, and this is picked up by the diagonal shadow. The curve of the tables then moves as shown in the diagram *below*, back up to the fields beyond. The figure of the girl is included for atmosphere, but she stoops to lower the baskets for two reasons: the way she faces imparts a movement downwards, as does the (assumed) eye-line, without being too contrived.

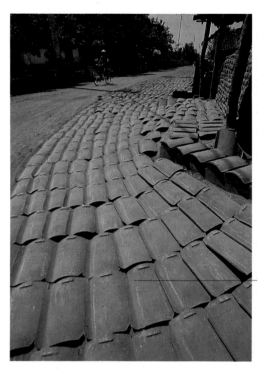

Movement in both directions

Mud tiles laid out to dry in a village street naturally suggested a photograph that made something of the strong linear arrangement. The most graphic treatment was a wide-angle shot, using a 20mm lens, close to the ground but including the horizon: the maximum linear perspective, in other words. The structure of the image posed no particular problems, but it was felt that the strength of the foreground needed to be balanced by something in the distance. An approaching cyclist provided the solution. The eye is first drawn to the foreground, and then, because of the converging curves, travels upwards and into the back of the picture. Finding the cyclist, it picks up the movement of this figure towards the camera, and so travels back down to the foreground. Offsetting the foreground thus brings more activity to the photograph.

Balance of picture makes foreground first point of attention

Spiral rotation

The central subject of this photograph, a large ship's propeller, suggests the structure of the picture, a spiral composed of three principal curved lines. However, the necessary reinforcement comes from the three men working on the propeller in a dry dock. To complete the image, the three men needed to be evenly spaced, visible, and facing in directions that helped to confirm the direction of the spirals. Once the viewpoint had been selected, the only thing to do was to wait until the appropriate moment.

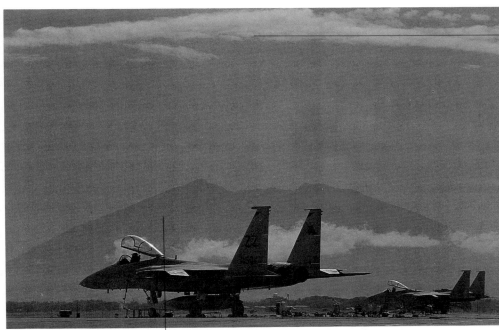

Line of clouds echoes horizontal base, balances image vertically

Opposing movement
In the first photograph, the mountain behind the F16 fighter at an airbase offered a natural background; this was useful in a picture that would otherwise have been very plain. The lens and viewpoint were chosen so that its outline would just fit around the aircraft; also, being a volcano, it has a symmetry that was used by centering it laterally in the frame.

The approach of a pilot offered a different opportunity, and the camera position and framing were both altered slightly to make something of this. The aircraft faces left, and this gives some suggestion of movement. The figure is walking to the right, and its movement opposes the first; the two together stabilize the picture.

Viewpoint chosen to place aircraft in front of mountain; makes symmetrical composition

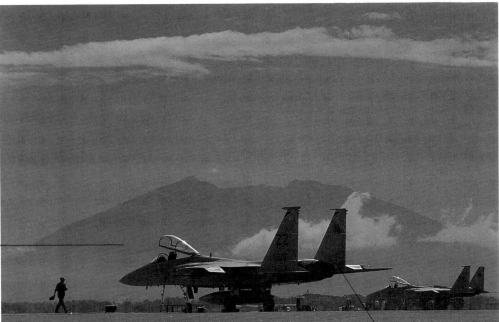

Viewpoint shifted to left so that mountain now centered over the *balance* of aircraft and figure

Aircraft moved to right to oppose movement of figure

167

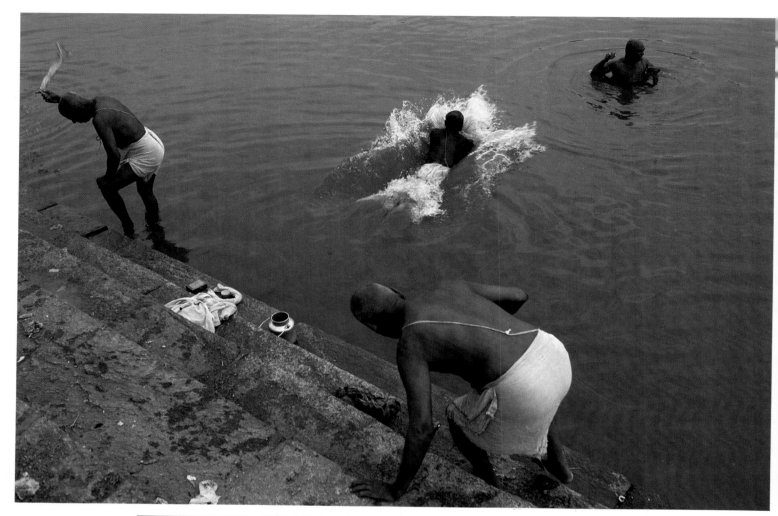

Triangular structure and movement
The diagonals in this shot of bathers in the Kapila River in southern India are integrated, forming a triangle, both of points (the figures) and lines (the steps and the implied lines from the movement of each person). The strong diagonal from lower right to upper left – the "base" of the triangle – is opposed by the movement of the man diving into the water, at an angle of 90°.

Lines and shapes
In this food shot, taken in India, the basic intention of the photograph is very similar to that of the picture on page 165. It had already been decided to photograph the dishes with the chef, and this combination at least simplified the subject of the picture. Graphic structure was needed for two reasons; to make the picture attractively coherent, and to make sure that the setting was not lost to attention. The actual structure chosen, after researching the location, relies on both lines and shapes. The shapes are the smaller circle of the food tray, the larger overlapping circle of the shadow behind and the slightly curved triangle of the chef; the three shapes are linked as shown in the diagram. The linear structure is convergence to the right. As the eye begins in the foreground and left of the frame, the natural direction is towards the right background, which helps to take the viewer's eye to the surroundings.

Structure in a wide shot
The purpose of this photograph is to give a broad view of Ngorongoro crater, a wildlife reserve in Tanzania. The relative lack of feature in the view was a slight concern, and to overcome this, a viewpoint was chosen which involved a pride of lions, grouped on either side of the picture. The use of a wide-angle lens introduces some linear perspective, although not strong, but it is the position of the lions, facing towards the distance and into the center of the frame, that gives the photograph the near-symmetrical structure it needs.

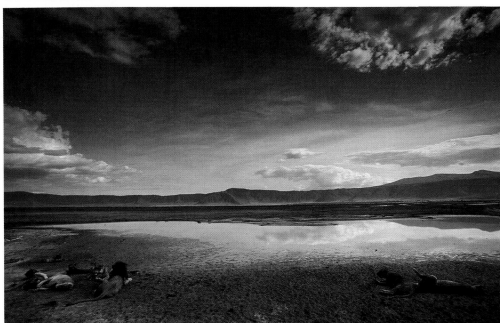

Delayed Reaction

A variation in controlling reactions to a photograph is to slow them down rather than to accelerate them. Whereas the most obvious need in directing attention is to make sure that the viewer sees a particular point quickly and without confusion, there are occasions when the effect of a photograph will work better if the viewer notices the key point in the picture a little later, only after having looked at some other part.

Perhaps the most common situation in which this holds true is when the idea behind the photograph is contained in the relationship between an object and its setting. In particular, if the surroundings are felt in some way to dominate something, and if you want to communicate the impression that they are overwhelming, then there is a good case for wanting the surroundings to register first. The means for doing this are not necessarily complicated, and usually involve reversing the normal design techniques of placement and scale that are used to draw attention. The risk is in so adjusting the bias of composition that the eye fails to notice the key point. The most common techniques, used here to varying degrees, are positioning the key point a little eccentrically, and choosing a viewpoint which keeps the point small.

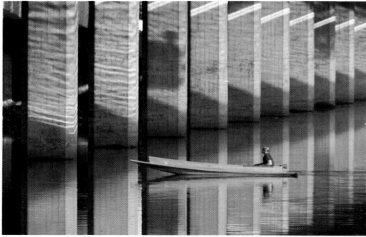

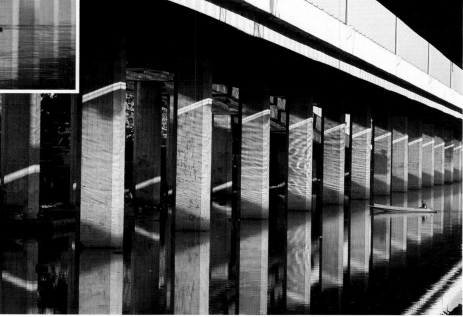

The interest in this photograph is not really the boat on a klong in Bangkok, but the fact that it is still there after a massive motorway has been built right over it. The concrete pillars make a landscape which one would not normally associate with a traditional way of life. Hence, a close view of the boat, as in the second photograph, would not have served the purpose. However, simply a long shot, with the boat very small, might just lose it from view. Instead, this viewpoint, and placing the boat at the far right of the frame, helps to point it out through the convergence of the motorway pillars.

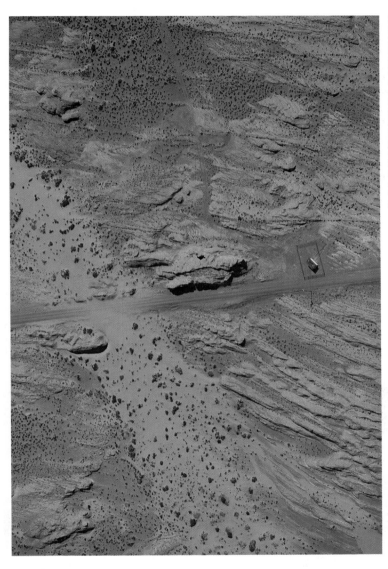

In many ways similar to the photograph on page 170, this aerial view gains its interest from the sense of isolation of the house and road in an empty stretch of rocky desert. The greater the area of the surroundings and the smaller the house, the stronger is this feeling. The judgement needed is to discern at what point the house actually escapes notice altogether. Much depends on the scale at which the photograph is reproduced.

This is a chance photograph, for which there was very little warning. The framing is right for giving some humour to the situation; by making sure that the boy stealing the fish appears just at the bottom of the frame, there is a small delay before he is noticed. The viewer first sees the women in a conventional market-place shot and then notices the petty thieving going on below. This, of course, is how the fisher-women themselves saw the event.

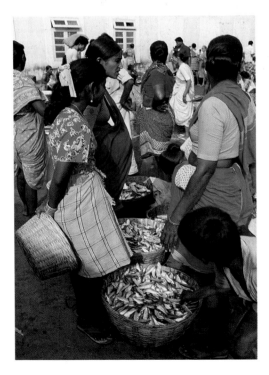

Using Focus to Direct Attention

Sharp focus is such an accepted standard in photography that it is rarely treated as anything other than a way of producing a "correct" image, on the lines of loading the film properly and other essentials. Only occasionally does it occur to most people to vary the focus for the effect it has on the design. Yet, under the right circumstances, this can be effective.

The question of where to focus seldom arises because the normal practice of making a photograph is first to decide what the subject is and then to aim the camera. Natural enough, certainly, and the usual focus problems are those of accuracy rather than of selection. Under normal circumstances, the point to be focused on – the eyes in a face, or a figure standing in front of a background – presents itself without an alternative, and if there is any variation in the way the focus appears in the final photograph, it is in the form of a mistake. The popularity and success of autofocus lenses is testimony to how predictable are most people's focusing decisions.

Certain situations, however, do offer a choice, and this lies mainly in how you define the image. When photographing a group of objects, should they all appear in sharp focus? Would it be more effective if just one or a few were sharp and the rest progressively soft? If so, which ones should be in focus and which not? Moreover, there might not necessarily be such a choice of deep or shallow focus. If the light level is low for the combination of film and lens, it may only be possible to have one zone of the image in focus, and in this case you will be forced into a selective decision.

Whatever the reasons, never underestimate the visual power of focus. The fact that sharpness is the virtually unquestioned standard is enough to show that whatever is focused on becomes, a priori, the point of attention. Deliberate misuse, or rather, unexpected use, works extremely well because it flouts established procedure.

If you are using focus in an expected way, it is important to appreciate its different uses with different focal lengths. Even without any knowledge of or interest in the techniques of photography, most people looking at a photograph are familiar with the way the focus is normally distributed. With a telephoto lens, the depth of field is shallow, and there is typically a range of focus that can be seen in one photograph, from soft to sharp. As the sharp area is expected to coincide with the main point of interest – where the eye is expected finally to rest – the range of focus contains a sense of direction from unsharp to sharp. This is not nearly such a strong inducement to the eye as the lines of view that we have just looked at, but it works nevertheless. What is important is that it works through the familiarity of the viewer with the way his or her own eyes will focus on an object.

Shorter focal lengths give images with better depth of field, and we are accustomed to seeing wide-angle views that are sharp throughout. As a result, focus is not normally a quality that is noticed. However, a fast wide-angle lens used at maximum aperture with a deep subject will show unsharpness somewhere in the frame, and this needs to be handled carefully. It can easily look like a mistake.

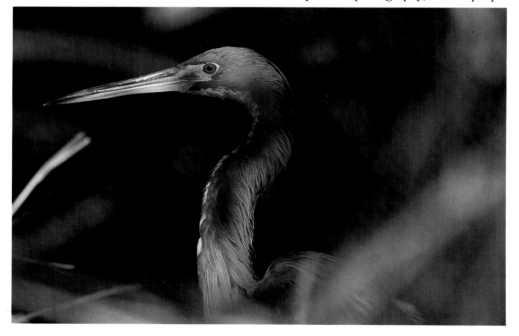

In wildlife photography, there is often no alternative to shooting *through* foliage with a telephoto lens. Nevertheless, it is no bad thing to have out-of-focus elements in the foreground. They reinforce the sense of a hidden glimpse, and emphasize the sharp focus more clearly.

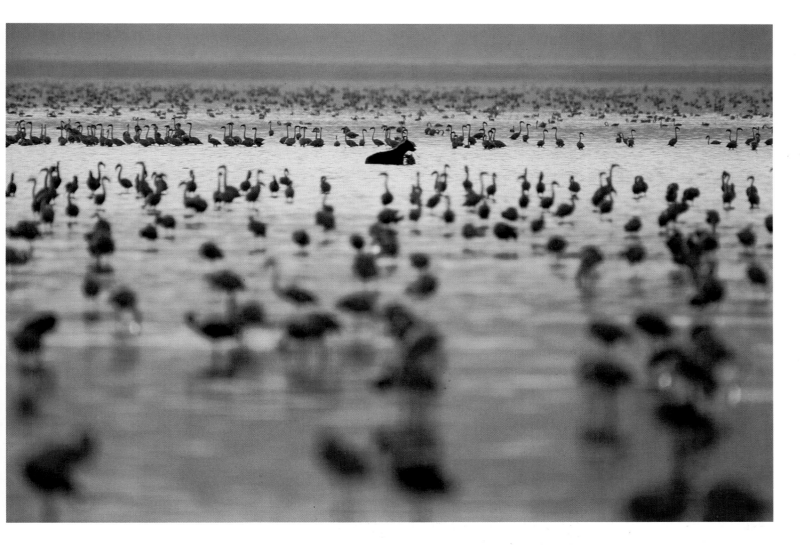

Sense of movement in focus
With a 600 mm lens focused on the distance, depth of field is very shallow. From a slightly elevated viewpoint (the roof of a vehicle), the focus is progressive, leading the eye rapidly upwards to the point of focus. Placing the main subject of interest high in the frame makes the most use of this effect.

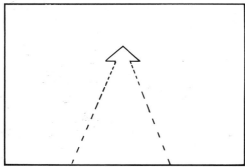

173

Using Exposure to Direct Attention

In the same way that focus is most commonly used in a standardized way, to produce a kind of technical accuracy in a photograph, exposure is also assumed to have a "correct" role. I should stress that this is how it is seen conventionally, not how it can or ought to be used. The theory of exposure involves both aesthetic judgement and the technical requirements of the film. From the technical side of things, the upper and lower limits of exposure are set first by what is visible, second by the expected appearance. To this extent, exposure has to normalize the view of what the eye would see of the real scene.

The conventions of exposure have much in common with those of focus. They are fairly strong, and so can be used to direct attention. The eye has a tendency to move towards the areas of "normal" exposure, for example, in the photograph of the two white buildings on page 161. The center of the frame, where the focus of attention normally lies, is deliberately over-exposed, and glows. An effect of this is that the eye slides away from this area to the side of the buildings. The exposure has thus helped to radiate the attention outwards, and contribute to the dynamic tension of the image.

The examples here show how exposure can both diffuse and concentrate attention. In the view of the village, there is a substantial contrast between the tower of the church and the remainder of the buildings. If we were to look at this scene with a purely technical eye, the process of deciding the exposures might be as follows. The light falling on the church is more than twenty times brighter than on the houses; the high reflectivity of the white-washed tower increases the actual contrast range even more. Nevertheless, if the village is kept fairly dark and the tower a bright white, the scene can be contained within the five-stop range of a normal colour reversal film. The result is the first version.

This technical approach sees the contrast as a problem, but one that can be solved. All this is perfectly correct, although not in fact the primary decision in taking this picture. The contrast gives visual drama to the image, and a considerable sense of timing; we are concious that, in the last moments of the day, the sun is picking out the highest structure in the village, just for an instant.

This is not, however, the only possible treatment. See what happens if the exposure is increased, and if we ignore the need for holding the level of the tower's image within the latitude of the film. The exposure now favours the shadowed buildings, and the attention spreads outwards. The subject is re-defined by the exposure.

Diffusing attention
Exposure can narrow or broaden the attention in a picture if there are two distinct areas of brightness, as in these photographs of a mountain village in Spain.

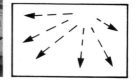

In the other pair of photographs, of Monument Valley, the process worked the other way. The first version is given sufficient exposure to include the clouds as a working part of the image (in part, this was necessary as the two buttes are outlined against some of the clouds, and a fairly full exposure helps to separate the tones so that they do not merge). The attention moves around the frame. In the second version, the exposure is reduced so that the clouds become intense and almost featureless. The attention now becomes concentrated on the horizontal strip of the horizon, on what is actually the dominant characteristic of this landscape: its outline of mesas and buttes.

Both of these examples contain these choices without making major upsets to the technical accuracy of the exposure. By no means every lighting condition allows this.

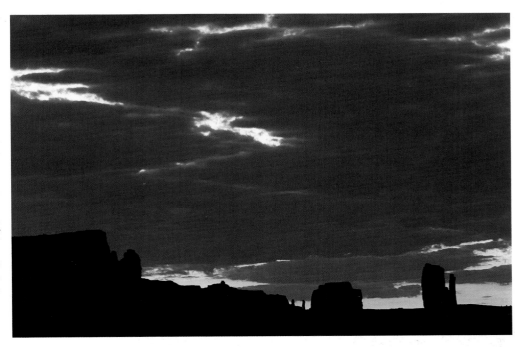

Concentrating attention
In this view of Monument Valley on the Utah-Arizona border in North America, the silhouette of the skyline is a constant black at virtually any exposure. The tones of the clouds, however, can be altered. Reducing the exposure removes detail from the sky, forcing attention down to the skyline.

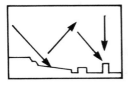

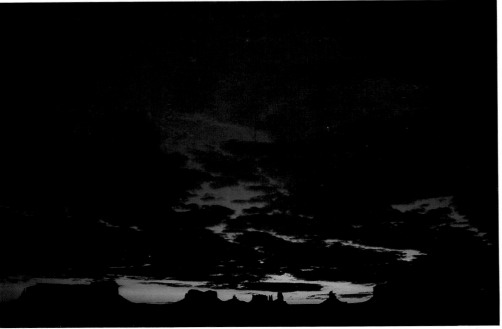

Reprise

The main function of graphic structures, like triangles and converging lines, is to bring some order to the image, to simplify its form and to give it visual coherence. Apart from this, a recognizable graphic structure can also be attractive, provided that it appears in a slightly unexpected way. There is no surprise at all in the rectangular shape of a doorway, but to see a spiral among a mass of trees and vegetation is unusual. There is a pleasure in discovering unexpected relationships.

By the same token, there is a pleasure in finding visual coincidences. Coincidence, by definition, depends on a certain unexpectedness. A visual similarity that everyone can see without the benefit of a photographer's eye has little to recommend it as the reason for taking a picture. A strong coincidence, on the other hand, can be entirely the subject of a photograph, and at least one photographer, the Frenchman Robert Doisneau, has made visual puns one of his trade marks.

Here, however, our concern is not with visual similarities as a subject for photography, but as an element in design. Apart from anything else, the danger of making a great deal out of a coincidence is that, as an idea, it can fall flat on its face. The response of other people is not always predictable. Like humour, coincidences have to be exact in order to work; not so obvious that the reaction is "so what?" and not so obscure that the point is entirely lost. As a contribution to the design, these similarities generally work best when understated, as a little touch to the image rather than a major point. The examples here, although different in type, are essentially a reprise – of form, line or action – and a kind of visual echo. Even when the reprise may go unnoticed, as is possible with the photograph of the jade horse, it can still continue to work at a gentle graphic level.

Apart from anything else, this kind of reprise helps the eye to move backwards and forwards, and to appreciate certain lines. In the photograph of the pearl shells, for example, the eye moves from one to the other across the frame, so taking in most of the area of the picture.

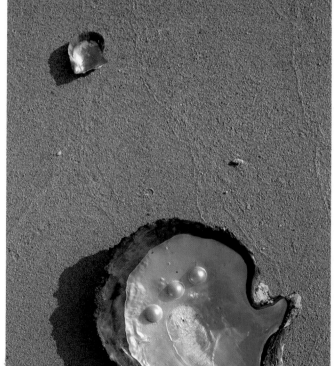

Reprise of shape
The subject is the larger pearl shell, with blister pearls inside it. However, rather than just fill the frame with this, extra light interest was added by including a young oyster, with exactly the same shape. The arrangement draws the eye backwards and forwards, from one to the other.

Reprise of content
The intention was a straightforward shot of this typical street in an old section of Singapore. The viewpoint was chosen for this alone. A figure was felt to be desirable to add some life; once the street sign was noticed, it was natural to wait until a figure walked into view which would mimic the picture on the sign. This type of reprise is not worth looking for in itself, but it adds a small touch.

Reprise of line
The reprise here is of the elegant curves of this fine jade carving. Considerable time went into moving the horse to find the best angle to reveal its lines. A major consideration in its position is the way the gap under the neck and jaw corresponds to the shape of the lower part of the horse's head.

Visual Weight

As a demonstration of how difficult it is to separate the graphic design of a photograph from its subject, its form from its content, look at the photograph of the helmeted East German guard. What is the focus of attention? With little doubt, the eyes. Yet, considered objectively as part of the image, they are in shadow, and the face occupies a very small part of the picture; it is not even near the center of the frame. The reason is that the human face, and the eyes in particular, have a greater visual weight than almost any other type of subject. They have this extra weight for no more complicated reason than our special interest in them.

Potentially, all subjects could be assigned a particular visual weight, although for most the value of the exercise would be questionable. Nevertheless, the fact that some subjects are more attention-getting than others influences the balance of the image. The description in terms of weight is appropriate if you refer back to pages 22–7 and the principles of balance. A face, for example, simply counts for more than virtually anything else in a photograph, and you should consider this when assigning proportions. Most people will do this naturally, but it does depend on being observant.

Together with the face and eyes, the human figure has this extra visual weight. Words also attract attention out of proportion to their size, tone or colour in a picture, although this evidently depends on whether they are understandable. A Chinese idiogram means little to most Westerners. At a level below recognizable lettering, however, almost any graphic representation has some extra pull. Practically, this usually means making special allowance for posters and street signs in urban settings.

Project: Focus of attention

Find a city scene that includes a poster or similar sign, but relatively small at the distance from which you are shooting (you may have to change the focal length of lens). The scene should also offer the opportunity for a shot without the poster, and the camera aimed slightly away. Take a photograph that just excludes the poster, making what seems to be a satisfactory composition. Then move the camera to include at least part of the poster, and again compose as best you can. You should find that, although the poster occupies a very small part of the frame, you feel that it dominates the balance. You could also do this project with a face.

Although they are in shadow, and away from the main area of the picture, the eyes of this sentry immediately catch the attention. This is true of almost any similarly composed photograph.

In the first photograph, which could be considered a portrait, the face draws attention away from the rows of silver necklaces. The second version is deliberately a photograph of the silver. The intention was to show the necklaces being worn (more interesting than a studio still-life), so just the mouth of the girl was included; enough to convey her presence in the picture, but not so much as to take any attention away from the jewellery.

Project: Focus of attention
In the first of these two photographs *below*, the attention of the viewer is immediately caught by the poster with the three faces, although this is not very large in the frame. The slight change of angle of the second picture to include the writing on another poster results in two main points of attention.

Visual Styles

What this book should have demonstrated is how much opportunity exists for influencing the design of a photograph. In most of the examples, it is the problem-solving capacity that has been stressed; how to use design skills to make certain things happen in a picture, to deal with specific situations and to manipulate the responses of somebody looking at the image.

This is essentially a pragmatic approach, and typical of the way in which most professional photographers work. There is a perceptible difference between using these design skills to communicate to an audience – the viewer we have assumed in so many of the examples up to now – and using them to express a personal view of things. This is a fairly recent development in the history of art; as Milton Glaser, the graphic designer, wrote in *Graphis* magazine: "As society developed, the information and the art functions diverged, and distinctions were made between high art and communicating information to increasing numbers of people."

Most photography falls on the mass-communications side of this divide. This is because it is essentially a reproducible medium (and so is seen more in magazines, books and newspapers than anywhere else), and also because it is so easy to perform that cameras are used by large numbers of people who are neither professionals nor have aspirations to art. There remains, however, the question of individual style.

Clearly, the same techniques that can be used so solve visual problems can also be used to put a certain graphic stamp on a number of images. The essence of a visual style is that the method of the photography, its form, should carry over from one picture to the next, and should be distinctive. At one extreme, a photographer may develop a particular combination of techniques that is recognizably different from those used by any one else, and then construct all images to this pattern.

Unfortunately, there is a lot less opportunity in photography than in any other graphic art for a style to progress, and a common result is that the potential of a photographic style is quickly exhausted. This needs some explanation. In painting, style is inevitable, and the very process of making an image depends on the perception of the artist and the way in which the basic materials are applied. There is no such thing as a neutral, characterless image (even imitative techniques, however badly done, are based on some style). The reverse is true of photography. Photographs can be, and unfortunately usually are, taken in a completely neutral fashion, without much thought for the design. The camera can produce a photograph by itself, and to influence the design takes effort, as we have seen. This is, after all, the central premise of this book, that training in the principles of design can make an improvement to your photography.

To make an identifiable difference to the style of a photograph, however, the techniques used must be definite rather than subtle. In most photographs it is the content of the image that tends to dominate, rather than the form, and most of the stylistic techniques that a photographer can use predictably and at any time are limited. If, for example, you decided to make misty silhouettes your trademark, this would severely restrict both your choice of subject material and the times at which you could shoot it. Most of the principal visual styles of photography are either selected ways of structuring the image, or are special manipulations of the materials or processes (in this latter case, the manipulations are always away from realistic representation). The problem of progressing with a photographic style lies in the fact that most of these techniques are fixed. For instance, once you have established prominent grain as the basis of a style, there is not much else you can do except continue to exercise the graininess. You can make photographs that are more grainy or less grainy, but not grainy in any substantially different way.

Depending on how you choose to define them, and in what detail you care to dissect the pictures, there are considerably more visual styles in photography than we show here. Intricate stylistic differences are rather more the province of fine art photography, however, and this is often self-limiting in terms of potential subjects. Here, without apology, we are concerned with the pragmatic approach to photography, and the styles illustrated here are ones that you can reasonably use to suit different picture-taking situations.

If you do choose to work exclusively in one particular style, make sure that you experiment with different design methods first. Afterwards, the limitations of one style will certainly inhibit you from thinking freely about alternatives. This is intended as a discouragement; a personal opinion perhaps, but there must be serious doubts about whether one photographic style, rooted in technique as it usually is, can satisfy any curious photographer over a long period. Using different styles for different purposes is another matter entirely; the ability to change from one to another is evidence that you have mastered the design skills described in this book.

Formalism

This has been one of the principal stylistic movements in photography, and had its heyday in the late 1930s, 1940s and 1950s among the group of American West Coast photographers that included Edward Weston and Ansel Adams. Their principles and methods are still applicable. Formalism has to be seen against the background of photography as it then was, still being used by many photographers to imitate painterly techniques and popular ideas about art.

Formalism was at heart a successful attempt to re-establish photography as representational. Edward Weston, who probably personified formalism more than anyone else, made a point of calling it "straight" photography. The importance of the subjects that Weston chose, whether shells,

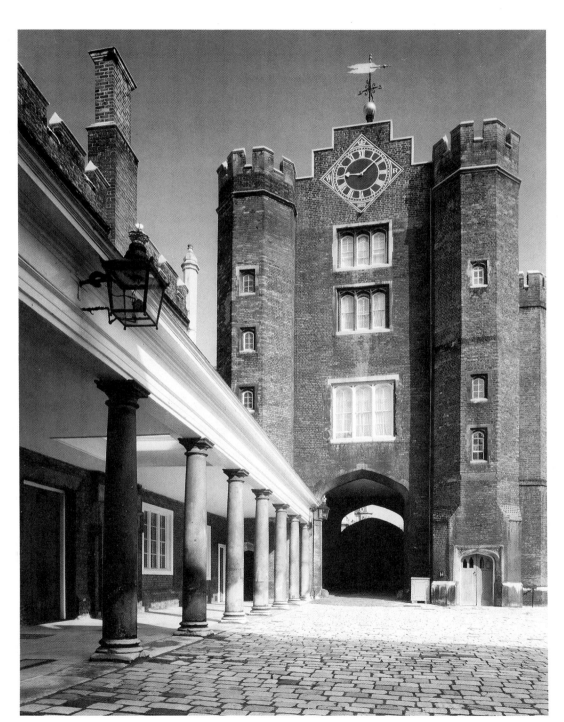

Formalism
In this "straight" photograph of St James's Palace in London, many of the representational concerns of Formalism are in evidence. The composition is considered, the essential architectural features are included, the verticals are correct, the detail is as sharp as only a large-format negative can make it, and the exposure and printing have been managed carefully, to retain both shadows and highlights.

rocks, nudes or landscapes, was that they offered opportunities to explore visual form and relationships. Weston and Adams despised the pictorialist approach to photography, with its soft focus and other technical tricks. Weston's aim, in his work, was "to present clearly my feeling for life with photographic beauty . . . without subterfuge or evasion in spirit or technique."

What all this meant was that, although the content of the pictures would remain foremost, careful consideration of it would suggest the design, and that every part of the photographic process would be used to enhance the quality of the image. The results were skilled and refined images that revealed what each photographer considered to be the essential qualities of the subject. There is more than a hint of logic in this, and also some conservatism. Ansel Adam's photographs are, above all else, ideal examples of classic proportions and well-considered balance; they are also per-

fectly crafted. Formalism is carefully planned design in the service of straight representation: no surprises, but careful observation. Perhaps an unkind view would be that formalism is documentary photography with added design aesthetics.

Subjective camera
Virtually the opposite of formal composition in most respects is the style of photography, widely used in photojournalism, that is fast, loosely structured and involving. The things photographed are mostly people and movement. Except when used as a pastiche, to imitate photojournalism, it is really a natural rather than a considered style. In the cinema, the equivalent style is known as subjective camera, and its characteristics are all the qualities you would associate with participating in an event.

This is eye-level 35mm photography, using wide-angle or standard lenses (never a telephoto, which gives a cooler, more

distanced character to the image). At its most effective, the framing includes close foreground, and truncates figures and faces at the edges; this seemingly imperfect cropping extends the scene at the sides, giving the viewer the impression that it wraps around (see page 146).

In general, imperfections are no real disadvantage, framing and depth of field in particular; they can help to give a slightly rough-edged quality which suggest the photograph had to be taken quickly, without time to compose carefully. Even if this is not really the case, the impression remains. Note, however, that photographs taken by experienced photojournalists are usually designed quite well, even under stress.

Photo-impressionism
This style, which involves a certain amount of abstraction, immediately invites comparison with impressionism in painting. Forcing the comparison is, however, dangerous.

Subjective camera
A wide-angle lens used close into a crowd scene gives the sense of being in the thick of things that is typical of subjective-camera shots. Truncation and loss of focus at the sides and extreme foreground help this impression of being inside the view.

It is important not to confuse either impressionism or its photographic equivalent with vagueness, despite the lack of obvious detail in the results. The impressionists were actually concerned with realism, in the sense of analyzing the effects of light, tone and colour, and reproducing some of these with great accuracy, if at the expense of sharply rendered detail and other literal qualities. Some, like Seurat, modulated colour by assembling close groupings of small dots of different hue.

This is the primary characteristic of photo-impressionism, as the photograph by Viesia Clavell on this page demonstrates. The techniques used to produce this effect are those that enhance the graininess: the use of a fast grainy film, and diffusing screens in front of the lens. These diffusers are used not to romanticize the image, but to lower contrast and to spread the areas of more or less even tone (this makes graininess more prominent). The choice of subject is, for the same reasons, important.

Photo-impressionism
Strongly filtered on fast film, this photograph combines diffusion and graininess for an intentionally delicate, mysterious effect (© Viesia Clavell).

Expressionism

Painterly comparisons are clearly very tempting, and if a photographic equivalent to impressionism can be found, why not expressionism? In fact, some technique-based styles come close, although it is arguable whether there is a true photographic equivalent. Expressionism in painting is so called because it is non-objective, and seeks to express the psychological content and sometimes highly personal experiences. The most immediate characteristic was non-realistic colour (El Greco, and later Kandinski, Munch and others).

Inevitably, that gives us a problem in photography. The techniques available for making this kind of major change to an image are limited, and difficult to control. Blurred motion is one possibility; it can be used to spread light and colours around an image, and the form of the streaks can be expressive (for instance, smooth and flowing, or jagged). In reality, however, because the motion of real things is creating this activity in the image, it is hard to say whether the results are usually expressive, or impressionistic. This is characteristic of one style of image by Ernst Haas, the German photographer.

Other possibilities are false colours, from various sources. Infra-red colour film gives non-objective colours and different filters vary the colours. With sufficient experience, it is possible to produce predictable results, although there is not very much freedom of choice. Coloured lighting is, in theory, one other method, as indeed is colouring the subjects themselves before photographing them. The problem is that these techniques are usually immediately obvious for what they are, with the consequent risk of simply looking ridiculous.

Minimal composition

This is a relatively recent development in art and design, and one in which photography is able to participate fully. It is a form of visual reduction to essentials, with an emphasis on the extreme. It is the principle of the spare, the least, the simplest, and often requires considerable effort

Expressionism
A long exposure blends in and around this fire being used for cooking. The full exposure and the yellow-to-orange colours also help to unify the elements, giving a swishing, flowing image.

to achieve, particularly on any scale. As the emphasis is on the form of the photograph rather than the content, successful minimal composition requires some evidence that the photographer has made the image appear like that, and not simply found an easy subject. The aerial view of the house on page 171 is simple enough graphically but hardly qualifies. Examples of minimal composition are the Japanese photographer Eikoh Hosco's austerely structured images.

Constructed images

This is a province of still-life photography, or at least of settings that can be entirely manipulated. The essence is that the image is entirely built up by the photographer, and usually to a prominent graphic structure. Nothing is left to chance, and realism is excluded. It is characterized by a highly geometric approach to design as in the photograph of the pieces of film.

Constructed images
This photograph of a variety of types of film needed a carefully planned geometric construction, featuring corners and edges, to ensure that the individual images do not attract attention.

Minimal composition
The essence of this nineteenth-century linen shirt hanging in a Shaker meeting house in Kentucky has been conveyed here with the least detail and least colours. Bare simplicity characterizes this style of photography.

Glossary

Abstract Non-representational, in which certain visual characteristics of a subject are separated from it in such a way that the image does not appear realistic.

Aerial perspective The sense of perspective communicated by increasing haze with distance.

After-image The impression of a visual sensation that occurs after the original stimulus has been withdrawn.

Asymmetry Lack of symmetry or proportion; off centeredness.

Available light Artificial lighting that is not specifically designed for photography. Principally, tungsten, fluorescent and vapour discharge lighting used at night and in interiors. Also known as existing light.

Background The ground or surface that lies behind the subject of the photograph. In many situations, the setting of the subject.

Balance The sense of equality in an image by means of elements that counter-oppose each other. The state of equilibrium.

Bauhaus School of design and architecture established in Dessau, Germany, in 1919. Both radical and functional in its teaching, its major influence on twentieth century design was due to its synthesis of art, design and modern materials.

Bilateral symmetry Symmetry in which the elements are arranged equally on either side of a central dividing line, so that one half of the image is the mirror image of the other half.

Brilliance (colour) The brightness or tone of a colour.

Broken colour *See* **Degraded colour.**

Burning-in To give selected areas of an image (usually an enlargement) additional exposure to alter the density in those areas.

Chiaroscuro Style of art in which only light and shade are used to create the image. Also, more generally, the effect of light and shade.

Chroma The intensity, or saturation of a colour.

Chromatic Coloured; having to do with colour. A chromatic grey is intrinsically neutral but with a touch of a colour.

Colour balancing filter Filters used to convert colour temperature of light sources to the balance of the film in use, and prevent the formation of colour casts.

Colour compensating filter Paler than colour balancing filters, these are used to affect slightly the colours present in the image. They are made in the three primary and three secondary colours, in varying strengths.

Colour conversion (CC) filter Filters available in sets of yellow, magenta and cyan, and red, green and blue, used for correcting or creating colour casts in photography, and for balancing colour in subtractive colour printing processes.

Colour harmony (1) Combinations of colours in respect of hue and brilliance which would, if mixed, produce a neutral. (2) Pleasing combinations of colours. This is the common use of the expression, but is, by definition, subjective.

Colour circle The arrangement of distinct colours in a ring for ease of calculating colour relationships and effects. The trichromatic colour circle used in this book (see page 107) is based on three primaries, red, yellow and blue, the other colours lying between them on the circle being mixtures of these.

Colour perspective The impression of distance created by the juxtaposition of certain colours. Red, for instance, appears to stand forward from green.

Colour reversal film Colour film that carries a positive, transparent image when developed. During the processing, the tones and colours of the recorded negative image are reversed, so that the final image is produced from the unexposed areas, hence the term reversal. Also known as transparency film.

Colour temperature The temperature at which an inert substance glows at a particular colour. The scale of colour temperature significant for photography ranges from approximately 2000 K (reddish colours) through 5400 K (white) to above 6000 K (bluish colours).

Colour transparency film *See* **Colour reversal film.**

Compensation Psycho-physiological effect in which the eye and mind make allowance for an imbalance in the image, producing an opposite reaction.

Complementary colours The colours which, when each is mixed equally with a primary colour, gives a neutral hue. Hence, the complementaries for the primaries red, yellow and blue are, respectively, green, violet and orange. On the colour circle, each complementary colour lies opposite its primary. Complementary colours are derived from the mixture of two of the three pure primaries.

Composition The deliberate arrangement of visual elements in an image in order to create a certain order within the frame. *See also* **Eccentric composition.**

Continuation The tendency of the eye and mind to complete or extend an implied direction in a picture.

Contrast The subjective difference in brightness between adjacent areas of tone. In photographic emulsions, it is also the rate of increase in density measured against exposure. Colour contrast is the subjective impression of the difference in intensity between two close or adjacent colours.

Convergence The appearance of receding parallel lines to become closer towards a common meeting point.

Cool/warm contrast The apparent opposition of colours tending towards blue-green with those tending towards red-orange, because of their associations with temperature.

Covering power The maximum diameter of image of a useful quantity that is projected by a lens. It must be larger than the diagonal of the film format, and considerably larger if camera movements are to be used.

Cropping The action of reducing the image area by means of closing in on one or more sides of the frame. Cropping may change the shape as well as the size of the format.

Curvilinear Bounded or characterized by curved lines.

Cyan One of the three subtractive primary colours used in printing – the others are magenta and yellow. A mixture of blue and green.

Cyclic Having to do with circles or cycles. A cyclic shape is enclosed and curvilinear.

Degraded colour A colour that is impure through the admixture of other hues (which may include neutrals).

Diminishing perspective Impression of perspective derived from a series of obviously similar objects becoming smaller with distance.

Distortion An image or part of an image that is twisted out of shape.

D-Max (maximum density) The maximum possible density that a photographic material can have: black.

Dodging To reduce the exposure in selected areas of an image to alter the density. *See also* **Burning-in.**

Dynamic The quality of apparent movement in an image, created by various compositional techniques.

Dynamic balance The sense of balance in an image created by the opposition of visual elements that each have a feeling of movement.
Dynamic tension *See* **Visual tension.**

Eccentric composition Method of composition in which the subject or main visual elements are placed well away from the center of the frame, close to the edges or corners. *See* **Composition.**
Ellipse A specific type of oval, or elongated circle, in which the sum of the distances from the two foci is constant.
Equilibrium The condition of balance between opposing forces or elements in a picture.
Existing light *See* **Available light.**
Eye-line The implied line in a picture suggested by the direction in which a person (or animal) photographed is looking.

Figure/ground relationship The relationship between the subject of a picture and its background. If the two appear to oppose each other almost equally (in terms of tone, for instance), the relationship can be optically confusing, with the background seeming to advance.
Fish-eye lens Extreme wide-angle lens in which curvilinear distortion remains uncorrected to allow coverage of over 180°.
Focal length Distance between the rear nodal point of a lens and the focal plane, when the lens is focused on infinity. Used to classify lenses.
Format The shape and size of picture, frame of film, or sheet of printing paper.
Frame (1) The borders of an image. (2) To position the subject and other visual elements within the frame.

Geometry The way in which an image is constructed in terms of its lines and shapes.
Golden Section Division of a line or rectangle to fixed proportions in such a way that the ratio of the smaller section to the larger is the same as that of the large to the whole. Widely regarded as being aesthetically satisfying, particularly by the Greeks and during the Renaissance.
Graduated filter Clear glass or plastic filter, half of which is toned, either coloured or neutral, reducing in density towards the center, leaving the rest of the filter clear. It can be used to darken a bright sky, or for special effects.
Graphic element The structural component of a two-dimensional image, such as a point, line or shape. Also known as a visual element.

Harmony A pleasing combination of elements.
Hue The quality of a colour that is defined by its wavelength. The means by which colours can be distinguished from each other visually.

Implied line, shape, etc A visual element that is suggested rather than shown explicitly. A row of points, for instance, becomes an implied line because the eye and mind complete the suggestion.
Integrated division A method of division (including, for example, the Golden Section) in which the resulting ratios are related to the entire frame.

Juxtaposition The placing together of visual elements in an image, often to suggest or exploit a relationship.

Kelvin (K) The standard unit of thermodynamic temperature, calculated by adding 273 to °C.

Light balancing filter *See* **Colour balancing filter.**
Linear perspective The impression of perspective that is created by the convergence of lines towards a vanishing point.

Magenta A mixture of red and blue, this is one of the three subtractive primary colours used in printing. The others are yellow and cyan.
Mid-grey Grey tone halfway between black and white, which reflects 18 per cent of the light falling on it.
Minimal composition Compositional style or technique in which the least elements are used, often with a deliberately eccentric arrangement.
Modulation The variation or regulation of brightness in tones or of hue, brilliance or saturation in colours.

Panoramic An unbroken horizontal view, usually of a landscape, in proportions that are longer than 1:2.
Paper grade Numerical designation of photographic printing papers from 0 (very low contrast) to 6 (very high contrast). Most papers are only available in grades 1–4; grade 2 is considered normal.
Pattern An arrangement of individual visual elements over an area; often similar elements arranged in an ordered fashion.
Perspective The appearance of objects, relative to one another, in terms of position and distance. Strictly speaking, perspective only changes when the viewpoint is changed.
Perspective-correction lens *See* **Shift lens.**
Placement The act of positioning a subject within the picture frame.
Primary colours Any three colours that can be mixed in proportions to produce any other colour. Each therefore covers approximately a third of the visible spectrum, and when all three are mixed equally, the result is neutral (white, grey or black, depending on whether light or dark pigments are being used). In painting, the primaries are considered to be red, yellow and blue, and this is the system used in this book. In combining light (and therefore film dyes), the primaries are red, green and blue. In printing, they are magenta, yellow and cyan. *See also* **Magenta, Cyan.**
Printing controls Shading and printing-in techniques used during enlargement to lighten or darken certain parts of a photographic print.
Printing-in A method of local printing control by which additional exposure is given to certain areas of the image that would otherwise be too light.

Reciprocity failure At very short and very long exposures, the increasing loss of sensitivity of photographic emulsion means that the reciprocity law fails to hold true, and an extra exposure is needed. With colour film, the three dye layers are affected differently, causing a colour cast.
Reciprocity law Exposure = intensity × time. Alternatively, the amount of light reaching the film is the product of the size of the lens aperture (intensity) and the length of the exposure (time).
Rectilinear Four-sided figure formed and characterized by two sets of parallel straight lines with all its angles right angles.
Representational photography Method of approach in photography in which the main objective is to show the physical qualities of the subject as clearly and recognizably as possible.
Reprise The recurrence of a visual element in a slightly different form (that is, a development on the original appearance).
Rhythm Successive movement in a measured, regular flow.

Saturation The purity and intensity of a colour.
Secondary colours *See* **Complementary colours.**

Shading Photographic printing technique where light is held back from selected parts of the image. Also known as dodging.

Sharpness The subjective impression of acutance (the objective measure of edge quality) when viewing a photographic image.

Shift lens A lens that can be moved perpendicular to the lens axis and which has a greater covering power than the film format. This combination allows converging verticals to be corrected. Also called perspective-correction lens.

Simultaneous contrast Psycho-physiological effect in which two different colours, when seen next to each other, appear to have greater contrast of hue than if viewed separately.

Single-lens reflex (SLR) Camera design that allows the lens used for projecting the image onto the film to be used for viewing also.

Spatial contrast The apparent opposition of different sizes of visual elements; contrast of area.

Spot colour A small, distinct patch of colour in an image.

Standard lens Lens with a focal length that produces an image with a perspective similar to that of the unaided eye. For 35mm format, 50 mm is considered the standard focal length.

Static balance Sense of balance in an image created by the opposition of visual elements that are themselves statically placed.

Straight photography Term coined by Edward Weston and the Group f64 association of American West Coast photographers to describe an approach with the minimum of special techniques and manipulation. *See* **Representational photography.**

Subject The object (thing or person) with which the photograph is principally concerned.

Subjective camera Style of photography, usually featuring close shooting with a wide-angle lens, in which the viewer is given the strong impression of being involved in the image.

Successive contrast Psycho-physiological effect in which the sight of one colour produces a tendency towards its complementary colour in the visual cortex. This may be experienced either as an after-image or as a modification of the next colour to be seen. Related to simultaneous contrast.

Symmetry Equal distribution of points, lines or shapes around a center or dividing line.

Telephoto lens Design of long-focus lens in which the lens-to-film distance is less than the focal length; in other words, a means of making the lens more compact.

Tertiary colours Colours derived from the mixture of primaries and adjacent complementaries on the colour circle; the third stage in creating colours from primaries.

Texture The structural appearance of a surface, particularly with regard to its component parts.

Tonal perspective The impression of distance created by the juxtaposition of light tones (which appear to stand forward) with dark tones (which appear to recede).

Trapezoid A four-sided figure in which two sides only are parallel (UK); a four-sided figure in which no sides are parallel (US).

Tungsten light Artificial light created by heating a filament of tungsten wire electrically to a temperature at which it glows.

Type B film Film for use in tungsten light. Gives a blue cast if used in daylight.

Vanishing point In relation to perspective, the point at which receding parallel lines, which converge in the picture, would meet if they continued far enough.

Viewpoint Camera position relative to the subject being photographed. Also known as angle of view.

Visual element *See* **Graphic element.**

Visual tension Sense of forces pulling in opposite directions when looking at certain images. Contains a feeling of potential movement, and so is also sometimes known as dynamic tension.

Visual weight The visual importance attached to an element in an image by the viewer. Psychological associations often play an important part.

Wide-angle lens Lens with an angle of view wider than that of a standard lens for the same format.

Bibliography

Adams, Ansel, *Examples: The Making of 40 Photographs*, Little, Brown, 1983.

Adams, Ansel, *Singular Images*, New York Graphic Society, Boston, 1974.

Adams, Ansel, *Yosemite and the Range of Light*, New York Graphic Society, Boston, 1979.

Anderson, Donald M., *Elements of Design*, Holt, Rinehart & Winston, 1961.

Arnheim, Rudolf, *Art and Visual Perception: A Psychology of the Creative Eye*, Faber & Faber, 1967.

Berger, John, *About Looking*, Writers & Readers, 1980.

Berger, John, *Ways of Seeing*, BBC/Penguin, 1972.

Bernard, Bruce, *Photodiscovery*, Thames & Hudson, 1980.

Booth-Clibborn, Edward (ed.), D & AD Annuals (series).

Booth-Clibborn, Edward *European Photography*, D & AD/European Illustration (annual series), 1981.

Bucher, C. J., *The World of Camera*, 1964.

Capa, Cornell (ed.), *The Concerned Photographer*, Grossman, 1968.

Diamonstein, Barbaralee, *Visions and Images: American Photographers on Photography*, Rizzoli International Publications, 1981.

Eauclaire, Sally, *The New Color Photography*, Abberville Press, 1981.

Eisenstaedt, Alfred, and Goldsmith, Arthur (eds.), *The Eye of Eisenstaedt*, Thames & Hudson, 1969.

Evans, Harold, *Pictures on a Page*, Heinemann, 1978.

Evans, Walker, *Walker Evans: First and Last*, Secker & Warburg, 1978.

Frank, Robert, *The Americans*, Aperture, 1958.

Garnett, William, *The Extraordinary Landscape*, New York Graphic Society, 1982.

Gernsheim, Helmut and Alison, *A Concise History of Photography*, Thames & Hudson, 1965.

Gernsheim, Helmut, *Creative Photography: Aesthetic Trends 1839–1960*, Faber & Faber, 1962.

Haas, Ernst, *The Creation*, Penguin Books, 1978.

Images of the World, National Geographic Society, 1981.

Itten, Johannes, *Design and Form*, Thames & Hudson, 1975.

Itten, Johannes, *The Elements of Colour*, Van Nostrand Reinhold, 1970.

Kasten, Barbara, *Constructs*, New York Graphic Society/Little, Brown & Co, 1987.

Kepes, Gyorgy (ed.), *Education of Vision*, Studio Vista, 1965.

Kepes, Gyorgy (ed.), *Module, Symmetry, Proportion*, Studio Vista, 1966.

Kepes, Gyorgy (ed.), *Sign, Image and Symbol*, Studio Vista, 1966.

Lartigue, Jacques-Henri, *Boyhood Photos of J. H. Lartigue*, Ami Guichard, 1966.

"The Art of Photography", *Life Library of Photography*, Time-Life Books, 1970–3.

Mante, Harald, *La composition en photographie*, Dessain & Tolra, 1977.

Mante, Harald, *La couleur en photographie*, Dessain & Tolra, 1977.

Martin, André, *Images d'une France*, Kodak Pathe, 1972.

Meyerowitz, Joel, *Cape Light*, New York Graphic Society, 1978.

Newhall, Beaumont, *The History of Photography From 1839 to the Present Day*, The Museum of Modern Art/Doubleday, 1964.

Newhall, Nancy (ed.), *The Daybooks of Edward Weston*, George Eastman House, 1961–6.

Newhall, Nancy (ed.), *Edward Weston: The Frame of Recognition*, Aperture, 1965.

Newton, Helmut, *White Women*, Quartet, 1976.

Penn, Irving, *Worlds in a Small Room*, Secker & Warburg, 1974.

Photography Year (annual series), Time-Life Books, 1973.

Porter, Eliot, *Intimate Landscapes*, Metropolitan Museum of Art/E. P. Dutton, 1979.

Private Pictures, introduced by Anthony Burgess, Jonathan Cape, 1980.

Sausmafez, Maurice de, *Basic Design: The Dynamics of Visual Form*, Studio Vista, 1964.

Snowdon, Lord, *Sittings 1979–83*, Weidenfeld & Nicolson, 1983–4.

Sontag, Susan, *On Photography*, 1973.

Steichen, Edward, *A Life in Photography*, W. H. Allen, 1963.

SX–70 Art, Lustrum Press, 1979.

Szarkowski, John, *American Landscapes*, Museum of Modern Art, 1981.

Szarkowski, John, *Looking at Photographs*, Museum of Modern Art, 1973.

Szarkowski, John, *Mirrors and Windows*, Museum of Modern Art, 1978.

Szarkowski, John, *The Photographer's Eye*, Museum of Modern Art, 1966.

Weston, Brett, *Voyage of the Eye*, Aperture, 1975.

Magazines
American Photographer
Zoom

Index